ELEVATE THE
EVERYDAY

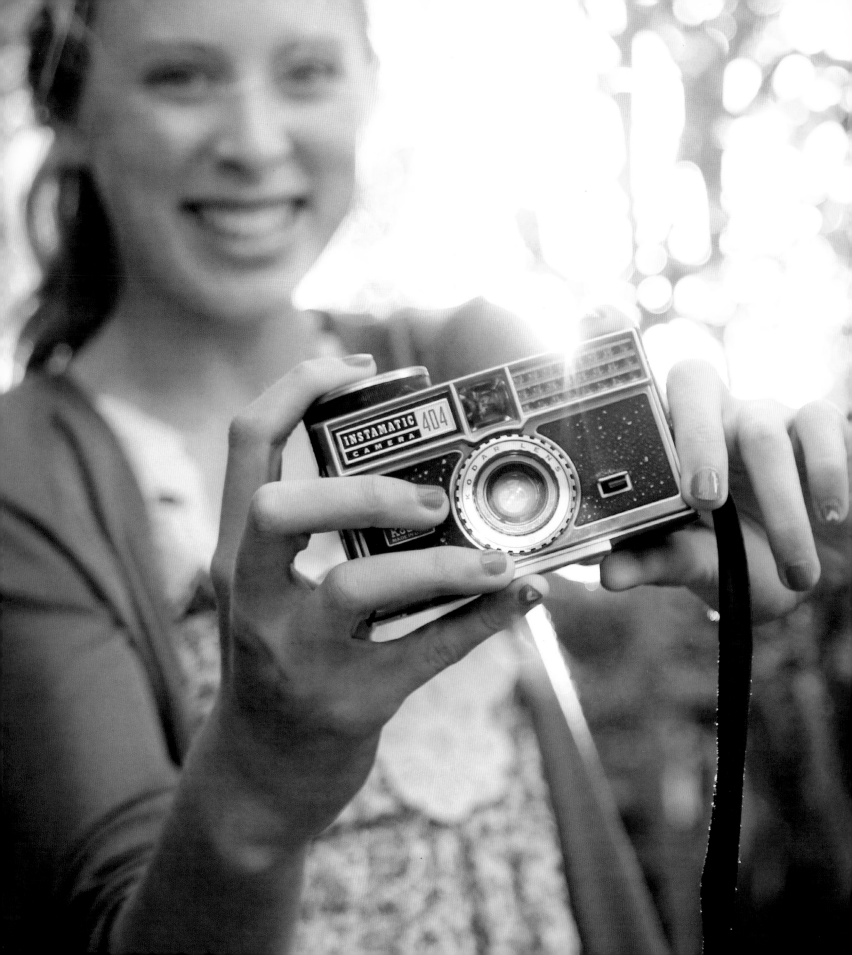

TRACEY CLARK founder of *Shutter Sisters*

ELEVATE THE EVERYDAY

A PHOTOGRAPHIC GUIDE TO PICTURING MOTHERHOOD

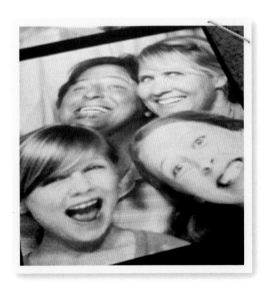

ELSEVIER

AMSTERDAM • BOSTON • HEIDELBERG • LONDON
NEW YORK • OXFORD • PARIS • SAN DIEGO
SAN FRANCISCO • SINGAPORE • SYDNEY • TOKYO
Focal Press is an imprint of Elsevier

Focal Press

Focal Press is an imprint of Elsevier Inc.
225 Wyman Street, Waltham MA 02451, USA

This book was conceived, designed,
and produced by Ilex Press Limited
210 High Street, Lewes, BN7 2NS, UK

Publisher: Alastair Campbell
Associate Publisher: Adam Juniper
Creative Director: James Hollywell
Managing Editor: Natalia Price-Cabrera
Editor: Carey Jones
Editor: Tara Gallagher
Specialist Editor: Frank Gallaugher
Senior Designer: Kate Haynes
Design: JC Lanaway
Illustrator: Jane Smith
Color Origination: Ivy Press Reprographics

Library of Congress Control Number:
A catalog record for this book is available from
the Library of Congress.

ISBN: 978-0-240-82109-2

For information on all Focal Press publications
visit our website at:
www.focalpress.com

Printed and bound in China
10 11 12 13 14 5 4 3 2 1

CONTENTS

We all have to begin somewhere.
Whether it's the spark of our very
existence or the start of a totally different
kind of journey, when we do begin, we
have the whole world to discover. The
beginnings of motherhood, of childhood,
and of photography are all exciting and
important places to be. This chapter
celebrates these beginnings.

As documentarians of our own lives,
our cameras are vital tools. The more
time and energy we take in becoming
acquainted with our cameras, the
more we can improve our everyday
photography. And even the most
simple of tips and tricks can make a
big difference. This chapter takes it
one setting at a time.

Our camera's viewfinder is our canvas.
As everyday photographers, it's our job
to fill that frame like artists. Even beyond
capturing the perfect expression at
just the right time, there are elements
of composition and ways to frame the
moments of our lives that can help us tell
even more effective stories. This chapter
touches on compelling and creative
ways to compose each shot.

PREFACE

I REMEMBER WHEN I WAS FIRST ASKED TO CONSIDER WRITING A BOOK LIKE THIS—A BOOK THAT WOULD HELP MOTHERS TAKE BETTER PICTURES OF THEIR CHILDREN. IT SOUNDED LIKE A GOOD IDEA, AFTER ALL, CONSIDERING THE IMPORTANCE PHOTOGRAPHY PLAYS IN DOCUMENTING OUR LIVES. BECAUSE THE DAY WILL COME WHEN OUR CHILDREN OUTGROW HOME AND BEGIN LIVES BEYOND THE ONES WE HAVE PROVIDED, AND THEN, IT IS ONLY OUR MEMORIES AND THE FAMILY PHOTOS THAT REMAIN.

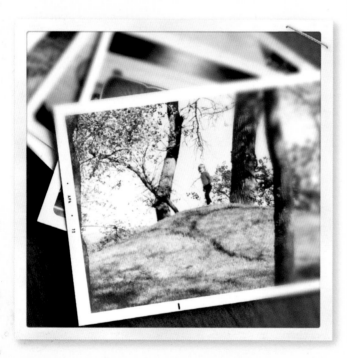

But there are already books like that out there, I kept thinking as I began the process of writing. And yet there was this whisper: *But there is also the book that only you can write. The one that isn't like the others. The one that you're meant to share.* And so I began to ask that voice for guidance and answers and clarity. I began to write this book with the faith that there was something that hadn't been said. That there would be room for a book that offered a unique perspective; a book that intertwined motherhood and photography (two very important parts of myself) in a way that resonated with all mothers, no matter what stage of the motherhood journey they found themselves in and no matter how well acquainted (or not) they were with their cameras. This was the idea and the hope that I began to work towards.

As I was fleshing out my thoughts and debating what to include and what to leave out, I realized that there was a part of the story that often gets overlooked—the story of motherhood itself. Eureka! Yes, I could write a book on f-stops and shutter speeds and tell you to drag the high chair closer to the window light in your kitchen (and I do cover that, and more, in this book), but what was most exciting to me was to encourage you, a mother, to not only capture great photos of your children,

but to also tell the story of you. Where do you fit into the picture (pun intended)? Where are you during the childhood of your children?

I am well aware that many of us moms who love photography remain faithfully behind the camera, clicking away at the moments of our kids' lives. But what about our own lives? What about that feeling you get after you have your brand new baby and you realize that everything has changed, that life will never ever again be the same? How do you deal with that? And how can photography play a role in answering that question? This, all of this, makes up the book that I was meant to write.

Even after my "lightbulb" moment, I had a flash of doubt: I'm so far from new motherhood—how can I write this book now? And then the gentle voice again replied, *There is no better time to write it than now, and no better place to be in your journey than where you are now. And you don't have to do it alone.* OK—I'll trust that voice. After all, I have been through the fire and I will go through it again (albeit in another phase of motherhood, as my eldest just started high school), and then again and again. Because being a mother is always new, no matter where you are on the journey of raising your own child or children. There are always moments to savor and stories to record. You might not be able

to travel back in time to take more photos, or write more in the baby book, but there will always be pictures to take today and memories to be made right now.

And so *Elevate the Everyday* began to take shape, and what I realized about not having to do it alone has become what might be my favorite part of my story. They say it takes a village to rear a child. What better way to write a book? Within these pages I've shared my own knowledge and experience, but you will also find words and images from some of the most inspiring mothers/writers/photographers I know. Each of their stories is unique. Every one of their images is captivating. Their work touches on struggle and joy both past and present, and they give heartbreakingly open and honest accounts of their own motherhood experiences and the integral part that photography has played.

And so, in the end, this book has been a labor of love. Of looking back and looking ahead. Of distilling my feelings on motherhood and my philosophies on photography. Of bringing stories and images to these pages in hopes to inspire all mothers to seek out the magic (even in the most mundane moments) and capturing it through the lens. Every photo a mother takes is a story that is worth telling. A story that elevates the everyday.

INTRODUCTION

MOTHERHOOD AND PHOTOGRAPHY ARE TWO VERY IMPORTANT PARTS OF WHO I AM. I FEEL VERY FORTUNATE THAT THEY COMPLEMENT EACH OTHER SO NICELY. ALTHOUGH I BEGAN MY LOVE AFFAIR WITH PHOTOGRAPHY LONG BEFORE I HAD CHILDREN, MY RELATIONSHIP TO IT —OR PERHAPS BETTER SAID, WITH IT— COMPLETELY CHANGED ONCE I BECAME A MOTHER. IN THIS BOOK I WILL SHARE PARTS AND PIECES OF THAT STORY, BECAUSE FOR ME, PHOTOGRAPHY AND MOTHERHOOD HAVE BECOME INTERWOVEN IN WAYS I COULD HAVE NEVER SEEN COMING.

Beyond my own story, there are a million others— both like it and nothing like it—that are just as authentic and equally as important. Within these pages there is a diverse tapestry of text, stories, and images all woven together with the common thread of motherhood in all of its rich complexity.

Some books are meant to be read cover to cover. This book isn't like that. Instead, you will find the content of these pages presented in a way that will make it easy for you to discover what you need, when you need it. You might be a new mother or a mother of a teen or even a grandmother. Wherever you are on your journey, this book is for you.

Although it's my instinct to dive into the heart and soul of things first, you will notice that I offer some photographic nuts and bolts in the first few chapters. Understanding how to use the creative tools of your trade to get the results you want is necessary to help you better tell your story. I cannot emphasize enough that I want you to enjoy the companionship of your camera. Every minute you spend getting to know it better will be worth it. Just take it at your own pace. My intention with both the *Camera* and *Composition and Creativity* chapters is that you get what you need, if and when you need it, and can incorporate it into your daily documentation over time. There's no rush. Further how-to concepts will be shared throughout the whole book in the form of helpful but casual tips and techniques, and will be marked with visual cues for easy reference. The camera icon represents photography topics, the frame icon stands for composition, while the lightbulb icon means creativity.

As the *Growing* chapter begins, you will quickly recognize that above all else, this book will encourage you to see your life for the magic that it is. Each chapter that follows covers different stages of childhood and different phases of motherhood. You'll find poignant original stories and blog entries from me and a chorus of other mothers that I hope will stir your mother-soul and empower

*"The true secret of happiness lies in taking a genuine interest
in all the details of daily life and elevating them to an art."*

WILLIAM MORRIS

you as you begin your journey of documenting your authentic and real life right now. Concluding the book, I end with some insights and ideas on what to do with your images once you've captured them. Just a few things I wanted to impart in the hope that you not only enjoy the process of shooting photography, but also enjoy the images themselves, both right after the fact and for years to come.

That being said, I want you to know what this book isn't about. It isn't about perfect children, the perfect home life, or perfect motherhood. This is not a book about professional photography featuring professional photography. The images featured in this book are from my everyday life—moments captured of close family and friends—and from the lives of the other mothers I asked to be a part of this book. There is more beauty in that than could ever be found anywhere else.

With every page, it is my intention to inspire and encourage all women willing to embrace the truth that ordinary daily life can be extraordinary if you know where or how to look at it, and that your camera is an invaluable tool to help you narrate it. And if you already know all that, then this book will remind you that you are not alone, that you belong to a vast community of mothers who believe

that it's all worthwhile. Every photo, every story, every scrapbook page, every blog post, every picture on the wall. All of it.

How you choose to experience this book is up to you. I only ask that in response, you be in your life. Live it, breathe it, appreciate it, honor it, and document it. The greatest gift you can ever give yourself and your children is to allow your story to be told, in your words and through your lens, with every picture you take.

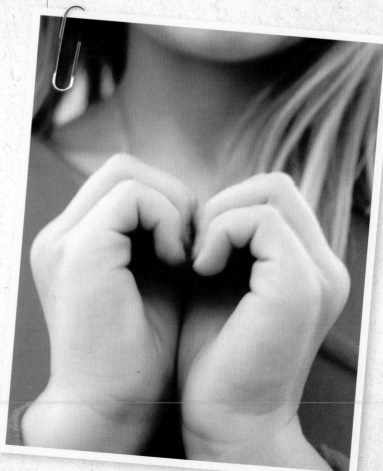

1 BEGINNINGS

I LOVE BEGINNINGS. FOR ME, THE WORD BEGINNING BRINGS TO MIND FRESH STARTS AND POSSIBILITY. I ALSO KNOW FROM EXPERIENCE THAT BEGINNINGS HAVE THE POTENTIAL OF BEING POWERFUL AND OFTEN TRANSFORMATIVE. BUT WITH THAT KIND OF GRAVITY, IT'S UNDERSTANDABLE THAT BEGINNINGS CAN FEEL OVERWHELMING AND EVEN TERRIFYING.

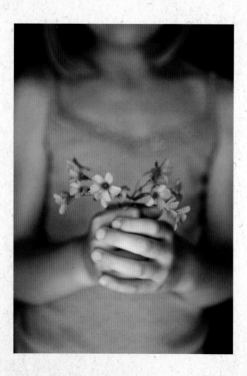

But wait, why aren't we talking about photography and motherhood? Oh, we are.

So what's all this about beginnings? It will all come together. I promise.

To begin means to start something brand new. Whether you're new to motherhood or photography or documenting your life through stories, as you read this book, you are beginning a process of seeing your life in a whole new light. This fresh way of seeing may usher in a new way of being more accessible and open to perhaps the most authentic, important and sometimes most vulnerable part of yourself: your everyday life.

Is that really true? Is your daily life really that important? After all, the daily routine can feel so mundane, so monotonous, so . . . ordinary. I won't deny that. But I also believe that at its most mundane, your everyday life can also hold great magic.

From mundane to magic, just like that? Indeed, and it's a transformation that will come as you begin to reframe your life through your lens and express your motherhood experience candidly through your photography.

So here you are at the beginning. *Of what?* Something extraordinary.

BEGINNING MOTHERHOOD

Each mother begins her journey differently. And irony of all ironies, we have to travel long and far before we even get to the place where we can begin. Each woman travels her own unique way toward that beginning: walking, running, crawling, laughing, sighing, crying, just to get to motherhood. Just to reach the beginning.

There is no one set or sure path that all women travel to reach motherhood. Sometimes it is a difficult road of struggle, questions, and heartbreak, while others may experience it with relative ease or even unintentionally. Yet, amidst every experience, in every story, throughout every journey there develops a deep desire to be there—the place where new life begins on every level imaginable. A brand new story, a new connection, a child, a mother, a relationship between people that changes everything. A phase of life where we are cracked open and transformed into something we never knew was possible. In our own way, we signed up for this. The unknown, the uncertain, the mysterious. The beginning.

This is motherhood.

Does this newness and unfamiliarity ever go away? It does, and it doesn't. I remember wondering soon after my daughter was born, "who is this person?" while at the same time feeling like I had never not known her. Little did I know that dichotomies like that are forever a part of the motherhood experience. There are times, over the years, through phases and stages where it feels familiar, where answers come easily, and sense can be made. And there are also days when being unsettled and unhinged is the norm, and you wonder how you'll ever manage. It is like this throughout all of motherhood. Not just with your first child, not just at the beginning or in the early days. Always. Motherhood is a whole new life and you will always be beginning, in one way or another, whether it is in the everyday, the milestones, the mundane, in the lives of your children, or in your own life.

Motherhood is a process, a practice, a journey with no destination. Sometimes it feels overwhelming, hopeless, lonely, scary, and at other times exciting, exhilarating, and enchanting. You can't depend on it being one or the other, but you can recognize it, embrace it, and celebrate it. Or even mourn it. And through all that, you honor it.

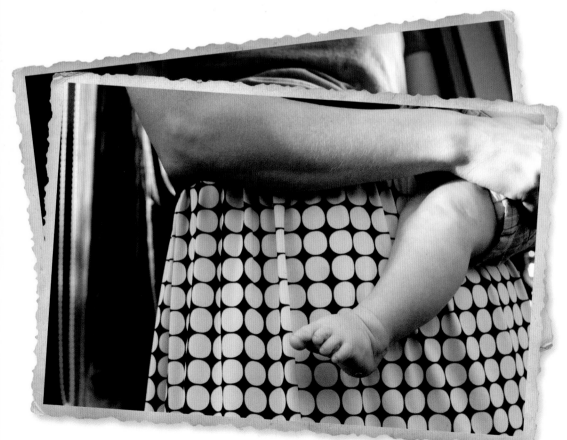

Patterns of Motherhood

Although every experience of beginning is unique, there will always be parts of the motherhood experience that are universal. When looking at your life through your lens, you will often begin to recognize that what you are doing has been done throughout history. It's these shared experiences that connect us, and these kinds of images that resonate with all mothers.

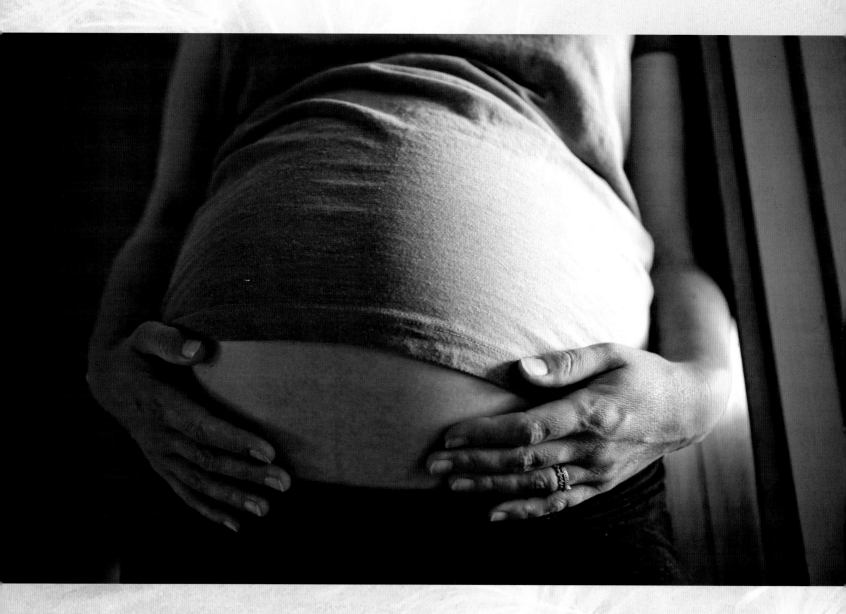

Embracing Your Story

*Each path to motherhood is a way all its own.
Understanding and embracing that our way is
unique to us as women and as mothers can be
a way of honoring it. Through documenting your
story, you acknowledge the path and celebrate
your own way of getting there. Your journey
is an important part of both your history and
your children's history.*

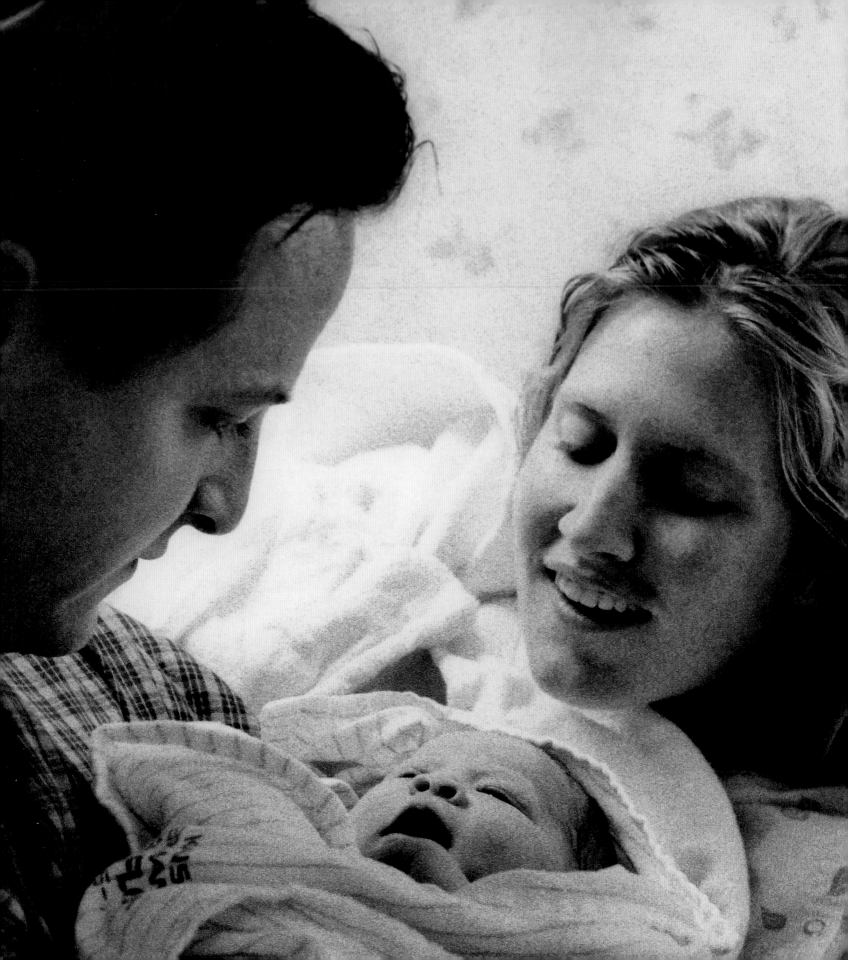

Blog Entry

Thoughts on Parenting

Words and image
Kelly Rae Roberts
Taking Flight into Art, Love, and Life
www.kellyraeroberts.com

It's such a strange land. I remember when True was first born, I felt so incredibly new, like I had just arrived for a permanent stay at a different planet where they speak a different language, and live a whole different life, where I knew nothing and nobody—a place where I was afraid, yet also comforted by the love I had for my new baby and the truth that everyone there—a sisterhood of souls traveling new mama territory—had gone through what I was going through. I've known from the beginning that I'd have to find my way to the new version of myself and this new life, one brave step at a time. It's such an odd experience—to feel brand new yet whole all at once. To feel love yet terror. To feel confused yet deeply okay.

Almost one year in, I can see how much courage it takes to be a parent, how terror and love dance with one another every second of every day, how harnessing that energy and that relationship takes major effort, but how all of that is worth it. I can see now how living with a completely stripped heart takes practice, how it beats deeper now, how it has more and more to lose with each new day of new life with a sweet baby, and how that alone can be scary enough to want to jump ship every now and again. I can see now how babies transform the whole family, how they can reset dynamics, and help forgive. I can see how love and new life and new ways of seeing and believing really are everywhere. I can see now how marriages deepen the second a baby is born, yet struggle through sleep deprivation—and how partnerships ebb and flow, steady as the tide with the push and pull of understanding and connection. I can see now how crazy hard it is to work when all you want to do is snuggle. Yet I can also see and feel exactly how we can lose ourselves to too much togetherness and not enough space to remain who we really are. I can see now how precious every single moment is—how we really are building our stories with all of those moments. We have to make them count.

It feels like grace, like wide open spaces of grace. I'm so changed by this journey. Having baby True feels like the best Christmas morning times a bazillion, every single day—so much giving and receiving and joy and celebration and wonder all mixed into the spirit of what really matters inside life's most special moments.

BEGINNING PHOTOGRAPHY

Not unlike the journey to motherhood, how we find ourselves with camera in hand is unique to each of us. How we got here isn't nearly as important as the why. Not having any traditional photography training and still building a career as a photographer—something that has now gone beyond a job and has become a lifestyle—has confirmed for me that a photography background isn't what is important. All that matters is why we are here.

You have picked up this book for a reason. You must either love photography or you love your children so much you want nothing more than to document every hair on their sweet heads. My guess is there's a little of both in there. The beauty of this beginning is that it doesn't matter how much experience you have under your belt, in either motherhood or photography. We are all starting from our own beginning. Because I most definitely experienced a creative rebirth after the birth of my second child, I know you can begin photography again and again. It all has to do with life experience, growth, personal evolution, and perspective.

MY STORY OF BEGINNING

Photography, for me, began at the very end of college, as I dabbled with photographic imagery in some of my artwork. Then, when my friends began having babies, I began a little love affair with photographing them. After graduation, I got a job working for a photographer (which felt like more of a fluke than an accomplishment).

It was only a few short years later that my first daughter was born. At that time, photography was more of a work thing than an everyday activity. I loved it, but I didn't need it. I was exploring it, making a living at it, getting to know it, and enjoying it, but not really living it. I took tons of photos of my first daughter, as so many new moms do. But it was only after my second daughter was born that my relationship with photography really shifted. All of a sudden, I didn't just love photography—I needed it.

In the few months before my second daughter was born, I was overwhelmed by a powerful and often debilitating surge of depression. The prepartum depression was only a precursor to the postpartum depression, which permeated my life for months to follow. It was then I kept my camera close, documenting the smallest of details of my life during those unsteady months, seeing through my lens what I couldn't see with my own eyes. What I didn't realize at the time was that I was using my camera to find the glimmers of hope and light that were clouded (and often hidden) by the darkness of depression. It was photography that helped me see the miracle of my daughter, the sacredness of those early days, the joy.

It took a while for that fog to lift and it breaks my heart to think I was hazy during those precious months. But then I look back at the photos and see that I was there. I was in the moment, capturing every detail of my daughter's first days. Every fold of her skin and hair on her head were accounted for. Every waking moment—and every sleeping moment, for that matter—were documented in poetic fashion, an artistic study of the baby days, and I am grateful. Not only that I have these photos to gaze at, to fall back on when my memory fails me, but that I had the gift of photography when I needed it most.

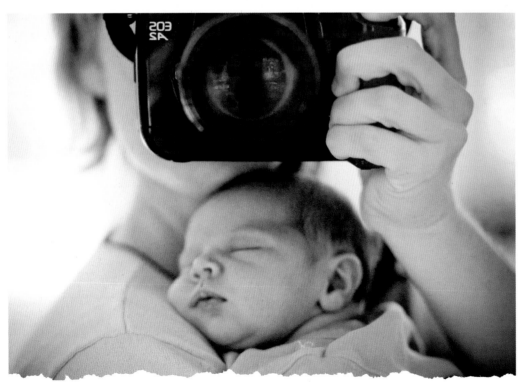

A Story of Motherhood

What Dreams May Come

Words and image
Denise Lynnette Andrade
Boho Girl
www.deniseandrade.com

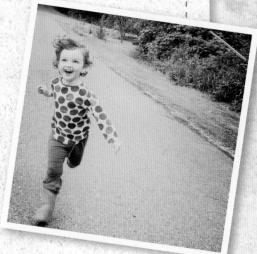

One of my mantras in life is never to force anything, but instead to just allow things to unfold organically. Some people consider themselves artists early on in their life. But for me, it took time to walk with the awareness that I was a creative person. From my childhood until the last few years of my life, I had expressed myself through poetry, dance, drawing, painting, and writing because I saw things and felt things that I desired so deeply to explore. Yet not one of those mediums fully expressed what it was I wanted to say. I knew if I just allowed things to unfold, I would eventually find a place for my voice. What I didn't know was that I would find it in a space that was full of brokenness, and grief, and a dream torn apart and put back together again in a way I never thought would be MY way. But it was, and it was beautiful. And heartbreaking. And heartFREEing. And it became the inspiration to my art. It was my journey to motherhood.

I wasn't a girl who grew up dreaming I was going to be a mother. When I envisioned my future, I imagined being in love and having a partner and living our dreams side by side. If children were meant to be, they would be, but I didn't ache for it. But one morning, having just turned thirty and living in a coastal city, I woke up from a very vivid dream in tears. My hands were searching my bed for the child that had been curled up in my lap on the sand. The child that had run towards me, blondish curls bouncing and arms outstretched, begging to be lifted up and held. It was the first time I felt the desire to be a mother. The spirit of the child in the dream would stay with me for years to come.

Six months after that morning, I met my husband. He understood me like none other. He taught me to listen to what gave me goose bumps. He celebrated and rejoiced in the way I danced to my own drummer. And surprisingly, being married to him brought back a yearning to unite with that child spirit from my dream, and he too ached for us to have a child. A year and a half into trying to conceive, I found myself broken. I was trying to channel my grief into writing, poetry, and artwork, but I found that I couldn't express the depths of my pain.

I went to a workshop and met an artist who encouraged me to connect online. It was there, through those connections, that I was introduced to the world of blogging, and discovered a blog about another woman's infertility journey. I finally didn't feel alone in my pain. I reached out, and we connected deeply. She encouraged me to write a blog too, as a tool to express my grief. Although it was frightening and exhilarating taking that leap, I wrote, and I picked up a camera to capture images that moved in harmony with my words. It was then that I found my voice. Finally, I could capture what it was I wanted so deeply to express. Through self-portraits, and then through photographing other artists, I was able to reach down into the depths of my soul.

With words and with images, I could paint a picture of my vulnerability, my blurred and confused sexuality, my body that yearned to feel whole even though it could not do one of the very things it was created to do. Putting it all out there was healing. It allowed me to not attach shame to any of it. It became beautiful. It became art. It became a door for others to reach out their quivering hand for me to lift them up and look into their eyes and say WOMAN . . . you are a woman. MOTHER . . . you are a mother. You will be a mother. I will be a mother. The ache is there for a reason.

Five years into our journey to conceive, the raw and honest words on my blog and the soul of my photography led my husband and me to an adoption consultant, which led us to our birth mother. It then led us to our son being born from another woman's womb and into our arms. He is the child with bouncy curls and outstretched arms I dreamed about years ago. And it was my allowing my creativity to have a voice that carved the path for us to find one another.

BEGINNING CHILDHOOD

"Seven years ago she broke through the dark and silent night with her complex and multi-layered symphony. Highs, lows, intensity, tenderness, discord, harmony, all woven together in a unique concerto that has become the soundtrack of our lives."

BLOG EXCERPT, JUNE 12th, 2010

Who's to say when childhood truly begins? Some may think it starts at conception. Others may say it begins at birth. Or maybe childhood really starts after the early days of newbornhood, when a baby begins to really engage with others, discover mobility, or participate in play. Whatever the case may be, we don't remember when our own childhoods began. But, if we're lucky, we have pictures. Old photographs (that may be few and far between) to visually prompt the stories we've been told about our early life: where we lived, who we spent time with, what we looked like.

It is our job as mothers to do this for our own children, to document the beginning. We are the family historians. The photographers. The storytellers. Now more than ever, we have tools literally at our fingertips to do exactly that. Unlike our parents, we are almost never without cameras, from our SLRs to our point-and-shoots to our phones. It's time to put them to good use. There is no job more important or more exciting than the calling to document the fleeting moments of childhood.

The Spirit of Childhood (Right)

Like certain moments of motherhood, there are also quintessential experiences of childhood. Stories of wonder and whimsy can reveal moments that tie together all that has come before us and all that will follow. Some photographs can symbolize the true spirit of childhood.

Symbolic Snippets (Below)

Visually communicating the beginnings of either our own experiences or our children's can be a creative method of storytelling. Capturing symbols of these times is an excellent way to start the first chapter of our children's stories.

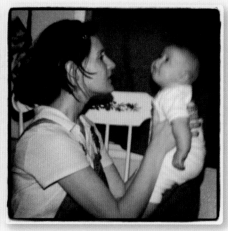

ELEVATE THE EVERYDAY

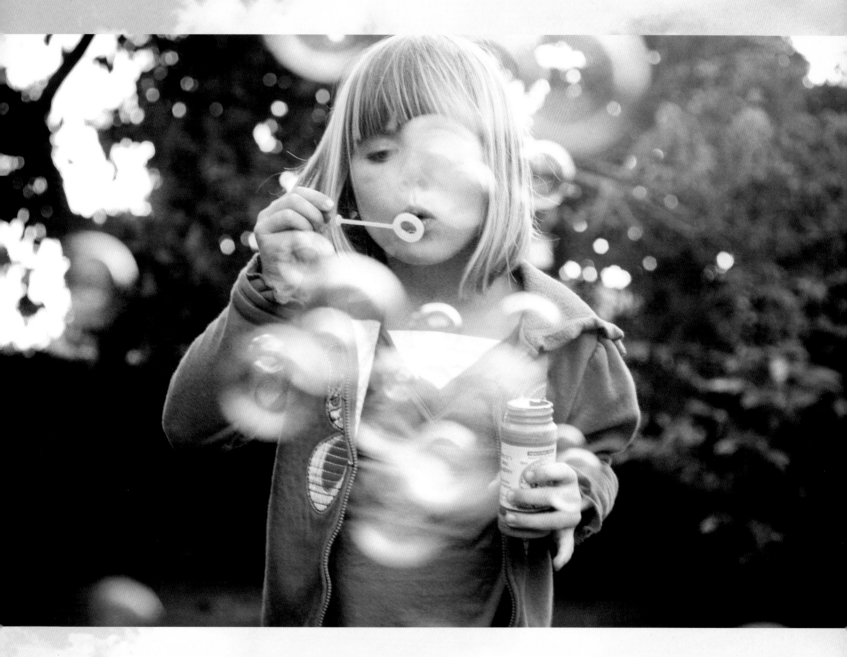

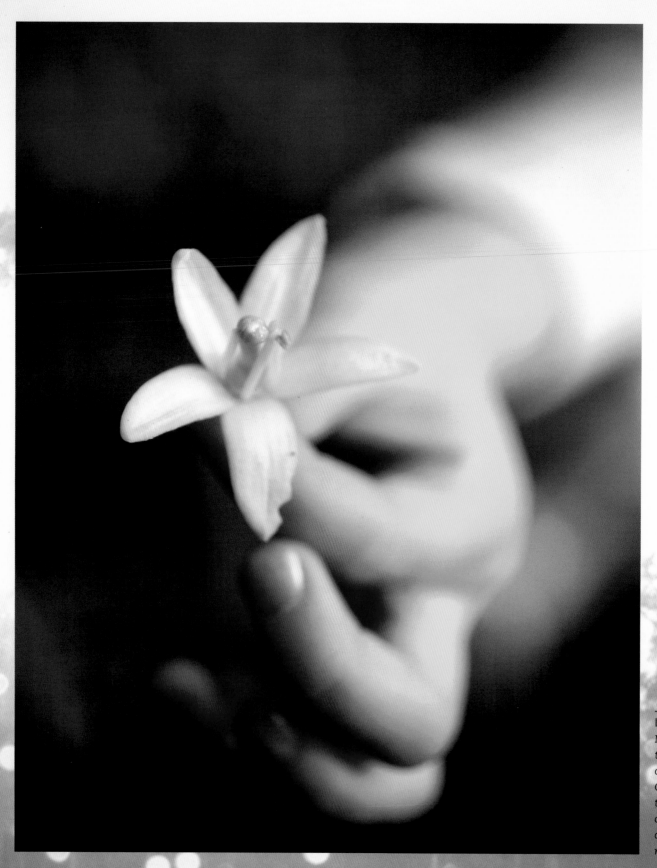

Life is a Gift
No one can discover
the wonder and beauty
of everyday life like kids.
Opening ourselves up to
the gifts our children offer
can help us better see and
capture in images what
matters most.

ELEVATE THE EVERYDAY

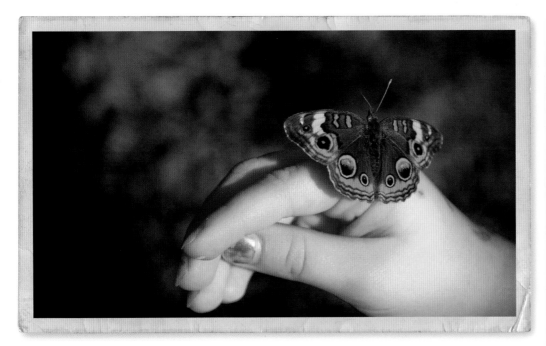

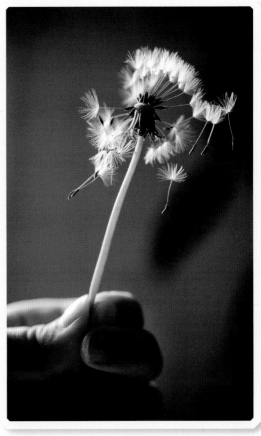

Maybe you already shoot everything your family does every day, or maybe you've never been all that good at doing so. It makes no difference. All that matters is that you begin. Wherever you are on your motherhood journey or on your photography journey, you are witnessing childhood every day, no matter how old (or young) your child or children might be. This is it. Their beginning. Your beginning. Approach it this way, and you won't get frustrated or disappointed with what you have or haven't done, or how much your children have already grown.

Today is a new day, a bright new beginning where motherhood and photography can intersect to create a rich tapestry of visual stories. Stories that speak of the childhood of our children and the journey of our motherhood. Where the focus is equally dispersed between joy and struggle, laughter and tears, ordinary and extraordinary. Where we can use our lenses to creatively express ourselves as women who know that this journey we are on is worth documenting each and every step of the way. As we travel this path, we are collecting the pieces and parts of what will become our family history. Our photographs will help shape and influence the way our lives are remembered.

As you move forward from here, consider this: you are creating a legacy for your children. Not just of photographs, but a way of seeing and being in the world. As you identify your life—their life—as beautiful, meaningful, and worthy of attention, celebration, and documentation, you encourage them to do the same. I can think of no better reason to elevate the everyday.

My Wish (Above)

In using your lens to elevate the everyday, it is my wish that you find more beauty and joy in your daily life. There is nothing more important than all of the little miracles that make up life with your family.

Every Detail (Above Left)

The stories of us and of our children can be captured with signs, symbols, and the smallest of details—like the pink nail polish in this shot. Along with the butterfly, the chipping polish reminds me that time that passes so quickly and that every moment matters.

2
CAMERA

I AM NOT AT ALL A TECHIE. I'M NOT
A GADGET GIRL OR A GEARHEAD EITHER.
I AM, AND ALWAYS HAVE BEEN, A GAL
WITH A CAMERA WHO IS WILLING TO
GO WITH HER INTUITION, AND SHOOT
WHATEVER, WHENEVER A PHOTO-WORTHY
MOMENT OCCURS. TRUTHFULLY, I DON'T
REALLY KNOW THE HALF OF WHAT MY
DIGITAL CAMERA IS CAPABLE OF.

I cling to this personal philosophy: I only know what I need to know and when I need to know more, I'll learn it then. I'm not sure if this is what you want to hear from the person encouraging you to take more pictures. Or maybe it is. I'm just hoping it takes a little pressure off.

As much as I try to resist spending too much time on the technical part of photography, I can't avoid it altogether. Our cameras, after all, are what make taking pictures possible for us, so they definitely warrant a chapter in this book. What good is a tool if you don't know how to use it? For most of this chapter I will share information that is relevant for a digital SLR, but if you're using a point-and-shoot camera, some of these points will still apply.

If the settings and dials on your camera are all new to you and you are shooting on all auto all the time, let me be the first to assure you that there is nothing wrong with that! Auto mode was created to make photography easy, and it can do exactly that. However, it doesn't always give you your most creative or best possible shot, so it's always helpful to learn how to override the auto to capture images exactly as you'd like them (instead of leaving it to your camera to decide). It's empowering not to be at the mercy of your camera's auto settings.

I encourage you to take the information in this chapter at your own pace. I know from experience that tackling too much tech at once—when all you really want to do is concentrate on shooting—can sometimes cause self-imposed pressure and expectations, pointless frustration, and even creative blocks. Take it from me: when the information clicks, it clicks, and it won't click a minute before that. Learn what you want and need as you want and need it.

If you already have the camera basics down, keep in mind that sometimes hearing it again and in a new way can offer a different understanding. You never know.

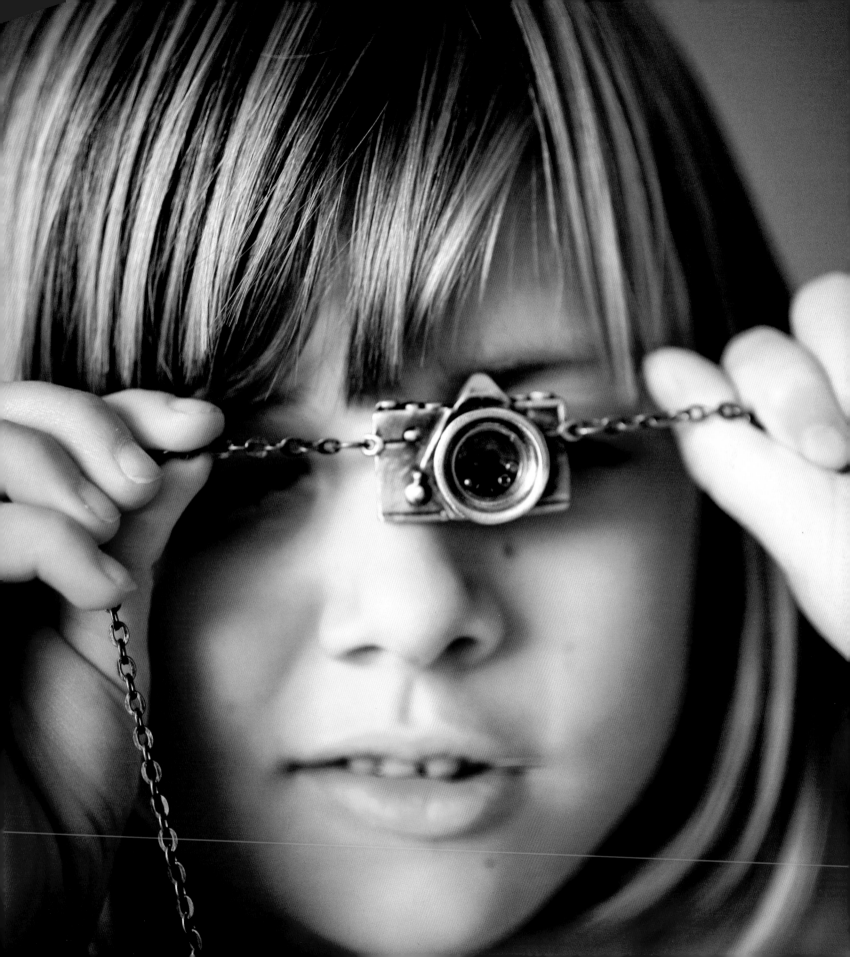

About My Camera

It's easy to get overwhelmed by all the numbers, letters, and dials on your camera. Truth is, many people use the most basic auto settings and rarely waver from them. There is no shame in that, but it can also be a great freedom to decode some of what your camera's settings mean, as you can improve your photography with very simple modifications. In this chapter, I will cover a few things that you'll want to be able to find on your camera. Use the diagrams below to help. I shoot with a Canon, so if you use a different brand of camera, the anatomy of your camera body might be different. Please feel free to use your camera's manual to compare and clarify.

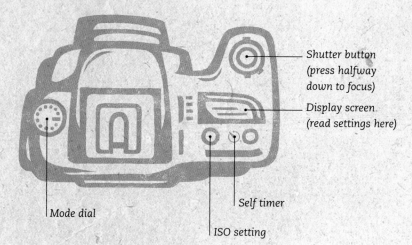

Shutter button
(press halfway
down to focus)

Display screen
(read settings here)

Self timer

ISO setting

Mode dial

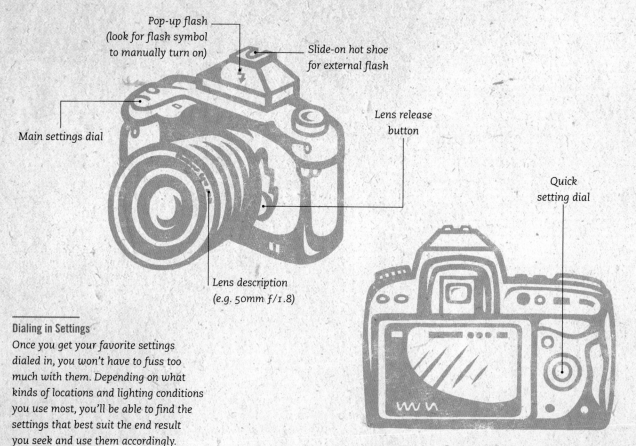

Pop-up flash
(look for flash symbol
to manually turn on)

Slide-on hot shoe
for external flash

Main settings dial

Lens release
button

Quick
setting dial

Lens description
(e.g. 50mm f/1.8)

Dialing in Settings

Once you get your favorite settings dialed in, you won't have to fuss too much with them. Depending on what kinds of locations and lighting conditions you use most, you'll be able to find the settings that best suit the end result you seek and use them accordingly.

FOCUS

Although learning how to focus your camera might not seem like something that needs to be taught, I have learned otherwise. When you push your shutter button to take a picture, your camera does a few things all at just about the same time. It decides on the exposure, it locks in the focal point, and it releases the shutter.

The camera does its best to choose the proper exposure for your setting, but it will usually only focus on what is right in the center of your viewfinder (or wherever you have your auto focus sensor set).

Try pushing the shutter button halfway down. You should hear the focus lock into place with a beep, and see the red box on the viewfinder light up. Now, when you finish pushing the shutter down, you've taken the picture. The freedom comes from knowing that you can lock the focus on whatever you'd like (keeping your finger only halfway down), and then recompose the shot putting the focal point anywhere you'd like in the frame. That point of focus is often called the "sweet spot." Look for some more creative ways to use focal freedom in the next chapter.

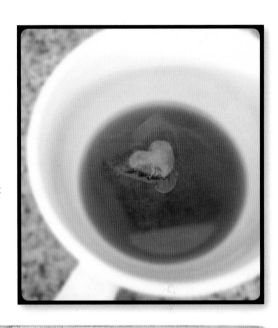

The Heart of the Matter (Top Right)
There are some delights in life that you could have never anticipated. In this shot, the heart in the teabag, a pure chance happening, tells the story. The mug offers context and didn't need to be in focus.

Intricacies (Right)
Surrounding the tiny teacup (the focal point) with my daughter's dress-up clothes enhances the story behind this shot. The soft blur of the background further emphasizes the focal point, while her hands provide context as to the scale of the teacup.

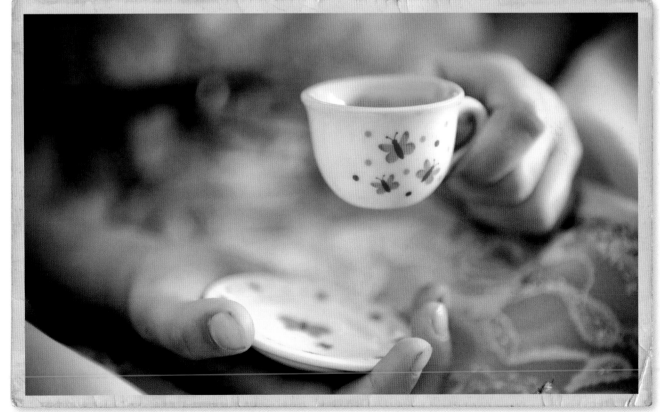

SIMPLE SETTINGS

Beyond following your heart and your intuition as you shoot, there are some key elements of photography that, once learned, will help you get your desired photographic results. These are the aspects of photography that are managed by the buttons and dials on your camera.

ISO

The thought of adjusting your camera's ISO might seem intimidating at first. Most people don't want to change a camera setting for fear of not knowing why or how to change it back. After reading this chapter, I hope any fear you may have dissipates.

The ISO of digital cameras measures the sensitivity of the image sensor, or, to put it another way, how your camera will react to light. The lower the number of your ISO (e.g. 100), the less sensitive your camera is to light and the finer the grain of your shot will be. Remember if a setting makes your camera less sensitive to light, you will need to provide more of it (as in bright sunlight or flash). The higher the number of your ISO (e.g. 1600) the more sensitive your sensor is to light, which makes it easier to shoot in low-light settings. Many people are afraid to use a higher ISO, but ISO is meant to be changed. Different lighting conditions call for different ISO settings.

Experimentation (Below)

As you begin to learn how to better use your camera, be patient. Understand that it is a process of trial and error, and allow time for it all to click in your head. Also remember that although some rules will work to your advantage, others are equally effective when broken. Shooting into the sun, for example, was on the list of "don'ts" until people began celebrating the effect of lens flare. You will never know what works best for you until you try.

You often hear people complain about "noise" when using a higher ISO. What does this mean? Noise looks similar to film grain in its best state—you know when the grain in an old black-and-white photograph stirs up a kind of nostalgia? Unfortunately, it's not always the effect you want. Even so, don't let your fear of noise keep you away from experimenting with ISO, as it can help make near-impossible shooting conditions possible—especially if you don't use or have a flash or don't like the results you get from your automatic flash. Plus, with every new model of camera, the trace of high ISO noise becomes less and less noticeable. You can change your ISO from shot to shot without repercussions, so don't be afraid to go up and down depending on the situation. If you don't want to bother with ISO now, chances are your camera can do it for you. Newer model cameras offer an auto ISO option. Look it up in your camera's manual.

APERTURE OR F-STOP

One of the most commonly asked questions I hear is "How do I get my subject in focus while keeping the background blurry?" How much of your shot is in focus is determined by your depth of field—the range of distance in your image that appears in focus. This highly desirable blurry background effect is achieved by using a shallow depth of field. The opposite of a shallow depth of field would be a deep depth of field (where everything from foreground to background is in focus). People often use a deep depth of field for landscapes or moving targets (so as not to risk parts of the frame being out of sharp focus).

Depth of field is controlled by your camera's aperture, or ƒ-stop. Once you demystify the concept of depth of field, your images will improve dramatically, and all it takes is manipulating one simple setting. You can choose a mode that's part auto and part manual to make it easy to control aperture. I'll talk more about this later in this chapter.

In a nutshell, the wider your aperture, the more shallow your depth of field. Your aperture will open up wider and wider the lower your ƒ-stop number is until you reach ƒ/1.4, which is "wide open." If you take some time to shoot the same subject at different ƒ-stops, you will better understand how each "stop" along your dial will change the result. Remember, the lower your number, the shallower your depth of field and the more background that will be out of focus, which makes your focal point (the sweet spot) the main "focus" of your image.

Dim Light (Below)

A shot taken in low light, like this reflection taken in my bathroom mirror, needed a higher ISO. Before I took the shot, I opened the blinds and turned on the light to give me as much light as possible in this usually dimly lit room of the house.

Sweet Spot (Right)

The sweet spot in this image is the tiny flower. With the aperture set to ƒ/2.8, the background (the little girl and beyond) goes into a softer focus than the main focus of the shot. As you look to capture the feel of a stolen, wistful moment in time, shallow depth of field can be just what you need. Something would be lost if everything was in focus here. The dreamy quality enhances the feeling of the innocence of childhood.

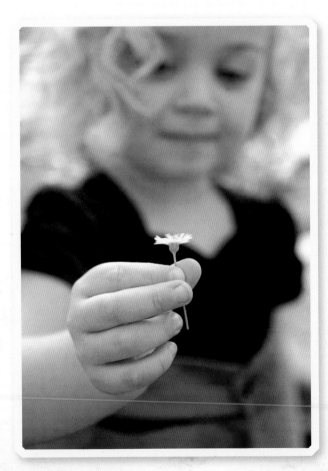

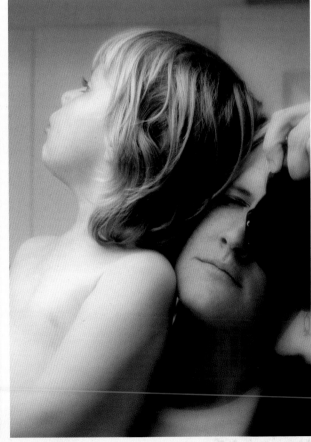

SIMPLE SETTINGS

As mentioned before, to shoot with the shallowest depth of field, you must set your aperture to its lowest possible number.

Although this is a camera setting you control, it's really your lens that dictates how open your aperture can be. The f-stop of so-called "fast lenses" can go as low (or open as wide) as $f/1.8$. But many "kit lenses" (the standard lens that is often packaged with your camera body when you bought it) won't go lower (or open wider) than $f/3.5$ or even $f/5.6$. It can be frustrating when you're limited by your lenses, especially when you didn't realize that different lenses allow you different options. But never fear. You might not get the dreamiest of blurred effects with a kit lens, but you can still manage to get some background softness. If you're shooting a lens that won't open up wider than $f/3.5$ (or even $f/5.6$), then place your subject even farther away from the background. The farther away your background, the softer (less focused) it becomes. I will share a little more on lenses later in the chapter.

Although depth of field is almost always discussed in the context of a subject in focus with a blurred background, that isn't the only way to use it. When you are shooting at a small f-stop number you only get a very shallow range of focus, which is universal in your shot. It's not just the distant background that will be thrown out of focus—anything in your frame that isn't sitting on the same focal plane as your subject will be blurred.

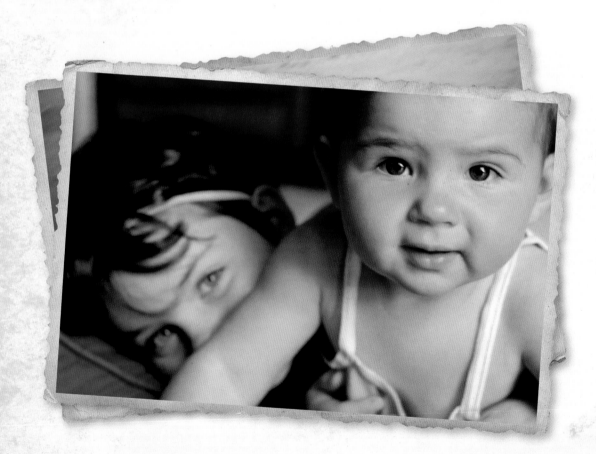

Focal Plane

To better understand focal plane, notice that with a shallow depth of field, the baby is in focus, while her big sister is not. Although she is close behind the baby, she isn't on the same focal plane. Imagine the baby's face pressed up against a window. If her sister had her face against the same window (and it was parallel to my lens glass) then she would have been in focus too. If I wanted both girls in focus I would have set my aperture to a higher number ($f/5.6$ or $f/8$) for a deeper depth of field. My intention here was to focus on the baby, as she's the primary subject, but had I not planned it that way, I may have been disappointed. This is a good case for learning more about your settings.

SHUTTER SPEED

Shutter speed is the speed with which your camera's shutter opens and closes. Remember, your camera needs a specific amount of light to expose your image properly. It makes sense that when there is a lot of light (bright sun or lots of natural light available), your shutter only has to open and close quickly (a higher number on your dial). In this case, you won't usually have trouble with blur, because the fast shutter speed freezes the action in its brief click. The slower your shutter speed (the lower the number on your dial) the longer your shutter is open and the more chance there is for blur. Blur can be awesome when that's the artistic effect you're after, but it can be maddening when it's not. As you get to know your camera, you can almost hear when the shutter is opening and closing too slowly to handhold your camera, and you'll know by seeing the blur in the image. This is why some people choose to use tripods in lower-light situations. As a mother, however, I have never opted for a tripod while shooting photos of my everyday life. To be honest, I have learned to embrace the blur. I feel it's pretty appropriate much of the time.

On the contrary, shooting with a fast shutter speed can be a mother's best setting. Moving targets like very active children can be challenging to shoot, so getting familiar with varying shutter speeds is well worth the effort. When using a creative tool, learning how to get a desired result deliberately—and not just by accident—is very empowering and useful!

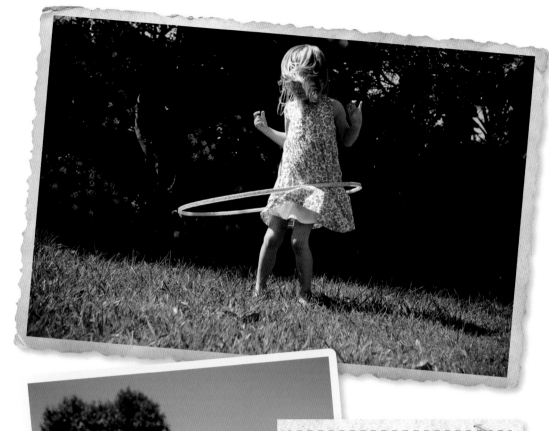

 For stopped action shots— moments frozen in time with no blur—your shutter speed needs to be fast enough to capture the moment quickly. The exact number will depend on how fast your action is. Jumping into a pool or hula-hooping can be caught by setting your shutter speed to 1000 or higher. Because this shot was taken in the bright sun, with plenty of light, I didn't have to even consider the shutter speed. I knew even if I used manual mode it would be fast enough on auto to freeze the action. A lot of light automatically means a fast shutter speed for proper exposure when you're in auto (or partial auto) mode.

SIMPLE SETTINGS

When you consider that the settings of ISO, aperture, and shutter speed all affect the amount of light your image gets, it makes sense that you can't change one of the three without it affecting the others. There are ways to set your camera to compensate for you as you tackle one concept at a time. It's important to remember that they all work together to give you the best exposure for your shot.

PART AUTO, PART MANUAL

When it comes to auto versus manual mode, you might be happy to know that it doesn't have to be one or the other. It can be a little of both! By understanding what options your camera offers, you can learn various ways to achieve your desired results with relatively basic technical ease.

AV OR A MODE

My favorite way to shoot is having my camera set to Aperture Priority. Most camera models refer to that as either AV mode or A mode. AV actually stands for Aperture Value, but no one calls it that. Above all else, I like full control over my depth of field, and Aperture Priority mode allows me to only concentrate on that while it sets my shutter speed for me, in order to compensate for my aperture choice. One part manual (I set my aperture), one part auto (the camera picks my shutter speed). Note: In this mode, I usually control my own ISO, but auto ISO is a fine choice if you want to use it.

When I am shooting for a sweet spot and want the rest of the image blurred (background or foreground) I know that I want my f-stop wide open (which on the dial will be the lowest number). I set it accordingly in AV mode and the shutter speed does what it needs to do to expose my image properly and automatically.

It works the same way if you want a deeper depth of field. If you have a shot where you want your background in focus as well as your subject, you up the number of the f-stop, like $f/8$ for instance (which allows less light in, but offers a greater range of focus in the shot). My shutter speed will adjust itself accordingly.

TV OR S MODE

TV or S mode is the Shutter Priority mode, where you set your shutter speed manually, and your aperture is set automatically so you don't have to think about it. TV actually stands for Time Value, but again, no one calls it that. Note: Again, the ISO can either be set manually or set to auto (if your camera offers an ISO auto option).

When I shoot in a low-light setting, I will often shoot in TV mode so I can be sure that I can hold my camera without worrying about blur from shake. The less light you have available, the slower your shutter speed will be (the shutter needs to stay open long enough to get enough light to expose your image). If you set it manually at a number like 1/60 then you'll likely be able to capture your shot without blur from your own movement. But you need to be very still, even bracing yourself on a tabletop or pulling your arms in close to your body as you click the shutter to minimize shake. I can't promise you won't get any movement, though. If your subject is running across the living room and your shutter speed is set at 60, they will likely be a blur. It's just not fast enough to stop that action.

AUTO ISO

What about the ISO in these half-and-half modes? Some cameras allow for auto ISO, which is very helpful and leaves the guesswork out of it, but if you need to choose your own ISO (either because your camera doesn't offer an auto ISO or you want to set it yourself), then you can do that before or after your other settings of choice are dialed in. In bright light, use 100 ISO; in low light, 400–800+ ISO. If you don't have an auto option or you don't want to even think about it, set it to 200 or 400; these are both adequate for lots of different shooting conditions.

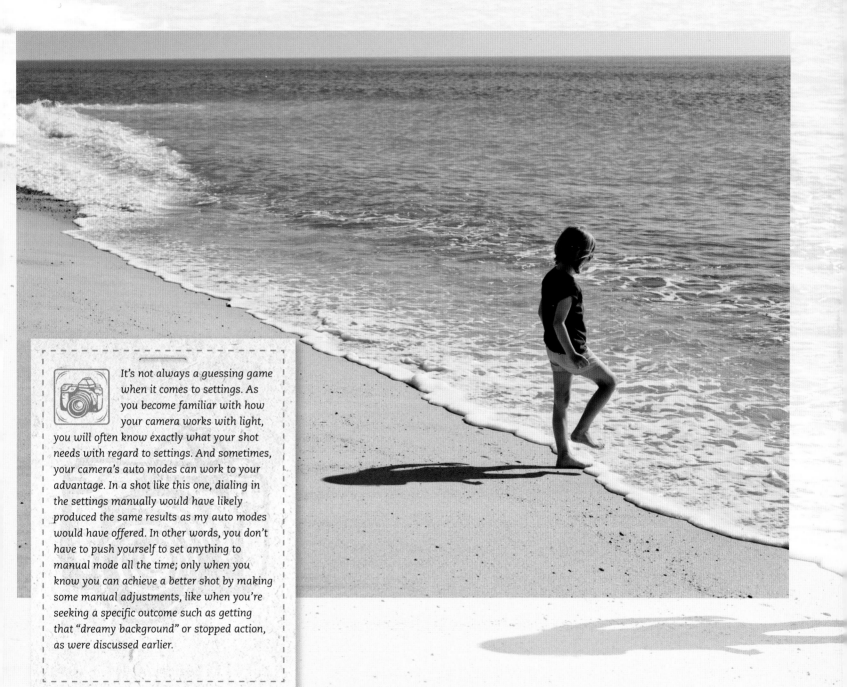

It's not always a guessing game when it comes to settings. As you become familiar with how your camera works with light, you will often know exactly what your shot needs with regard to settings. And sometimes, your camera's auto modes can work to your advantage. In a shot like this one, dialing in the settings manually would have likely produced the same results as my auto modes would have offered. In other words, you don't have to push yourself to set anything to manual mode all the time; only when you know you can achieve a better shot by making some manual adjustments, like when you're seeking a specific outcome such as getting that "dreamy background" or stopped action, as were discussed earlier.

USING YOUR FLASH

Another element of your camera that is important to learn how to control is your flash. Even in auto mode(s) you can almost always find a way to override the setting that automatically fires it. Quite often, by using the settings I've already mentioned, you won't even need to use a flash, even when you're shooting indoors, so learning how to turn it off when you don't need it is imperative.

Don't be fooled by your auto settings when it comes to your flash. It might pop up and fire, but that doesn't really mean you need it. If you learn how to turn your flash off and play with your other settings, you will likely be thrilled with your results. With digital camera technology progressing as it is, newer model cameras offer really high ISO with less noise repercussions as I mentioned earlier. When that's the case, you can shoot in lower-light scenarios without a flash and still get a great exposure. For my everyday photography, I eke out as much natural or ambient light as I can and I'm usually satisfied with the results. I encourage you to find what works for you.

Although it's not my first choice, there are times when a flash is necessary for proper exposure. When I shot events full time, I had to use a flash for a lot of my work (wedding receptions, for example). There are all kinds of ways to use your flash to its best ability. Learning how to turn your camera's pop-up flash on and off at will is a first step. It is also helpful to know is that you can get a little more "ambient light" in your flash images by slowing your shutter speed down enough to let some extra light in. This cuts down on the drastic (and usually unwanted) black backgrounds that you get when your flash illuminates (or, more accurately, blasts) your subject without ever making it to the background.

Another trick of the trade is to use a thin piece of tissue over your flash to diffuse the light and get it to spread out a little bit over your entire scene. There is some experimentation involved, but it's worth it when you get your desired results. Using this trick helps you to get more even light when shooting, for example, a group of family and friends at a nighttime gathering.

Every once in a while an opportunity may arise where you might want to use your flash outside in the bright sun. This is a technique called "fill flash" and it is used to fill in the dark, harsh shadows that are cast by bright sun (usually on someone's face). Your camera won't usually pop up your flash in the daylight, so you'll have to turn it on manually to fill flash your subject.

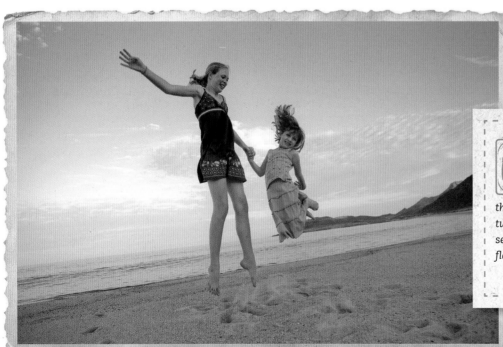

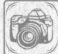

For this jumping shot, I knew that a little "pop" of light from my flash would help fill in any shadows from my daughter's faces as well as help freeze the action of the jump in motion. I had to be sure to turn my flash on manually; I knew that in this well-lit setting, my camera would have never popped up the flash automatically.

LENSES

If there is any one tool that can influence and impact your photographic work, it is your lens. No one tells you that when you are buying a camera. The body of your camera is important (obviously), but your lens is actually what affords you many artistic freedoms (at least the good ones do).

When learning the ins and outs of something like shallow depth of field, for instance, not all lenses will allow you to shoot "wide open" as I mentioned before. You need a "fast lens" for that. Not all lenses let you get up really really close to your subjects either—you need a macro lens for that. Not all lenses will let you zoom in on the basketball court or football or soccer field—you'll need a telephoto lens for that.

I can't tell you what kind of lens you'll need or enjoy most. Everyone has different interests, needs, and styles. I can tell you that you can ask for help: research online, talk to the staff at your local camera store (they are invaluable), or even rent lenses to try before you buy. I just encourage you to experiment, play, and invest in a good lens for yourself. You're worth it.

Decisions, Decisions

Lenses come in all shapes, sizes, weights and prices. Gathering up a small (or large) arsenal of lenses is something you can do over time. As your skills develop you may find yourself wanting or even needing a variety of lenses to fit your photographic needs.

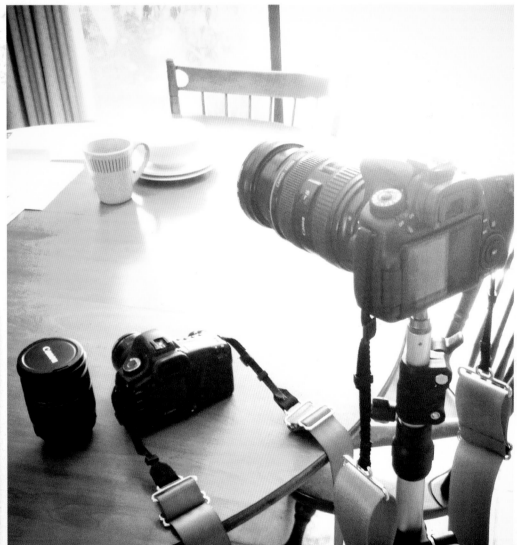

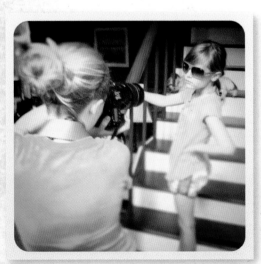

RESULTS

As you test and try out these settings, hints, and tricks, keep in mind that they will all yield different results that can benefit your everyday images. Be mindful of the feeling you want to evoke and the moment you want to capture, and it will likely help you decide what settings you want to focus on.

It can take time and concentration as you are learning some of these things, but the more you shoot and aren't afraid to tweak your camera settings, the quicker it will become second nature. As you play with the dials, and get more comfortable with your camera and its accessories, you are learning how to use a very powerful (and fun) creative tool to your advantage. It's worth the extra work to have that kind of artistic control and freedom as you capture your images!

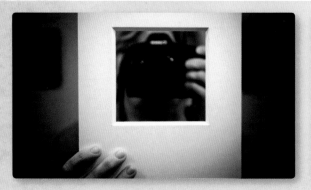

Knowledge is Power (All)
The more knowledge you have, the more comfortable you will be with your camera, and the easier it will be to unleash your creativity.

MOBILE PHONE CAMERAS

Since some of the images in this book were shot with my iPhone, I also need to address the art, ease, and joy of mobile phone photography. It's becoming such a mainstream way of taking photos of our everyday lives that, chances are, even if you have an SLR you will shoot at least some images with your cell phone.

Although it's a fairly new creative muse for me, I can tell you that it takes a lot of the thought out of photography. With a gadget that small and with so few options before you click, it makes it really easy to just point and shoot. However, pointing and shooting can be the exact mindset you want to get out of when you are trying to shoot visually compelling pictures. Although the freedom of the medium is at an all-time high with mobile phone cameras, you can still use all the creative ideas from this book to elevate your mobile phone photography. You're just taking the complication out of it. And that is perfectly fine with me!

Convenient Creativity (All)
Because you likely always have your phone with you, take advantage of small pauses in your day to exercise photographic creativity by using it to capture snippets of daily life. From life at home to your routine out and about, your camera phone can prove to be an invaluable tool for documentation.

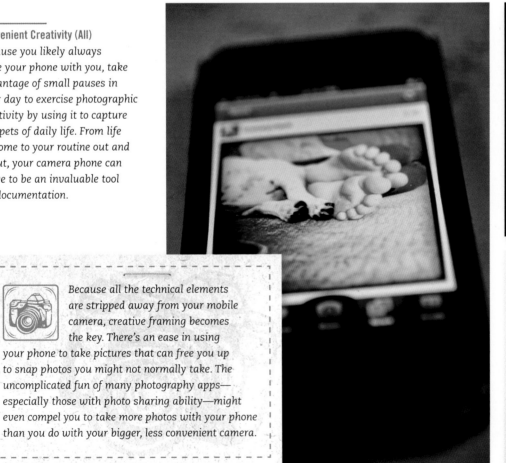

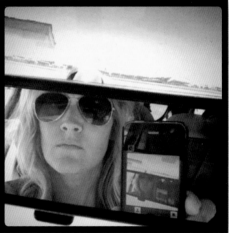

Because all the technical elements are stripped away from your mobile camera, creative framing becomes the key. There's an ease in using your phone to take pictures that can free you up to snap photos you might not normally take. The uncomplicated fun of many photography apps— especially those with photo sharing ability—might even compel you to take more photos with your phone than you do with your bigger, less convenient camera.

3

COMPOSITION & CREATIVITY

LEARNING THE ELEMENTS OF COMPOSITION CAN BE AS IMPORTANT AS LEARNING HOW TO USE YOUR CAMERA—A BASIC UNDERSTANDING OF COMPOSITION WILL HELP ELEVATE YOUR EVERYDAY PHOTOGRAPHY FROM SNAPSHOTS TO WORKS OF ART.

Composition, simply defined, is the arrangement of visual elements. Traditionally, composition does not take into account subject matter or emotional expression. However, for the kind of photography we as mothers create, it can seem difficult and even unnecessary to separate them. As in the *Camera* chapter, I am offering this information for you to use on your own time. I will give you a lot of guidance on how to better compose your photographs, as well as tips and tricks for how to exercise your creativity, but you need to know this about me: I believe that shooting from the heart is what matters most. I would never try to persuade you otherwise. Above all else, I want you to enjoy the process of shooting, playing, exploring, creating, documenting, expressing, and celebrating your life, as woman, a photographer, and a mother. It's as simple as that.

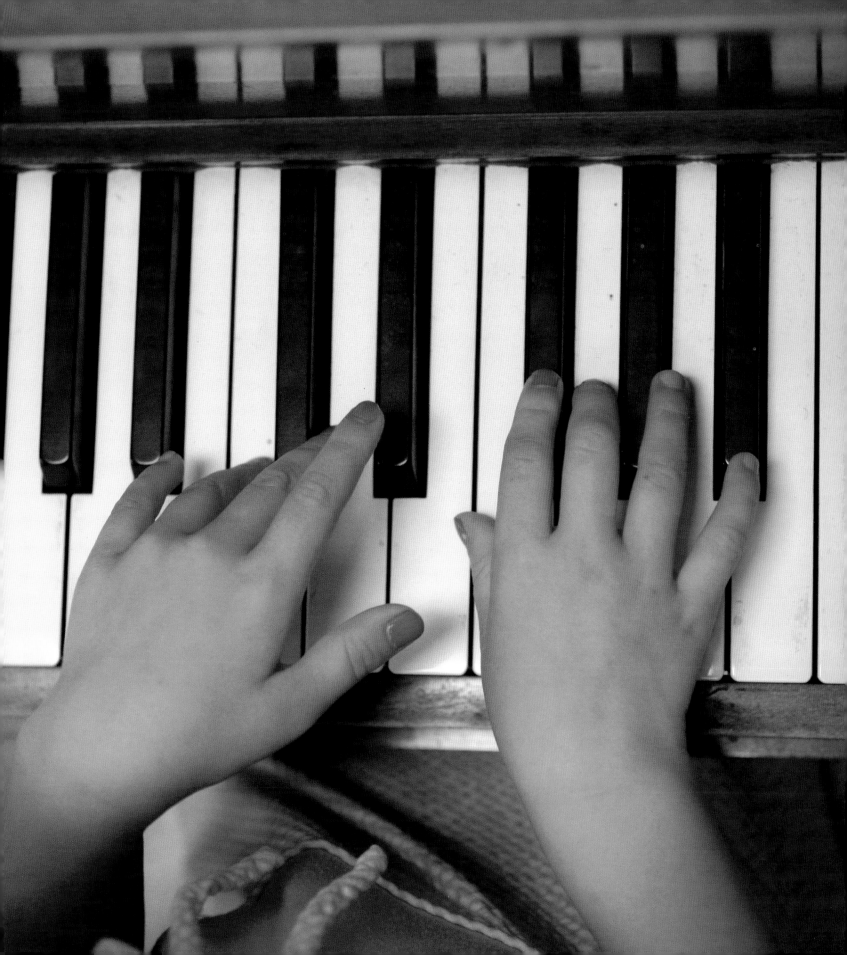

FRAMING & SPACE

As you look through your viewfinder, consider what you see to be your canvas. Everything within that frame (or on your canvas) plays a part in the overall shot.

Taking this approach can help you to pay closer attention to what you are including (besides your main subject matter) and how you are arranging all of it within your image. Being more deliberate with the various elements in your frame will improve your work tremendously. When we approach our photography like this, we become photographic artists and our work reflects that. As you decide what to include in your photographic frame, you must choose whether to fill your frame with subject matter or keep it sparse and simple. Just because you've got a lot going on in your everyday life doesn't mean every photo has to include it all. Sometimes keeping it simple can make for the most effective shots—shots that distill a specific moment and focus on exactly what matters most. It can be as simple as changing your angle or perspective as you frame your shot, and it's another way to get out of snapshot mode while tapping into your creativity.

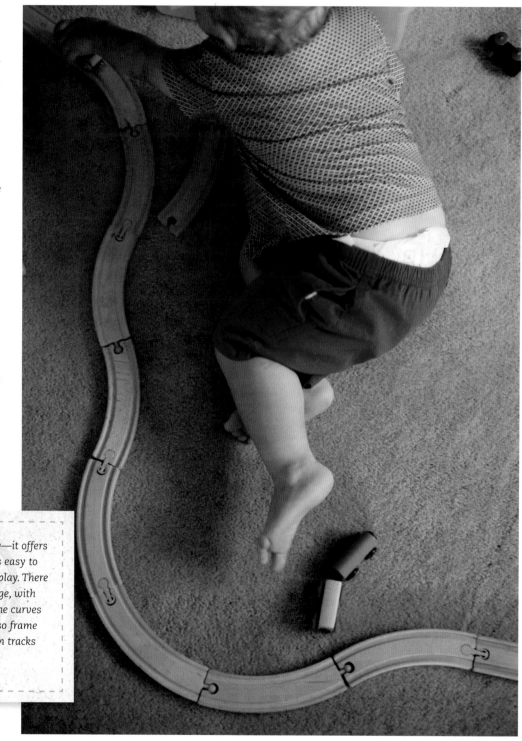

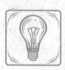 *Try shooting from a bird's eye view—it offers an unexpected perspective. And it's easy to do when your kids are engaged in play. There is a nice feel of balance in this image, with equal parts positive space and negative space. The curves of the track divide the space wonderfully, and also frame the main subject of the baby. Notice how the train tracks also lead your eye through the frame.*

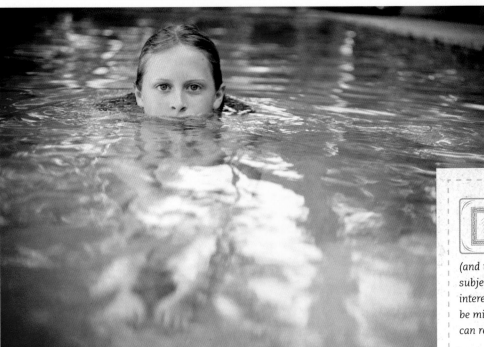

Usually the shapes within our images are quite simply defined by our subject matter—the round shape of our child's head or the square shape of the cereal box, for example. Once you begin to identify the shapes within your frame, it's then time to decide how to place those shapes. Dividing your frame up using the subject matter can then create other shapes in the frame.

Placing your subject off to one side or the other, instead of the middle of the frame, can yield artistic results. There's much more negative space than positive in this image (and that negative space is off to one side because the subject is off to the other side), which helps adds visual interest. Framing shots like this is something you have to be mindful of, but being this deliberate in how you shoot can really help improve your work.

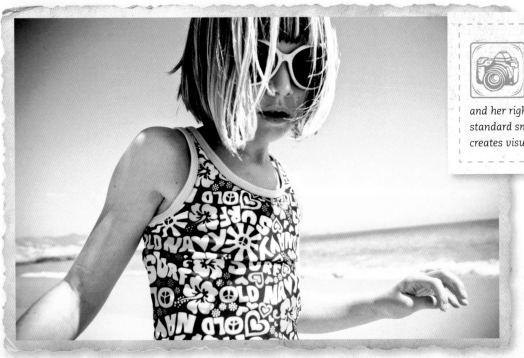

The way my daughter is framed in this beach shot divides the frame up into a number of different interesting shapes. Cropping her in this way (at the top of her head, her waist, and her right arm) creates an artful image rather than a standard snapshot. The diagonal of the horizon line also creates visual interest.

The main subject of your image usually defines the positive space while the other parts (the background, for example) are considered the negative space. Being mindful of both the positive space and the negative space and how they work together can improve your overall image. Often the way you know if they are working well together is a simple gut instinct. We often know what works just in how we react to or feel about an image.

NO ORDINARY HEADSHOT

I worked as a professional family photographer for years, and throughout that time, the classic headshot was the bread and butter of my business.

Year after year, mothers brought their children to the studio with their hearts set on getting the one head-and-shoulders shot that represented their child, something that truly captured them above and beyond their annual school picture. I recall working with the kids, coaxing out expressions and gestures that were uniquely theirs, and snapping away in hopes of catching a short story of exactly where each child was, in age, in look, and in personality. It was challenging and rewarding. After every session, after all the pictures I took, the headshot was always the one that the mothers wanted most. I remember wondering why. Why not any of the other shots I took? Like the beautiful poetry of the swirl of hair on top of a child's head or the bare feet and chubby legs? That was before I became a mother. When you want a quintessential portrait, it's usually of their face.

I enjoy shooting a variety of shots of my own children, but now I can totally relate to the love of the headshot. I cherish every detail, of course: their profiles, their backs, their arms and legs, fingers, and toes, and all the other parts that make up who they are. But there is something about a perfect headshot that gets me every time. Well lit, bright eyes, and a telling expression. What's not to love?

Unexpected
Although I had my camera poised and ready, I didn't prompt my daughter in this shot. Instead, I asked her about her day at a party where she got her face painted. By letting her express herself, I captured a moment (and a headshot) that is perfectly "her."

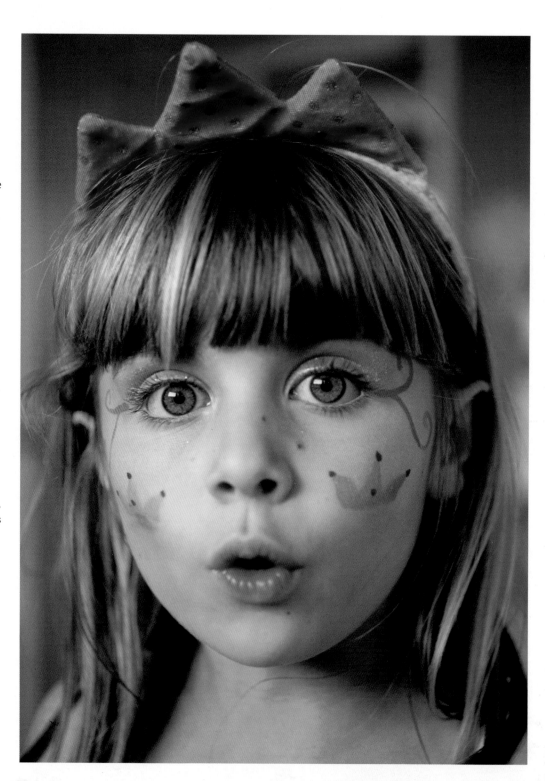

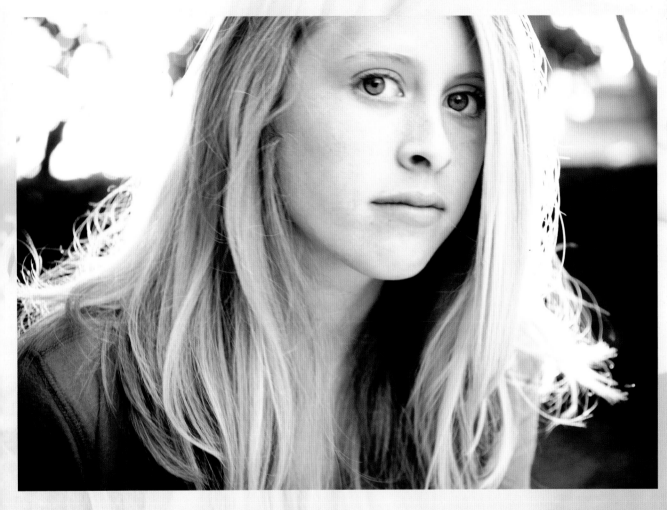

All Eyes
The success of a headshot often lies in the eyes. Light, expression, and soul: my daughter's eyes in this shot reveal much more than her smile ever could. This portrait is a shining example of how taking a different approach can yield captivating results.

The secret to a great headshot goes beyond just the head and shoulders, however. There are a number of ways to put a spin on traditional types of portraits of our kids without them looking too traditional or static. Infusing your everyday portraits with creative composition and the magic of authenticity will keep your photographs genuine and fresh.

Perhaps the most important way to create works of art with your portraiture is to consider how you frame your subject. Old-school headshots can resemble the classic school photo pictures we know and (don't always) love. That's partially because of the formula used—everyone is meant to look a certain way.

Same pose, same lighting, same space around the head, and same crop at the bottom. Head, shoulders, and forced smile. Once you start mixing up those variables, your chances for a stellar shot increase.

Even when going for a quintessential headshot, take into consideration your child's natural way of being. Let them relax into what it is they are doing or how they are comfortable before you go in for the shot. Normally, you might think of getting your subject in the right position before shooting, but if you work with your child and allow them to take the lead, the images you will capture will feel 100 percent "them," and that's exactly what every mother

is after. The more comfortable the child is, the more relaxed and natural they will come across in the portrait. The beauty of working with your children in a more comfortable state is that by default you'll stumble across better compositional options. Using the shapes, curves, and gestures of your kids' bodies in any shot of them (headshot included) will often present the most artistic of possibilities. Your child's natural state will yield the best chance at creating an effectively composed shot and also up your changes of an expressive and compelling shot of your child. It can be a really good idea to sneak up on kids for these kinds of shots!

NO ORDINARY HEADSHOT

As mothers we know exactly how to get our kids to smile authentically, and yet I often hear moms urging their kids to "say cheese" which, ironically enough, is the one way not to get your children to feel free enough to be themselves.

I know the inevitable snapshot or strained expression is a fact of life; you can't get a perfect expression every time. But you can learn to be more at ease, which will also put your kids at ease with you documenting everyday life. The more used to your camera your kids are, the more comfortable they are with being themselves when the camera's clicking.

Uninterrupted (Below)

As my daughter skipped around the yard, I grabbed my camera to capture her being her charismatic, expressive self. I allowed her to move about without asking her to stop or slow down. When I found the light I wanted for the shot, I asked her to look over at me, if only for a second. That moment was all it took.

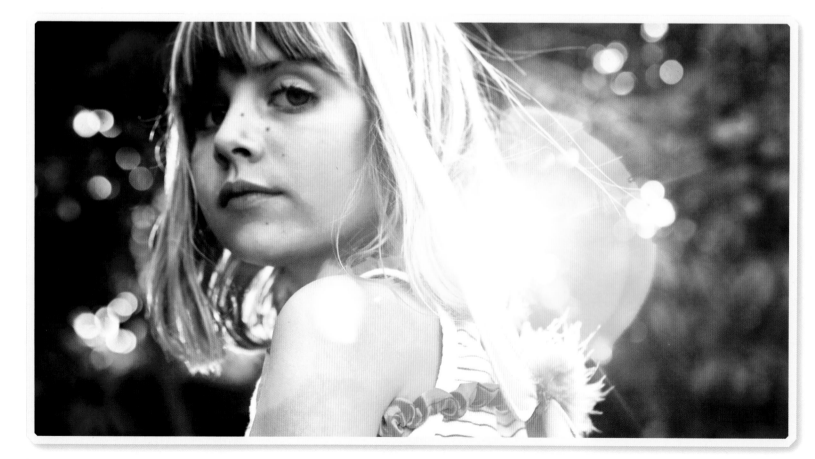

Blog Entry

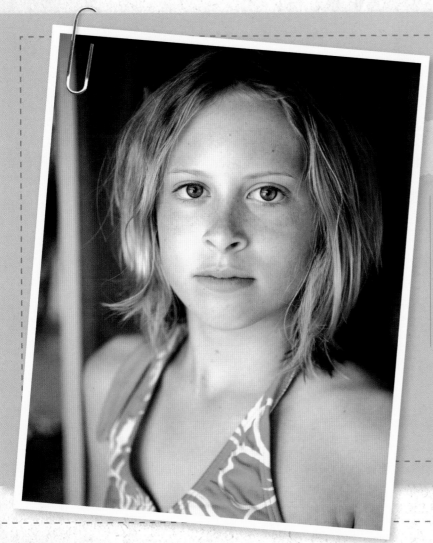

A Word on Summer

Words and image
Tracey Clark
www.traceyclark.com

I have volumes to say about this image. About how each time I look at it my heart skips a beat. About how sometimes it feels like a dream that my daughters are growing up so fast and so beautiful. But, the words don't really do it. I can't really articulate it clearly, how I feel when gaze at this long-legged, funny, creative, bright, compassionate, gorgeous human being. How can it be that she, my very first baby, has become this amazing (big) person? So, even though there might be words . . . sometimes words don't say enough. The photo says it all.

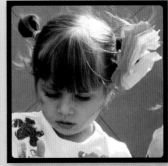

LIGHT

I can think of no more important topic to discuss when it comes to photography than light. Without it, there would be no photography.

To get the exposure you need, you need the right amount of light, this is true, but that is only the beginning. Light defines everything in our frames, and learning how to best use it will always be of value. Observing light is the best way to start. Study the light in each room of your home at different times of the day. Take note of how it falls on countertops, how it's diffused by window blinds, when it gets soft, and when it's more harsh. Watch how it makes the bathtub glow or totally illuminates the nursery when the curtains go up.

I have been known to let my children nap in the rooms where the light is best, just to get some shots of them sleeping. This is how far it can go. But that is how important light is.

Don't forget, however, that light is what is also used to create shadow. Illuminating an object with light can give it depth, but only where shadow (even a subtle one) comes into play. As you learn to see, use, and even control the light in your everyday environment, you will begin to notice how every nuance of light can be used in your photography to enhance your images.

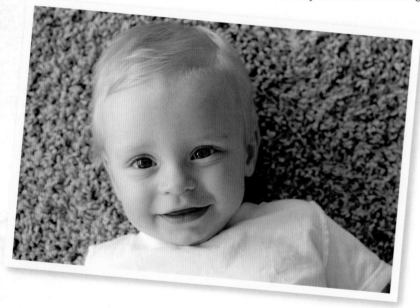

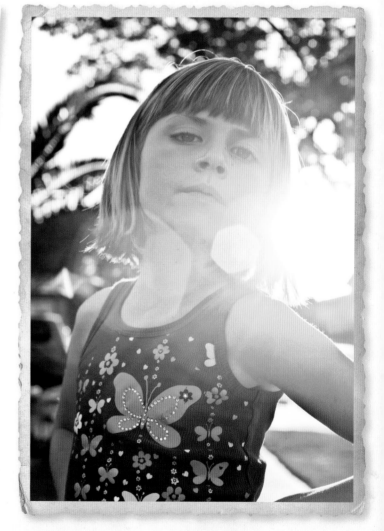

Observing Light (Above)

When shooting pictures of people—your children or otherwise—the catchlights (the lights that provide the twinkle in the eyes) are almost always what you're after. It's the light that brings your subject to life! If you want to really learn about light, pay attention to people's faces and how the light illuminates them (specifically in the eyes and under the eyes). Observe when faces are lit well and when they're not, and notice how subtle movement of your subject in relation to the light can make all the difference.

Shaping Light (Right)

Consider yourself a sculptor, with light being your tool. Take some time to really watch how the light can not only illuminate, but also shape and sculpt your subject. There are a million ways to light up your life, and there's no reason why you can't try to find them all.

FOCUS

Because improving your photography means learning how to control certain settings to get your desired results more consistently, many moms work on mastering a shallow depth of field.

We touched on how that works in the previous chapter. Because this is a creative technique, there are ways (besides merely learning how to get your camera and lens to do it for you) to use your chosen focal point to your advantage.

When making your choice of where to put your focus, remember that your focal point does not have to be in the center of your frame for every shot. This is one of the most misunderstood ideas for beginning photographers. Because we are often introduced to photography through point-and-shoot cameras, we think that once we point and focus, we have to shoot as we see it, as it is. But you have so much more creative freedom than that.

As we discussed in the last chapter, when you point your camera at your subject and you press your shutter button halfway down, you lock the focus on your subject. Keeping your finger on the shutter in the locked focus, you can then make adjustments as to how you choose to frame your subject. After you have "recomposed" your shot, you can then press the shutter the rest of the way down to take the photo. Here's what is great about this: almost every kind of camera has this focal lock ability, even point-and-shoots. Be prepared to have a whole new open world up to you. The sky's the limit!

And if you already know this trick, then your challenge is to be more mindful of where you choose to put your focus. Ask yourself these questions: What is most important in this shot? What story am I trying to tell by using selective focus? Does the choice make the overall shot confusing or clear? Muddled or amazing? Getting the focus to work for you, to bring to light exactly what compelled you to take the shot in the first place, will provide you with both better images and creative satisfaction. This is much easier to experiment with when you're shooting a flower on a windowsill than when you're trying to capture a child in motion. The message stays the same; you just have to be quicker on the creative draw. It takes some time to get good at this, but so does everything worthwhile.

Choosing the Focus

I wanted to capture the scale of these small flowers to express a tender vulnerability. Using a shallow depth of field so that the only thing in focus was the flowers and the space around them, I was able to include a lot of negative space in the bottom of the frame without it taking away from my subject.

STORYTELLING

As we shoot photos of our daily life, we vacillate between wanting to get in close to something as to bring all of our attention to that one particular thing (our children's angelic faces come to mind) and backing off a little to include more context in our images.

When cropping in close, remember to allow yourself the creative freedom to crop out any and all distracting elements that are going on around your child. You can actually reveal something magical about your child that might not have anything to do with the surroundings

of where your photo was taken. When you want to add more context to the story, try to include the background in such a way that it improves the overall shot and reveals something about the moment captured.

What Matters (Right)
Soft light, windswept hair, and a wistful expression were all I saw this late summer day at the park. The playground may have been busy and the play equipment less than photogenic, but as she made her way to the sliding pole she paused for a moment, looking down before she descended. It was as that moment I pressed the shutter. You'd never know what was really going on at the time. All that mattered to me was how she glowed.

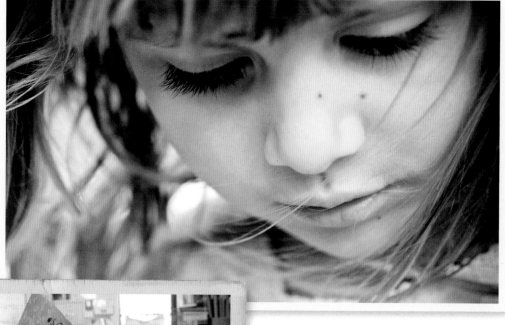

Class Party (Left)
Although my daughter's back is to the camera, the elements that remain still tell the story of her kindergarten class's Halloween party. This kind of visual storytelling can be done effectively by simply including enough of a scene to reveal its meaning and importance.

CROPPED

Sometimes what you leave out of your images is as important as what you leave in. It's your photograph and your artistic vision. What do you want to express?

When it comes to pictures of our children, especially with portraits, we often want to only include what matters most. Don't be afraid to shoot your subject with what you might consider an extreme crop. If you're after capturing facial expression or the details of your child's face, cropping into the top of their head is not only acceptable, it also delivers highly desirable results.

What if it's a detail like a hat or a pair of shoes you're after? The same rule applies. You have permission to crop into your subject in such a way that it brings into better view your desired subject matter and the story you want your images to tell. What's important is your creative intention and your story.

Extreme Crop (Right)

Of all the shots I've captured of my nephew, this has to be my favorite. The extreme and unexpected crop catches his animated expression, but it also brings attention to his fair complexion, the gentle contours of his facial features, and the subtle curves of his mouth.

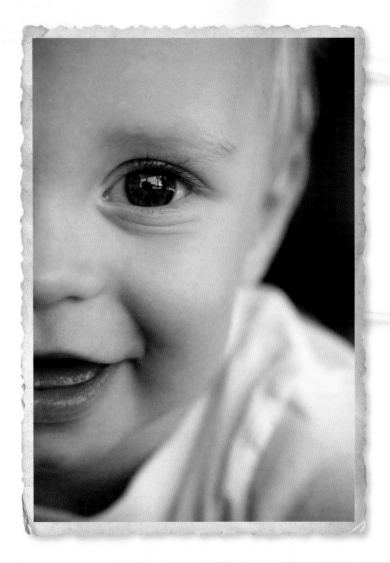

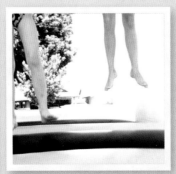

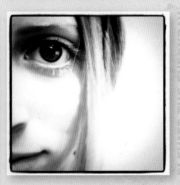

ELEVATE THE EVERYDAY

SQUARING OFF

With the ease and convenience of mobile phone photography (aka iPhoneography) and today's ubiquitous and popular photo apps, the frame of the shot is often a square, rather than a rectangle.

This can be either a refreshing change or a creative challenge. Working within a square format takes the same amount of compositional thought and effort. Just because you're using a point-and-shoot approach with your camera phone doesn't mean you have to revert back to snapshot mode. Using your phone as a creative tool (despite its size and simplicity) is a wonderful way to document the everyday details of your life. It can also be an enjoyable and gratifying means of self-expression and an easy way to share your photography with others!

 Shooting in a square format can take some getting used to. Consider playful experimentation as you learn how to capture the world around you in a square frame. You can either choose to shoot with a square (some mobile phone apps allow for this) or go back to the original rectangular image and crop that into a square— taking a rectangular image first allows you to try a number of square crops before deciding on your favorite. Once you've got the knack, though, you might find shooting through a square viewfinder comes more naturally.

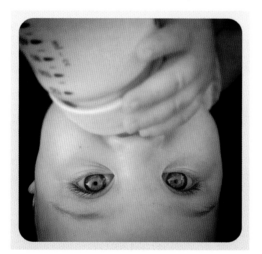

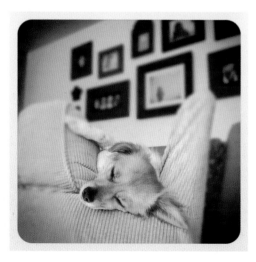

CLOSE UP OR CONTEXT

Although my natural tendency is to zoom into most subjects, if I had to choose between always capturing just the close-ups, or just the context, it would be a difficult decision.

Either Or (Right and Below)
Both of these shots were taken at the beach, but each captures a unique and distinct perspective. The left shot captures the windswept hair of a beach day, while the sand is so out of focus that it's unrecognizable. In contrast, the right shot features enough of the landscape to offer a true context of the moment. Note how these opposite approaches result in pictures that tell different stories.

For as much as the close-up shots melt a mama's heart, backing off a little (or a lot) in order to include the context of the moment can be exactly what it takes to reveal something special. Have you noticed that photojournalists almost always get the context? That's because it's relevant to the story as a whole. With photojournalism, chances are you only get one shot to tell the whole story, so it's got to include everything. Expression, emotion, composition, and context. Luckily, we moms usually get more than one shot. But this is an idea you can use to creatively challenge yourself to tell the whole story with just one image.

My philosophy is pretty simple. Shoot a little of everything. Get right in your child's sweet face and capture that freckly nose. Go wide and capture the whole crib with your tiny baby swaddled inside. Shoot the spilled Cheerios on the floor as the Hot Wheels roll by. The more variety in your photographs, the better the stories they will tell.

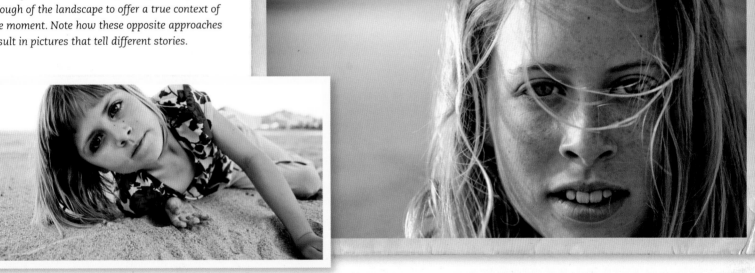

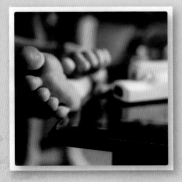

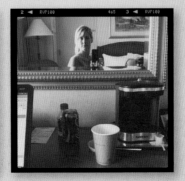

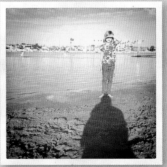

ELEVATE THE EVERYDAY

4
GROWING

AS I CONTEMPLATED THE CONTENT
I WANTED TO SHARE FOR THIS BOOK,
EVERYTHING THAT CAME TO ME FIRST
FELL INTO THE "GROWING" CATEGORY.
ALTHOUGH EXPANSIVE, ELUSIVE, AND
INTANGIBLE, GROWTH IS THE ONE
THING THAT WE LIVE WITH EVERY DAY
OF OUR MOTHERHOOD EXPERIENCE.

Growing bellies, growing babies, growing up. Us, them, together and apart: growing is the one constant. But how does one get hold of a concept, an idea, that is so transitory? The beauty of focusing on the fleeting moments is that it can keep us most in the moment. I think it comes from a deep appreciation and constant knowing that nothing is forever. That our children change by the minute, and that our precious time with them is short-lived.

There are days, however, where this beauty and preciousness feels far from reach. Like when we're in the trenches of intensity, pushed near or past our limits. Overtired, over-touched, over-needed, overboard. We seriously wonder if we'll ever make it through, let alone get past whatever stage or phase of our motherhood that has brought us to the very edge of our capacity. But then, we blink and it's over.

We've moved on, they've moved on. And then we wonder how it was that our children were once so tiny and needy and maddening.

All in all, it's the growing—the curious and mysterious act of this slow transformation—that becomes the heart of our documentation. The hair that goes from fuzz to fluff to wisps to waves. The clumsy, chubby fingers that elongate to become effortlessly fluid. The legs that start out kicking, quickly crawl, then walk and eventually run, skip, twirl, and dance. How can we use our camera to capture the quintessential signs and symbols that mark both the growth of our children and the growth of ourselves?

The answer, just like every experience, isn't completely universal. However, our approach can be. The object here is to distill the tiniest stories of your own life and that of your child or children. What are the things you know you'll miss? What is endearing or enlightening about where your child is right now, and how can you focus your attention and your lens on that visual piece of today's puzzle?

Contemplating these questions helps keep us focused on what's important. They keep us looking through the lens of gratitude and reverie, appreciating this incredible gift of being a mother.

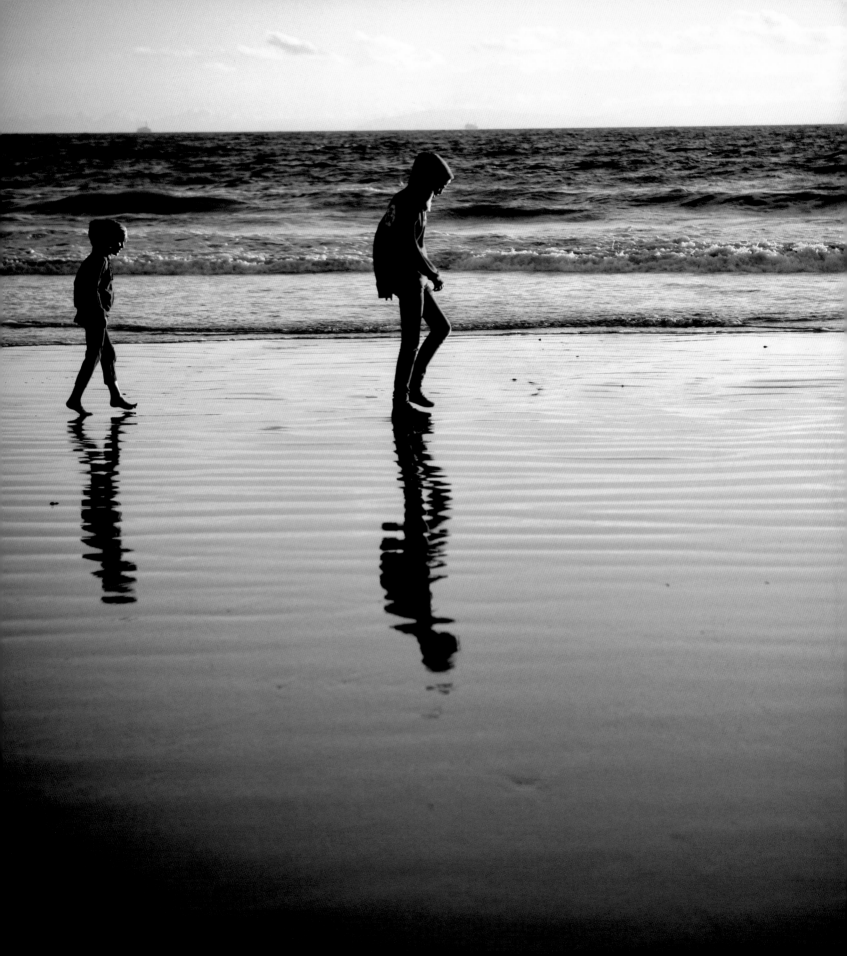

PERSPECTIVE

The way we look at our life is as unique as our life itself. What we notice, what is special, which nuances and vignettes mean the most—these are the things that should be considered when choosing what to capture in our photographs.

To take those things and feature them effectively, you'll need to take on a perspective or point of view that will best accentuate your subject and the feeling you want to convey. Small changes in how you approach your shots can help move you away from merely pointing and shooting and can get you engaged in creatively documenting your life. Challenging yourself to think outside the box can make a big difference.

A Different Angle (Right)

Meeting your subject down on his or her level opens up a whole new way of seeing. Shooting this moment from a different perspective enabled me to highlight how my nephew defied gravity as he held up a book far larger than himself.

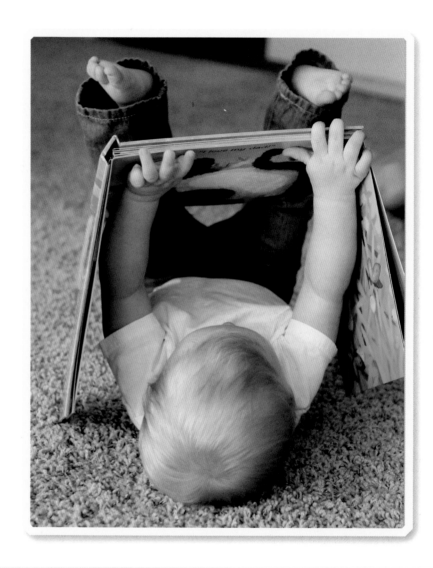

ELEVATE THE EVERYDAY

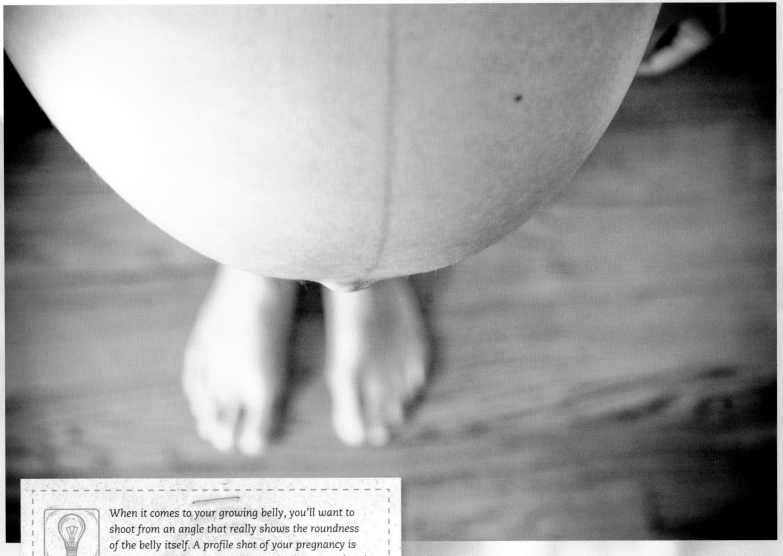

When it comes to your growing belly, you'll want to shoot from an angle that really shows the roundness of the belly itself. A profile shot of your pregnancy is an obvious way to capture your new shape. But shooting down upon or upwards toward your belly can offer a unique and artful angle that gives a larger-than-life feeling—which is quite often exactly how you feel when you're pregnant. You might need the help of a partner or friend with a shot like this, or if you're committed to the self-portrait, a tripod and self-timer can help you capture what you're after. The wider your lens and the closer the distance between your lens and your subject (the belly, in this case), the more emphasized your subject will become.

SIZE & SCALE

To gauge exactly how much your children have grown, it is helpful to call on tools to showcase scale and size.

To translate the moment into something where the size of your child is clearly noted, you can bring in elements of comparative context. These don't necessarily need to be contrived props. Using the elements and object of daily life can make for easily accessible size comparisons and can also give your story a context.

Doorjambs, thresholds, and hallways offer easy to find, simple to use backdrops. If you can capture your child in a shot that's almost floor-to-ceiling, the context of size is unmistakable. The graphic lines of the architecture can also be used to enhance the overall composition of your shot and be used to frame your small subject. The same goes for the inclusion of furniture. Whether it's a child-sized chair or a large couch, the context of child to furniture can be just the reference point you need to better show the scale of your story.

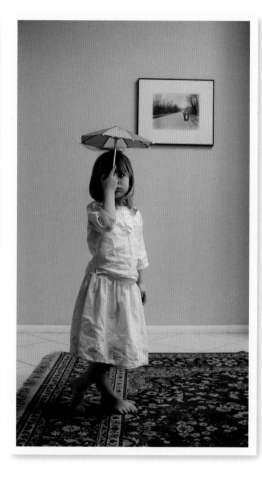

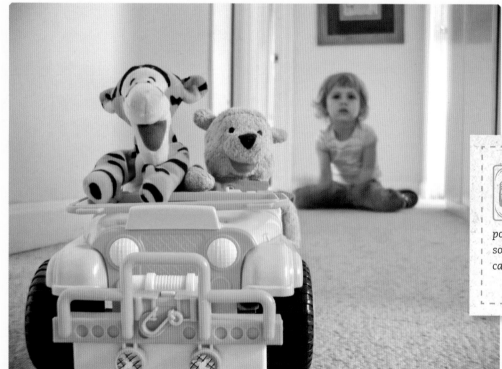

Hallways are often dark and hard to shoot in. In this case, I opened all the blinds in the bedrooms and opened the doors to get as much natural light as possible. I was also shooting at a higher ISO (800) so that I could set my shutter just fast enough to catch the Barbie jeep in action without blur.

Your Story

Including ourselves in the shots of our children's progression is a very important—yet all too often overlooked—part of our lives. Forget the tired eyes, extra pounds, and bad hair days. All that matters is that you are using your camera to bear witness to your being there for and with your kids, cheering them on all the way. Consider unique ways to get yourself in a shot that captures a moment in your life that you want to document. Think outside the box. Include your feet, your hands, your reflection, your shadow. Anything that can bring you into view all the while, wielding the camera. Let's not forget to include ourselves, the person who is taking meticulous notes and paying attention to every growth spurt along the way.

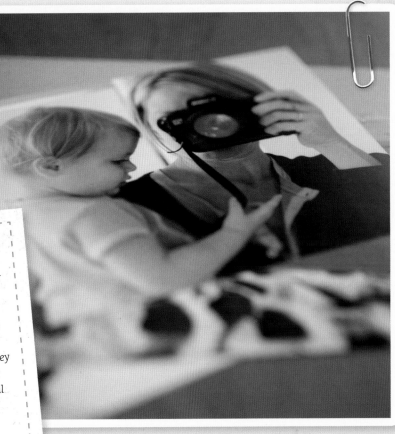

 The mirror can be a photographer mama's best ally. Use your mirror regularly to capture everyday reflections of you and your children—no big occasion needed. Over the years, I have periodically taken reflection portraits of myself and my daughters in our bathroom mirror. As the years have progressed, I have watched their legs slowly extend right out of the bottom of the frame. Now that they are older, I rarely hold them, so these images with them in my arms makes me even more nostalgic and thankful I have images like this to remember these baby days.

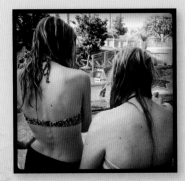
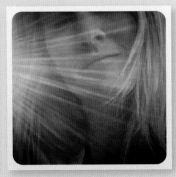

ELEVATE THE EVERYDAY

BABY STEPS

Recognizing the big milestones in our kids' lives is the easy part. We more or less know what to expect and when to expect it.

But what about the baby steps, the smaller, less noted markers in our children's development that are just as important? Like a summer buzz cut or swimming for the first time without floaties? Depending on what we value as mothers and how our kids travel their own path, everyone's smaller events will be different. However, no matter what they are, they certainly merit documentation. Don't let them go uncelebrated by your lens. Every part of the journey matters.

 When approaching a scene that might lend itself to evoking more complex emotions, like the picture on the right, consider how to frame the elements in a way to accentuate the emotions. This kind of visual storytelling takes some creative thinking, but in the end, expressing your feelings through your photography makes for both great images and creative satisfaction.

Deep Blue Sea

Learning to swim is one of those quintessential processes of childhood. In a photograph like this, it's not the actual swimming itself that is featured; it's more a symbolic story of how small my subject is compared to how big the milestone. Swimming, like so many other seemingly small things, is really a big deal for both you and your child. You don't even need to see an expression of your subject in a shot like this to feel it with your mama heart.

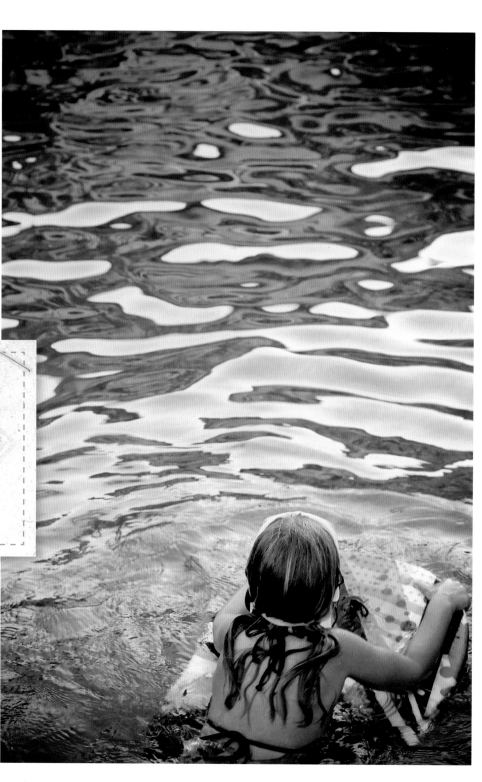

Blog Entry

The Big Shoes

Words and image
Angie Warren
Musings from Me: A Blog by Angie Warren
www.angiewarren.com

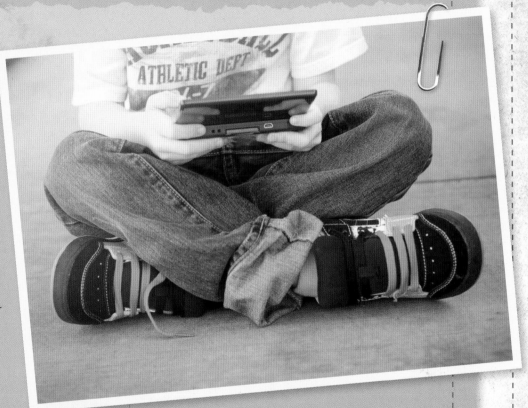

Six years ago, a beautiful boy was born. He was swaddled in plush blue blankets and wore tightly knit hats. He then grew into a toddler dressed in T-shirts adorned with sailboats, baseballs, and trucks. Preschool entered the picture, and this little boy had a collection of striped shirts with drawstring sweats, cutoff shorts, and easy shoes. He was still the child, though, who wore clothes from the toddler section, shoes that closed with Velcro, and who hadn't a care in the world about whether he had on the latest or greatest of fads.

This slow transformation of *little boy* to *bigger boy* has taken me by storm. No longer okay with whatever mama picks out, he has preferences and favorites and things he plain refuses to touch. His socks are always dirty and his pants rise up to his ankles. I have to face it: he's growing up.

Christmas 2010 brought us to a new level. Grandma asked if he needed shoes. Sure, of course! When he unwrapped that box and pulled them out, my breath caught in my throat. They were big shoes, shoes that fit him, but my goodness, were they something. Not the slip-on shoes of 2010 or the Velcro loves of 2009. These shoes took my little boy and made him something else. Something bigger and taller. Braver and full of anticipation and life.

I know that these shoes mean more than a new size from a new section of the store. It means that as time passes, so he grows. Though my mama heart feels the tug of this truth, I feel blessed to get to know the Danny of 2011. So cheers to the big shoes and cheers to what this amazing new year has in store for us.

THE INTANGIBLES

The stages and phases our children go through aren't always easy to capture in a traditional photo.

So try shooting something totally unexpected. Taking pictures of your child's block castles, playdough sculptures, artwork, handwriting, or bedroom wall can say everything you need to know about a particular age, phase, or stage in his or her life. These details will soon be forgotten, but documenting them will help you remember.

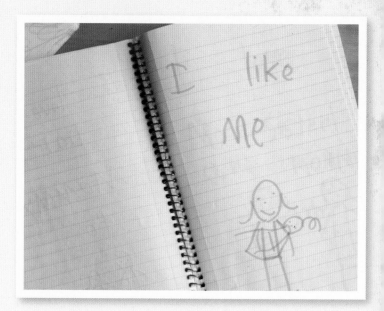

ELEVATE THE EVERYDAY

Your Story

As our children grow and change, so do we, as women navigating the motherhood chapter of our lives—a chapter that has changed everything. Who do we become? How do we change in those early days? What about once the kids start school? Or when they move out altogether? Documenting who we are as women (even beyond motherhood) can help up to remember ourselves and not get totally lost in our mommy role. Sometimes you can't help but feel devoured by something this much larger than yourself. It's the reality of life with kids. But what about if you turned your lens toward yourself once in a while? Are there ways you can capture a glimmer of who you are, how you've grown, where you are now, and maybe even where you might go from here? Your challenge is to use your camera as a way to document your own experience of motherhood and how with each moment, day, week, and year, you grow and change as much as your children do, just in different ways.

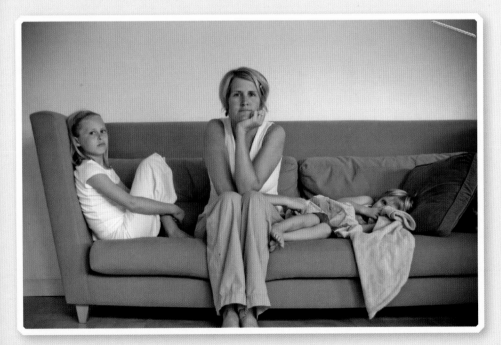

Picture of Us

I was asked to submit a photo of myself for an article I was writing. Instead of the traditional headshot, I thought, why not try to capture myself in my life as it was in that moment of time? Enter my trusty self-timer. Although I didn't know it then, what I see now is a representation of not only how I looked, but how I was feeling, and after getting comment after comment from other mothers on this shot, I realized I was expressing something many other mothers also felt. I remember feeling desperate to hold on to my autonomy, and knowing my kids were not all too thrilled about it. This image told the truth for me. Do I love being a mother? Of course. But has it always been important to me not to lose myself in that role? Absolutely. This is why I value this frozen moment in time. With this image, I can remember it like it was yesterday, and I remember to acknowledge how complex my own motherhood story can be.

LETTING GO

I couldn't possibly write about our children growing up without including the part of letting go. This is perhaps the most constant and bittersweet experience of motherhood.

From the first steps, to starting school, to driving away—with each stage of growth comes another step away from us and toward independence. Although we know what's coming, we can still get blindsided. As you document the moments of development and change, challenge yourself to capture both the emotions of pride and joy and the pang of loss.

 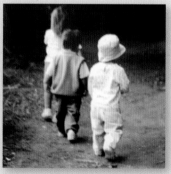

ELEVATE THE EVERYDAY

All Dressed Up (Above Right)

Shopping for my daughter's first Homecoming dance was a tender moment. Exciting for her, of course, but I felt the gravity of her growing up. Capturing this moment in the dressing room with my mobile phone, I wanted to freeze the texture of the surroundings and the layers of emotion.

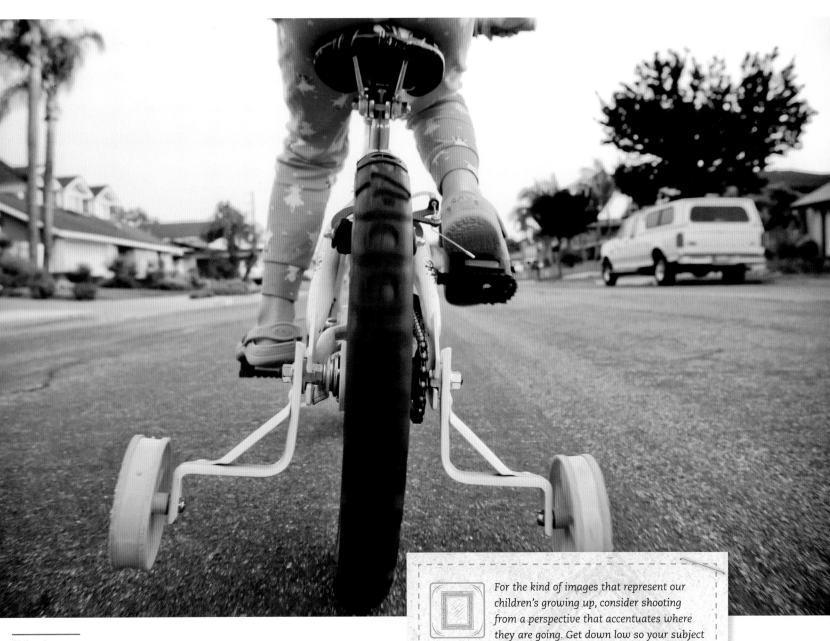

Riding Away

Quite often, children learn how to ride a bike in stages that sometimes span many years. From tricycle to training wheels to finally a two-wheeler, each accomplishment offers a burst of childhood independence. This shot not only captures the motion of my daughter riding her bike, but also the emotion I felt as she rode away.

For the kind of images that represent our children's growing up, consider shooting from a perspective that accentuates where they are going. Get down low so your subject looks larger than life. Or leave extra space where they've come from to feature what they've left behind. Shooting with this concept in mind helps you express the moment with more impact.

Blog Entry

In an Instant

Words and image
Tracey Clark
Shutter Sisters
www.shuttersisters.com

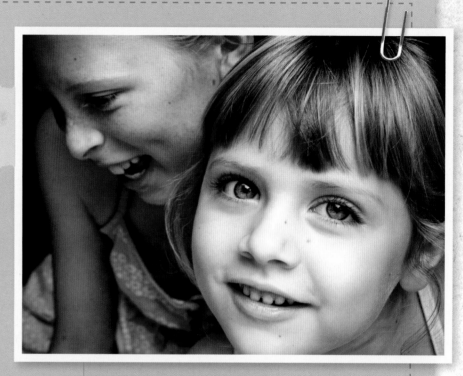

Last night my daughter took a tumble and landed teeth first into the leg of a chair. *I know. Ouch.* The incident had all the makings of a total emergency room disaster. But we were lucky enough to avoid that. *Thankfully.* But, there was fear, some pain, tears (no blood, believe it or not), and a front tooth that was knocked back just enough to make my little girl look totally different than she did not a minute before the fall. And from what I can tell, the displaced tooth is either staying right where it is for a while or it's getting pulled. We have a dentist appointment on Monday to get an X-ray and an assessment. At this point, I am thankful. It could have been worse. A lot worse. But even still, the whole ordeal has left me shaken.

I am the mom who will forever try to convince you that I'm okay with my kids growing up. And I am, most of the time. I feel like now that my kids are independent and much more self-sufficient, I am a better mother than I was in their early days of total dependence. I recognize how much I need my own autonomy and how much I enjoy time to myself. But this whole tooth thing has been a wake-up call.

I look at my daughter today and see a different girl. A growing, changing girl. It might sound dramatic, and I realize that part of her metamorphosis is the fact that she's swollen and somewhat discolored by the inevitable bruising. But even when that fades, her tooth will still be in a new place and it's changed the way she's always looked. Sure, she's going to be losing her teeth in the next year or so anyway—as my husband keeps reminding me—but somehow I realized that part of me is in no way ready for it. I am not ready to let my baby grow up.

The emotions I have experienced over the last twenty-four hours have blindsided me. I didn't feel melancholy when she started kindergarten a few months ago, so why now? I guess there's just no way of knowing exactly what it is that reaches in and finds our most tender spots, our soft parts, the place in our heart that aches with the pain of life's losses. Although this is a small-scale loss (very small, I know), I feel that ache deeply today. There might not be another photograph I take of my daughter where she looks like she did two days ago. That's a strange and surreal thought. More than anything, I am grateful for the photos I have already captured, the ones that will always remind me of my babies, my children as they were, as they are, and as they will never be again. Photographs are the only history we have besides our memories and our stories, and it just reminds me that I will never regret a single picture I ever take. In fact, I will only celebrate them more.

A Story of Motherhood

Stopping Time

Words and image
Amy McMullen
Through This Lens
www.amymcmullen.com

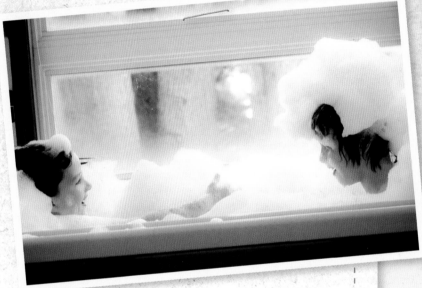

Parenthood is loaded with clichés, a favorite being "time goes so quickly" and variations on the theme. As annoying as clichés may be, there is certainly validity in this one. What people don't warn you, as you discuss impending motherhood, standing at some park, sporting swollen belly and ankles and all the hope in the world, is that once that baby is out of your womb and into your arms, time doesn't breezily "go quickly" . . . it thunders by like a loosened boulder, quickening as it descends, shocking you with its greedy speed and voracity. That it takes your breath away, how they grow at superhuman speed, and that try as you might, you cannot slow it down.

One would think you'd come to expect it at some point; that those dimpled baby thighs will stretch into lanky legs, that they will one day pronounce "spaghetti" properly and crush your heart while doing it. There will inevitably be the day that they casually let go of your hand before approaching school, or turn their cheek toward your kiss. Everyone knows that they don't stay all yours for long, and that the time that you star as the center of their universe is ever so short-lived. Still, after eleven years as a mama, I'm dumbfounded daily that my boys are becoming young men, and that it's happening at such a frighteningly fast pace.

Whenever I start to get worked up about all of this, and frantically scramble to remember every detail of how they are just now, knowing it will all change before blinking, I am thankful for the weapon that is my camera. It is the one magical tool that, if only for a thirtieth of a second, can stop the crashing time and record the details. That they had identical, twinkling eyes or the tenderness in their brotherhood. How my son looked in Grandpa's old baseball cap, how his spray of freckles grew, that he wore the thinned striped pajamas until they were three sizes too small. Catching my boys in dappled afternoon sun on the porch, nestled under our wedding quilt, the oldest first reading *The Chronicles of Narnia* to his younger brother. The bubble bath that lasted an hour and a half and the giggling never stopped.

There are the occasional times the boys ask me to put my camera down, or worse, not to bring it out at all. I try to be respectful of their wishes since they're rather patient and compliant about the camera being part of my body the rest of the time. Of course I want them to feel that I was present with them and not always seeing them through my lens. But the truth is, that lens really is my other eye. It sees them with all the love that nearly bursts my heart open; it sees who they are and how they were, and thankfully it memorizes them for me. It serves as witness to this little life of ours, and chronicles what would otherwise fall into the blur of my spotty recollection.

My memory is not dependable; the photographs are. Time can't be trusted . . . it will continue to belligerently hurl itself along, barely slowing down enough to let us catch our breaths or even see where we are. Stopping time with this little black box is a wondrous way to testify that we were here. That we had this life. And that it was peppered with beauty, and full with love.

5
DETABS

❦

AS WE DOCUMENT OUR LIFE AND
THE LIVES OF OUR CHILDREN, THERE
IS PERHAPS NO MORE IMPORTANT PART
OF OUR STORY THAN WHAT CAN BE
FOUND IN THE DETAILS.

Carrying on our family legacy through both our written words and visual images, we ensure that our stories will be remembered and passed on. Photographs will stand as prompts and reminders of the story of us. The details that we choose to bring to light tell more about us than we may realize and even still, there is so much more to it than that.

Focusing on the details of our life can change our entire perspective. Being mindful of the "little things" not only rounds out our life's stories by balancing the "big picture" with the much smaller details, it has the power to keep us—or bring us back to—the present moment. Simplicity often paves the way for the most profound changes. When we focus on what is immediately in front of us, and honor it, we allow for all the extraneous things to fall away. By doing so, we afford ourselves a much clearer view. This clarity can bring into light what is most important and what can save us from getting overwhelmed and lost in the day-to-day disorder of motherhood. As we seek out the small yet special things that surround us amidst our daily lives, we can celebrate the magic that makes it all worthwhile.

Observing and capturing everyday details can do more than just round out the stories we tell, it can also serve as a catalyst of transformation and healing. I found that out first-hand during my postpartum depression. I know now that it was writing in my journal and focusing my camera on even the tiniest joy (like my new baby) that kept me connected to a thread of perspective I needed to keep going. It's how I came to understand the importance and power of seeking out life's glorious details. However, our photography doesn't need to hold all of this intensity. As a creative outlet, our photography process can be equally celebratory and light. That's what makes it so much fun! But the idea that there is a potential of well-being that can work to our advantage as we play with our cameras and document our lives can make the process that much sweeter.

Blog Entry

Details, Details

Words and images
Tracey Clark
www.traceyclark.com

They say that life is in the details, and I know this to be true. And love, beauty, truth . . . all of these are also in the details. Although I often plan my life around the bigger picture, I observe it through the little things. This is especially true for me in how I see and experience motherhood: a wisp of hair, a scraped knee, a ruffle on a skirt, well-worn shoes, or no shoes at all.

Capturing these elements of my daily life helps me not only better appreciate my life, but also helps me see what is beautiful in the mundane. It tends to bring out the best in things. Click after click, I am being mindful and living in the moment of my life right now. Even after all these years, it still never ceases to amaze me how something as seemingly simple as "taking pictures" can be so transformative.

The best part is that through my daily practice of taking in the little things, I am telling stories of the bigger things. As my children grow up, they will always be reminded of the details that made up their childhood—the nuances, favorite things, activities, daily comings and goings, and nearly every hair on their sweet heads.

I recall my daughter reading back to me a short quote I had given to a magazine I was once featured in: "You can better tell the story by capturing both big and little things." Indeed.

Taking "too many photos" is never something you will regret. Telling your story through each detail of your life is not only satisfying today, it's also a way to leave behind a legacy. I can't think of anything more worthwhile.

EXPRESSION

By framing the details, you can tell a more thorough, interesting, and unique commentary of who you and who your children are at the time of the documentation. Time is fleeting. What details are present in your life now might not be the same in the days, months, or years to come. You are capturing an expression of this moment, today, right now.

The big-picture stuff is what we will likely recall in the future, but the small details are what are completely forgotten unless we document them. One of the most descriptive photographic studies I can think of comes in the form of capturing gesture. Whether our subject is something as animated as our children or something as seemingly expressionless as a ruffled collar, there's a gesture in there somewhere that can tell an entire story. A bend, fold, or angle can convey feeling and evoke emotion. When capturing the details of our children, we can move beyond the obvious facial expressions and begin to seek out other gestures of body, posture, stance, and movement to capture who they are and how they feel.

To capture an expression like this you must first observe your children in action and at rest. How do they use their hands, hold their head, stand, sit, twist, turn, lay, play? Watch for the nuances, the details of their way of being that you can focus on to help tell your story. Using a unique (and sometimes unexpected) way to feature and frame this kind of detailed expression, you can capture a telling vignette of your child.

A Moment of Rest
As my daughter rests, I study every detail of her, from her lips to her freckles to her strands of hair. Capturing a shot of her frozen in time, I am able to hold onto these moments of still beauty for a lifetime.

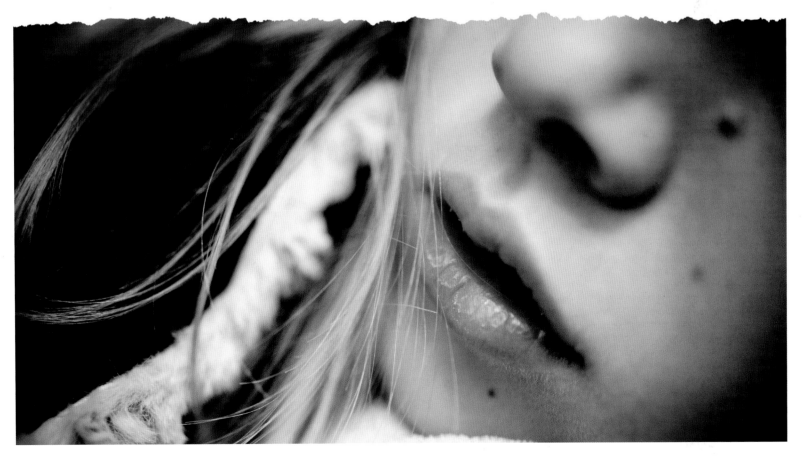

CURVES

I realized early on in my career as a children's photographer that the contours of small bodies were something I loved to capture for parents. I longed to shoot beyond the average headshot and was on a quest to find the soft shapes and gentle curves of the children that sat in front of my lens.

With each image it was as if I was reciting poetry: the inimitable, lilting expression of each child. The children were each unique but the beauty was universal.

The creases in chubby arms, subtle contour of the nape, or shape of the shoulder blades. The bend of an ear, the swirl of hair, the curvature of the mouth and lips. Framing these details is what I wanted to do for my clients. After I had my own children, I was able to take those images as a gift to myself. The more you can distill these nuances within your frame, the better you can truly capture the details that matter most to you.

Waves (Right)

Some details can be captured as universal markers of childhood, while others might be indicative of your specific children or the stage that they're in. I shot this image of my oldest daughter mere days before she started high school. With the light of the sinking sun, the hint of the blue water, and the curves of her wild blonde hair, this shot captured both the end of summer and the end of a chapter of her childhood.

Cropped Curve (Below)

An extreme crop places the focus on the beautiful curve to the tiny, perfect mouth and nose.

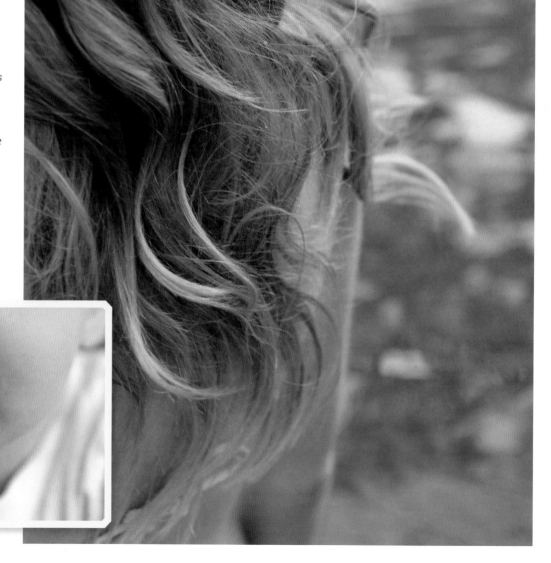

Blog Entry...

Cathartic

Words and image
Kristin Zecchinelli
Shutter Sisters
www.shuttersisters.com

Lately I am finding real peace when I use my camera to work through something personal. Life gets messy, sometimes scary, but when I pause and acknowledge those moments through my lens, I feel a release. This is not for everyone, this is for me. I am visual. I process life through my lens. I snap, I write, I move through, I let go, I get on with things.

This image was taken one week post-hysterectomy. This day one week ago, I was under anesthesia, surrendering everything to the great unknown. I feared many things. I feared not waking. I feared waking. I feared the possibility of pain, for surely it would come. I woke. I did have some pain. Now I was seven days out, fresh from my morning shower when it hit me that those very same moments one week before were so scary and yet here I was safe, changed, different, but well and healing. I wanted to mark that moment. I wanted it to be real and to see me, the me now. I wanted to nod and tell this me all will be well, and so I picked up my camera and clicked.

I have no shame in this photo. This is the real thirty-nine-year-old me. My soft belly and thick legs. That tattoo I got at age twenty-two when I was so sure of everything and so full of myself. That bunion on my right foot that sticks out and prevents me from ever wearing awesome heels. This body that birthed three babies, but now has no uterus. It is all okay. All will be well. Funny thing—when you share a piece of yourself you ultimately wind up touching others. For we are all women, mothers, sisters, daughters, sharing our human experience. We all feel, struggle, grieve, fear, celebrate, love, and mourn. When I use my camera to work through something personal, somehow it makes it not so scary.

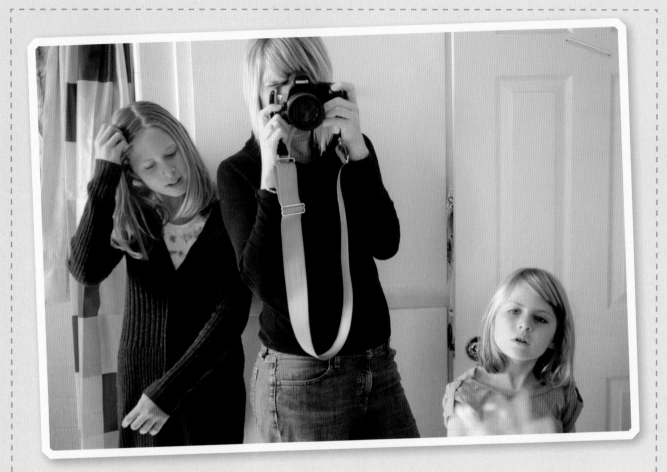

Your Story

As comfortable as we are hiding behind our cameras, sometimes the healing can come when we allow ourselves to be seen. The details that make us who we are are as important as the ones we are documenting of our children. To find the courage to share and shoot something that speaks of you isn't easy, but in years to come, these authentic stories of us will likely be personal expressions that our grown-up kids will cherish.

 Consider some creative ways to capture yourself with your lens. If you shoot with a wide-angle lens, you can hold the camera at arm's length and get much of yourself in the frame. Pay attention to the details you're including in the image. Are they telling a story about who you are or where you are in life right now? There's no shame in telling it like it is, only courage and authenticity.

THE TRIMMINGS

Buttons, bows, shoelaces, and shirt-sleeves can all be telling little embellishments that can visually describe our children's ages, interests, and personalities.

Sometimes the cuffed pants and logo t-shirt can be symbolic of a stage our child might be in. Accessories display an outward expression of who our children are. Day-to-day accoutrements show personality and are used to communicate individuality. What our kids wear can either melt our hearts or drive us mad. Whatever today holds, remember that the tidbits they choose (to wear, carry, or leave around the house) tell a part of their story and yours.

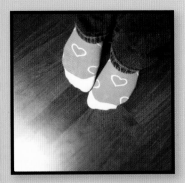

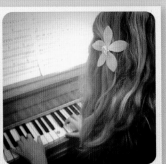

Sometimes the accessories alone can stand as the main subject of our images. When focusing on details like this, you can take all the creative liberties you want. Notice the color, texture, and shape, and seek out an interesting way to frame them in your shot. Whether they are in context (on your child) or on a bathroom counter, these little things speak volumes about our kids.

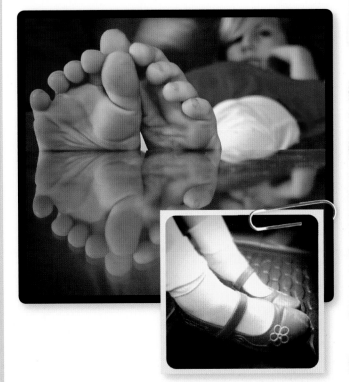

Feet and hands can make for excellent and expressive images. My daughter is no fan of shoes and has referred to shoes and socks alike as "cages for your feet." Whether or not it's a coincidence that we can never find a pair of shoes around our house that match is beyond me. This of course means that I have years of photographs of her feet. On the ground, in the air, up on furniture, in the sand, and, on rare occasion, in shoes. Each image is unique, but every one tells a story of her (and her passion for being barefoot).

BEYOND THE BEAUTY

No matter how hard I try to see the beauty in everything, the truth is, stinky gym socks aren't beautiful. Such is life.

Not everything is seemingly photo worthy. But, sometimes the story must be told. For instance, throughout the years I have documented the progression of what I find on the bathroom counter—from bath toys to toothbrushes to (most recently) curling irons and makeup. The odds and ends that we take for granted (and sometime learn to despise) are the details that once gone, will forever be forgotten. Sometimes by honoring what these details mean to our children and to us as mothers can result in a change of heart—or at least a shift in perspective—that lasts just long enough to appreciate the remnants of lunchbox scraps before we toss them out.

Life isn't always beautiful, but that doesn't mean it's not worth documenting. Messes are a part of reality. The challenge is to see if you can actually take creative pleasure in capturing them! Just remember, some day we will actually miss the Legos and, quite possibly, the dirty laundry.

Your Story

As mothers we often don't even have time enough to ourselves to get a shower in, let alone doll ourselves up with bits and baubles of self-expression. But even without knowing it, there are little details of us that speak volumes of who we are and where we are at in our lives.

Consider how you wear your hair, the sweater you throw on or the color you paint your toenails—all the little things that are vignettes of you being you. The creative challenge of mining for the gems of details of your own life can be a fun and rewarding way to express yourself. You rarely get time to do it, so why not use photography as the catalyst you need?

Reflections of Me
I love shooting reflections, so any rain is a reason to get out my camera. This shot captures enough of the real me (in my holey jeans and flip flops) as well as my reflection and the perfectly imperfect crack in our patio to create a well-told story of my life.

This was a low-light scenario, so I set my camera down on the ground to steady it as I pressed the shutter. The floor is an ideal tripod both because of its accessibility, and because it also offers an unexpected and often compelling way to look at the world.

Life Gets Messy

As my daughter sat at her desk doing her homework, I took the liberty of capturing her real life as she was living it in that moment. Her school backpack, gym shoes, dirty laundry, and dictionary pretty much summed up life as we knew it. It was liberating to look past the mess, if even for a brief period.

Blog Entry

Me Being Me

Words and image
Tracey Clark
www.traceyclark.com

In handing my thirteen-year-old daughter my new iPhone and teaching her the basics of the Hipstamatic app, I was evoking magic. With her creative flair and a brand new tool to play with, I knew she'd manage to create something wonderful and have a blast doing it. That's the way it goes with kids. They see the world through fresh eyes, with excitement, wonder, curiosity, and unbridled enthusiasm for anything and everything that crosses their path. No plan, no worry, no hesitation.

This photo is one of the images she captured that afternoon that stopped me in my tracks. I had no idea she even took it, which is probably why this might be the most authentic image of me ever taken.

Me in my daily life. Me in motion. Me in my routine. Me as mother. Me in my mini-van. Me in my aviators, ponytail, t-shirt and jeans. Me as who I truly am.

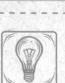 *Let someone else turn your camera on you. Seeing yourself in your everyday life from another perspective (especially that of your children) can give you an unseen and illuminating look into how your life looks from the other side of the lens. It can be a fun exercise in letting go.*

A Story of Motherhood

Contour

Words and image
Catherine Newman
Ben and Birdy
www.benandbirdy.blogspot.com

I did not actually become a writer until after my first child was born, and I think I understand why: before kids, I had my various thoughts and feelings, and I was able to express them in language. Easy peasy. "He seems nice." "I'm glad I got the chowder." "You're kneeling on my hair." Whatever. But then a baby came out of me, to me, and it was the emotional Big Bang: my heart and psyche exploded into a million fragments of love and terror that glittered in the infinite darkness. "I love the baby," I would say to various people, only that utterance was the wrong tool for the job, like chasing a woolly mammoth with a butterfly net, putting out your two cupped hands to catch Niagara Falls. I loved the baby in a constantly unspooling way that had no beginning or end or shape to it, just more and more and more, twinned with the simultaneously unspooling fear that I would lose him. I lay awake to memorize his pimply moonlit moonface, to watch him breathe inside the tightly-stretched terrycloth, to study his small, but oddly ragged fingernails and wonder if the swelling balloon of my heart was going to carry me aloft or burst and kill me. I cried and laughed a lot in those days. I googled "baby rash" and "baby dies from rash" and "bursting balloon-heart syndrome." But I had strangely little to say.

And what I'm trying to say now is this: it's too big, it's all too big, and so the only thing you can do is contain it with a story or a picture—frame some tiny part of it that gestures at the enormous rest. Why, it's not an infinite and abstracted universe of love and fear! It's just a story. You don't have to stuff a hot-air balloon through the eye of a needle: you just have to hold the needle up and see which of the colors you can see through its eye. You show a piece of it, even if it's just breakfast or a bike ride, and because it has a defined shape and size, because it has a beginning, a middle, and an end, your heart can rest a little. Sometimes it goes badly, and words (or pictures) fail you, of course—like you're trying to recreate Michelangelo's heartbreaking *Pietà*, the son limp in his mother's arms, but the medium at your disposal is actually cotton candy. You just do your best.

Plus, you can make it funny if you want to. I have made something of a habit of the funny retelling of a story that either was or wasn't funny at the time, and now, while somebody barfs into my lap on the Berserker Pirate Ship ride, I think to myself, "If this is going to be funny later, is there any chance it could be funny now?" Sometimes there is (nose with black bean inside it) and sometimes there isn't (MRI machine with child inside it). And always, however mundane or ecstatic the story, however funny or sad, it's just about giving some contour to this absolutely heartbreaking love that is being a parent. Like the time—let me tell you about it, it won't take long—when I sat last night on a low bed, pulled a thick pink blanket up around a sleeping pink face, and felt a single dark crescent of eyelashes crash over me like a tidal wave.

6
ROUTINES

WHEN YOU BECOME A MOTHER,
ROUTINES KICK IN HARD AND STRONG.
ALTHOUGH IT MAY FEEL THAT YOU LIVE
IN A WORLD WHERE CHAOS REIGNS
SUPREME, THE INEVITABLE DAILY GRIND
BECOMES SO MUCH A PART OF YOUR
FAMILY LIFE THAT YOU WILL LIKELY
DEPEND ON IT LIKE OXYGEN.

The odd part of our routines is that they become both necessary to life and the bane of our existence. For the first few years it's waking, eating, sleeping, playing, fussing, eating some more, and (hopefully) sleeping some more too that become the markers of the day. Each day it's much of the same, with the only variations being the exact timing of the routines. There are showers to be had, phone calls to make, errands to be run, and work to be done—but for the most part, it's morning, noon, and night, routine, routine, routine.

As our kids move from infancy to toddlerhood to childhood and beyond, our routines adapt to each new stage of life. Whether we mothers stay at home, work at home, work outside of the home, or do a little of each, there remains the thread of

day-to-day normalcy that we use to stitch together our everyday. Our routines are the fabric of our lives, the backdrop to our story.

But, as important as our routines are, they can still drive a mother to near insanity. The same mundane routine that adds stability to our lives is also a recipe for exhaustion, boredom, hopelessness, and isolation. When documenting our comings and goings with photography, the objective is to allow for all of these feelings to come into the light. We don't have to pretend to love mornings—especially if we haven't slept through the night—but we can find the beauty in them somehow. Perspective is everything. It's all in the way you look at it.

The memories that we make as a family aren't usually found in the routines of our everyday life. They are usually found while on vacation from our everyday life. But the everyday is the foundation from which all the big and exciting memories grow. My daughter might not remember that I had tea parties with her and her stuffed animals for months on end, but she will remember that I loved her, and that I was there when she needed me. Even for something as ordinary (and sometimes tedious) as tea parties.

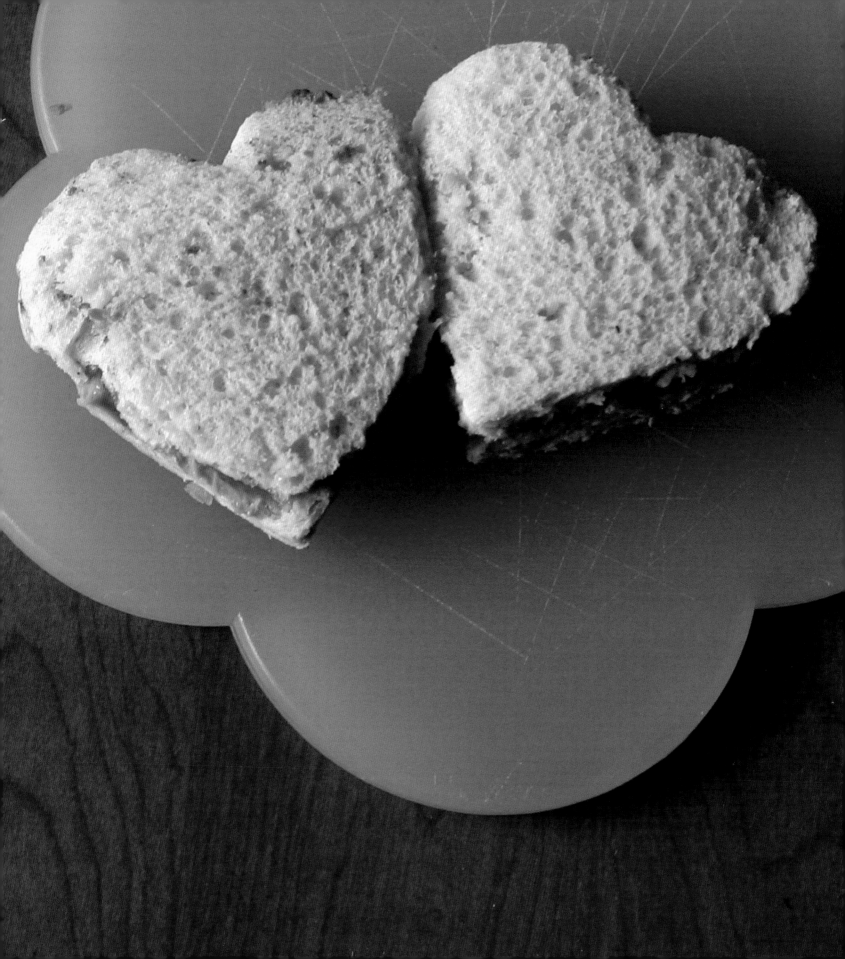

Blog Entry

TEAdium Time

Words and image
Tracey Clark
www.traceyclark.com

What could be sweeter than the image of a mother and her daughter sitting down to tea? Nothing. Especially when the daughter is mine and she's adorably two, chatty and charming. The tea set is tiny and the tea is really apple juice, while the accompanying snack is a little bowl of popcorn. Come on. It's too cute.

Now, what could be more tedious than a mother and her daughter sitting down for tea every day, sometimes two times a day, sometimes three? Nothing. Especially when the daughter is my cranky, demanding two-year-old. The tea set is tiny and therefore tips easily and is fumbled often, while the snacks are Teddy Grahams or Goldfish (again) that get smashed to crumbs under the microscopic tea table I uncomfortably wedge my knees under, and end up all over the rest of the family room floor as well. Come on. Enough is enough.

Motherhood can be the crown of the most tedious state of being. And this is what continues to be really difficult for me. The monotony, the dullness, the routine, the tiresome tasks that never seem to end because if and when they do, they turn right around and beg to be redone, rewashed, recleaned, recooked, redressed . . . you get the point. I spoke to a mommy friend today and she confirmed that "on some days you can sit and enjoy the tedium and become one with it and on other days you just gotta get the heck out of the house." Can I get an Amen?

Well, I have not fled from my house today and have been contemplating Mother Tedium: recognizing her presence in my life, acknowledging her, and doing my darnedest to embrace her. Although with a definition like "the quality or state of being wearisome" well, let's just say she's not that easy of an old gal to appreciate.

I am reminded of *The Guest House* by Rumi.

"This being human is a guest house. Every morning a new arrival. A joy, a depression, a meanness, some momentary awareness comes as an unexpected visitor. Welcome and entertain them all! Even if they're a crowd of sorrows, who violently sweep your house empty of its furniture, still, treat each guest honorably. He may be clearing you out for some new delight. The dark thought, the shame, the malice, meet them at the door laughing, and invite them in. Be grateful for whoever comes, because each has been sent as a guide from beyond."

I'm not sure I've ever really invited Tedium in (I'm pretty sure I haven't), but she's come anyway. Perhaps if she felt a little more welcome, she wouldn't be so hard to live with.

Rest assured, the next time my daughter and I sit down to tea, I'll be setting the table for three.

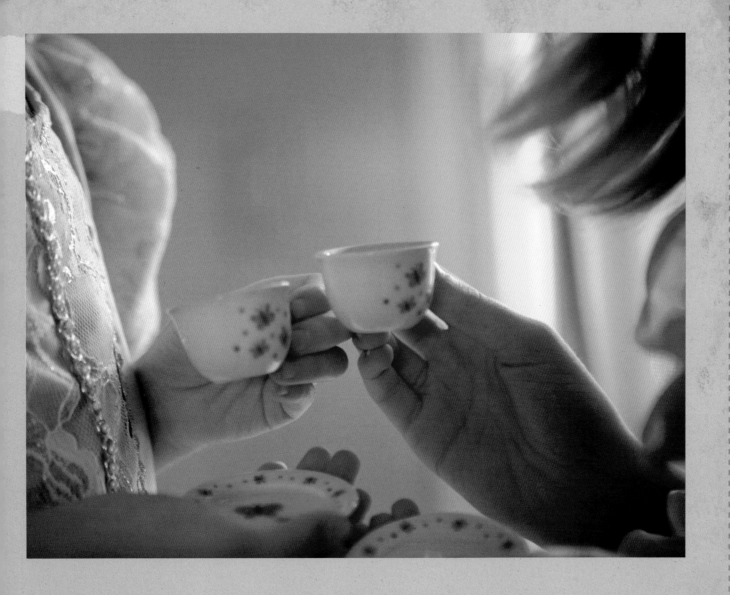

MORNING

The tone of our mornings can really depend on the type of person we are; there are morning people and then there are those who are definitely not morning people.

Even the most chipper morning person can still feel a little less than thrilled with the lack of sleep that comes with motherhood. Despite that little wrinkle, mornings can be a sweet time of reflection, togetherness, and inspired photography.

Between pajamas, slippers, bedhead, and sleepy eyes, I am a sucker for capturing mornings through my lens. When your children are in the hustle and bustle of the school routine, sometimes the only thing that matters is getting out the door in time.

But the weekends often offer time to exhale and creatively document what goes on under your roof in the wee (or not so wee) hours of morning.

Whether your kids wake before the sun (and before you, too) or you have to drag them out of bed, documenting the early hours will help you "remember when." Remember when they looked so tiny in their crib? Remember when they'd crawl into bed with you and fall back to sleep? Capturing the meaningful moments of morning can start with the sun, if you are so creatively inclined at that hour.

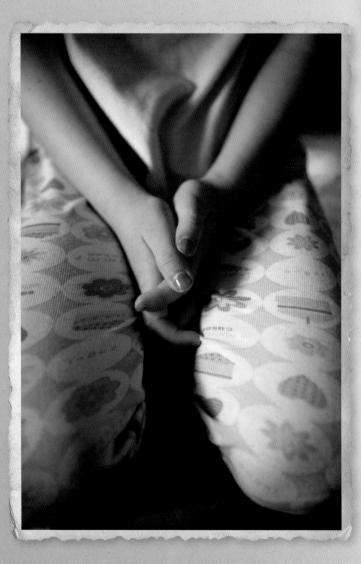

Morning Light (Left)

Bleary-eyed or not, you can't deny the soft light of the early morning hours. The lower the sun, the softer the light, which makes this a fantastic time for beautifully lit images. So the next time the sun streams through your windows in the morning, consider capturing what it brings to light, even if it's just your child patiently waiting for his or her breakfast.

 When you've got really young children, you're almost always up with the sun. Although it may feel like you'll never get to sleep in again, I promise you that this too shall pass. And if you're looking back on these days, is there a way to capture a moment in the morning hours that will remind you of the time when, like it or not, you were at a baby's beck and call?

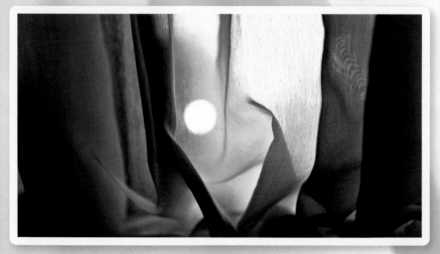

Your Story

Whether you cherish mornings or dread them, chances are you settle in each morning with a warm beverage and a routine of your own. Even when that might revolve most around your family's needs, be mindful of your own morning story. Slow down and observe long enough to recognize your own rhythm and how you begin each day. Morning can be a sacred time if you allow it to be—use your lens to find the sacred in the ordinary and the magic in the mundane. This is your story, after all. You can write (or shoot) the script.

Time for You

I have a love affair with mugs. Although I most commonly shoot them on my counter or at my dining room table, on this day I opted to shoot a self-portrait of myself and my mug of choice. A shot like this, as simple as it is, tells the story of me and a moment I savor daily.

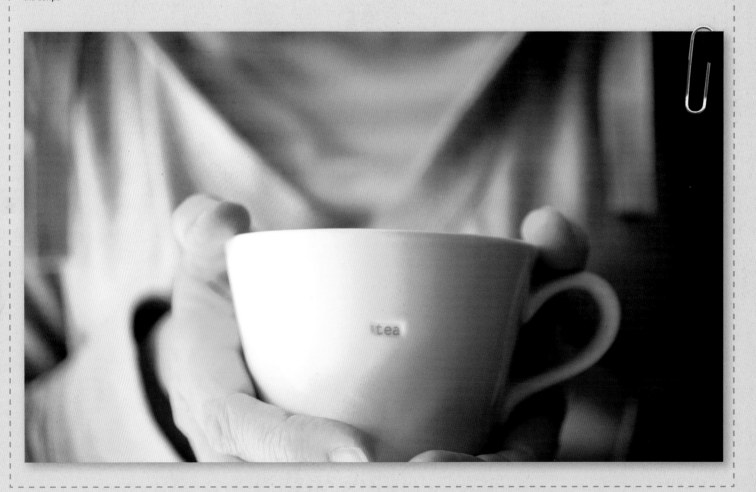

MEALTIME

I'm a true believer that there is magic to be found in a simple cereal bowl. Maybe that's because one of my daughters went through a phase of eating cereal every chance she got. (A girl after my own heart.)

Bowls and mugs are favorites of mine—I love their simplicity and harmonious shapes—but paired with the soft light and quiet of morning, there is a level of enchantment to be found in such basic kitchenware. For as many mornings as there are, you will find equal the amount of possibilities for cereal bowl photos. You certainly don't need to be enamored with cereal, toast, or even pancakes, but since so many of our everyday routines revolve around food, it can be a telling way to document and elevate our everyday. I challenge you to find a simple morning photo muse to kick-start your day with a little creative play!

Beyond the culinary wonder of breakfast, there is of course lunchtime. There are quite often elements of the midday meal that really say a lot about where our kids are in age and stage. Is it sweet potatoes? Peanut butter and jelly and Goldfish on a colorful plate? A juice box, or a lunch box, or both? What you are feeding your child (or more to the point, what your child will eat) is part of the day-to-day constancy in our lives. Some of the most savory shots are those taken in the throes of a good meal.

What I Love (Right)
Serving up a bowl of cereal for my youngest daughter is a daily routine that I cherish. Maybe it's because she's already grown out of her favorite striped pajamas that I realize that the day will come all too soon when I will deeply miss our sweet and simple mornings together.

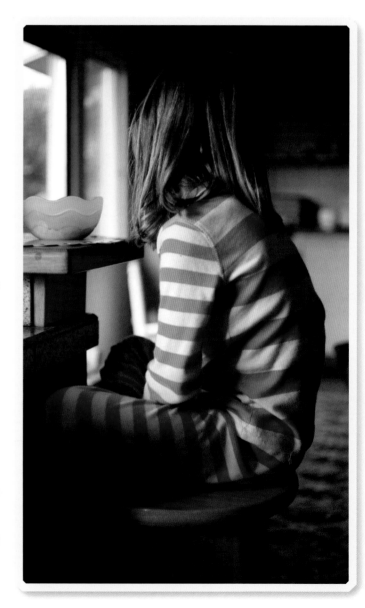

Dinnertime, for me, is a bit more photographically elusive. Maybe because it's the time of day right around what us moms like to call the witching hour, where all the planets get thrown off their access and everyone is hanging on by a thread. With breakfast and lunch, life seems manageable and fairly easy to photograph. As for dinner, it's all I can do to get it on the table. But, when I'm so inclined, I will capture at least the preparing of dinner from time to time. Especially when it's a delicious barbecue *à la* my husband. Remember that small snippets and telling details are all it takes to capture the story of your family meals.

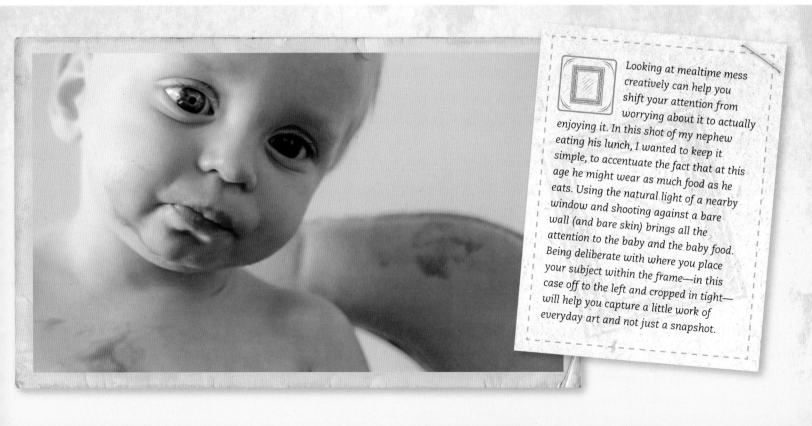

Looking at mealtime mess creatively can help you shift your attention from worrying about it to actually enjoying it. In this shot of my nephew eating his lunch, I wanted to keep it simple, to accentuate the fact that at this age he might wear as much food as he eats. Using the natural light of a nearby window and shooting against a bare wall (and bare skin) brings all the attention to the baby and the baby food. Being deliberate with where you place your subject within the frame—in this case off to the left and cropped in tight—will help you capture a little work of everyday art and not just a snapshot.

Blog Entry

Dinner and Thoughts on Documenting

Words and image
Angie Warren
Musings from Me: A Blog by Angie Warren
www.angiewarren.com

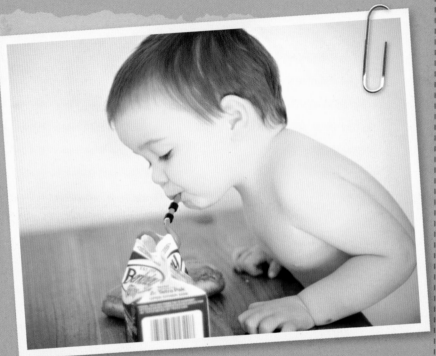

With my phone hooked up to the iHome, I settled into my groove. Stirring, grating, slicing, dicing. My favorite song, "Pandora" came on and a smile spread across my face. Cooking in my place, my kitchen, with music that soothes my soul—I couldn't ask for much more.

As the song played I felt my heart swell. Across the room were my boys, safe within our nest. The house was cool with a breeze unlike most Januarys here and for that moment, in between the crackling of turkey cooking and little boy voices, *everything was perfect*. Dinner became something else for me tonight. It brought us together ever so briefly, it healed tiny broken pieces of my heart, and meshed my tiny family in a way I didn't know I had hoped for. But first, it led me to grab my camera, which then turned my thoughts to this vast space that has been hovering over me lately. A space full of words such as *real*, and *life*, and *raw*, and *documenting*. *Documenting, documenting, documenting*.

I can't seem to get around that incredible word. My soul craves it like no other, to document our lives—to document for others. To plain and simply give and receive the gift of our everyday. The details and the in-betweens and bits and pieces. Isn't that what we set out to do as photographers? To *document*?

Where has this art been lost? It gets caught up in between the perfect shot and the right settings. It's lost somewhere underneath piles of caring-what-they-think, on top of that-won't-sell.

Not for me. Not anymore. This documenting thing is the real deal, friends. It is what it's all about. Don't allow it to get lost. Perhaps it will take a perfectly imperfect dinner, or something more. Whatever it is, grasp onto it ever so tightly, and just do it.

MIDDAY

Routines of midday hours range dramatically from age to age and family to family. Playing, schooling, sporting, reading, resting, cooking, cleaning, or, chances are—a little of everything on most days. Paying attention to the rhythm of the comings and goings of our families can help us not only document accordingly, but also acknowledge and appreciate the pulse of our daily life.

When our children are young, naps are the pixie dust that ensures our daily magic. Without naps, life isn't nearly as easy or predictable. But as every mother knows, this short window of our lives where naps are a given doesn't last long. Capturing our children sleeping might just be the crowning photographic achievement of motherhood that results in many a mother's favorite shots of her children.

Speaking as a photographer, naps are dreamy—pun intended—because there is usually enough available light during the daytime hours to easily get pretty captivating naptime images. Taking advantage of these opportunities is a must.

A Fresh Start (Below)

Quite often, our babies are at their best upon waking up from a nap. It's the perfect time to use your camera to snap a shot of the rested and happy baby! Some of my most cherished images of my daughter as a baby were the ones when she was fresh from a nap. To up my chances of getting great shots, I would sometimes put her down where the light was best and I could get a more intimate angle as she slept and woke up. These images were taken as she napped in the middle of my king-sized bed. Some might call that cheating, but I call it a photographer-mom's prerogative!

Relaxation (Left)

My teenager isn't too keen on napping any more, but that doesn't mean she doesn't have ways to slow down. Relaxing with a magazine is how I find her when she gets extra time on the weekends. So a simple shot like this is a marker of a small window of time in our lives.

BATHTIME

One of the most intimate and sacred moments of our daily routine is that of bathtime. I don't know a single mother who can resist taking pictures of her children in the bath.

Because our kids are self-contained and self-entertained in the bathtub, it can make it that much easier to get a natural, candid shot of your child. Add that to bare shoulders, shriveled toes, and light dancing on the water and you've got a photogenic moment. Take your time to get creative with your perspectives or angles. Shoot candids or let your child pose for you if they would like. A mother can never take too many bath pictures.

Although you can't go wrong with the subject matter, the lighting here can be tricky. If you're getting too much blur in your tub time photos, up your ISO to a higher number. This will allow you to shoot in the dim light of a bathroom with a better chance at capturing the all the splash action.

BEDTIME

Since this is the time of day that can sometimes feel like it stretches on with no end in sight, there is plenty to acknowledge and appreciate in relation to telling our bedtime photo stories.

Although the bedtime routine varies from family to family, it might be one of the most universal rituals we have. Bedtime is when we wind up our busy days, slow down, read a book, rest our bodies, and drift off to sleep. Of course, we all know it's not as peaceful or consistent as it may sound. The truth is, there can be all kind of hyperactivity and hijinks at bedtime, but even still, there is nothing more sweet than when sleep does finally come, however and whenever it finally does.

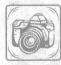 *Like bathtime, the dim light of bedtime can be challenging to shoot in. Using the glow of a reading light can be enough, but again, you'll probably need to use a higher ISO. Or, if your subject is relatively still (reading is the perfect activity for this) you can set the camera down on the dresser and use that like a tripod. That way, when you click the shutter, you're less likely to get any shake from your own hand (which can cause unwanted blur).*

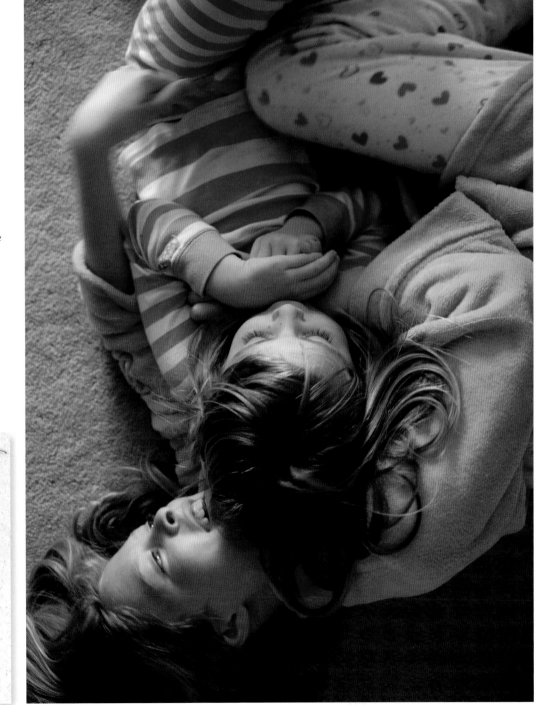

OFF DAYS

They can't all be good days. Sometimes, whether it be illness, exhaustion, stress, or merely a funk, some days just don't go as planned.

Cold Season (Right)

These square tissue boxes are a mainstay in our household, especially during cold season. Instead of focusing on the flushed cherubic face of my sick daughter, I chose to use the iconic tissue box as my main subject to convey the picture of that particular sick day.

When kids are under the weather they are usually calm and sedate by default. Although taking pictures might be the furthest thing from your mind, there are ample stories to be told in the off days. Obviously, there's a fine line here. My teenager would rather die than have me take photos of her while she's sick, while my younger daughter pays my lens no attention when she's not feeling well. Our kids might not be at their most chipper, but oftentimes that makes for great and natural images. Obviously, being considerate of our kids is of the essence and although sometimes I skirt that line in my desire to get good shots, I have captured some tender and true images of my children—no prompting necessary—when they've not quite felt themselves.

Your Story

Off days don't just happen to our kids. What about your own off days? I have found that using my lens to interpret the world around me can be cathartic. I also know that sometimes the gems we mine with our lenses can often reflect our own state of mind. Using a tool like photography to express yourself is one way to creatively work through the blues (or any other color your mood might resemble).

 You might think you'll need a tripod as you dabble in self-portraiture, but any steady structure will suffice. Consider using accessible everyday surfaces like your dining table, the kitchen counter, a park bench, or even the ground to steady your camera, set the self-timer, and click!

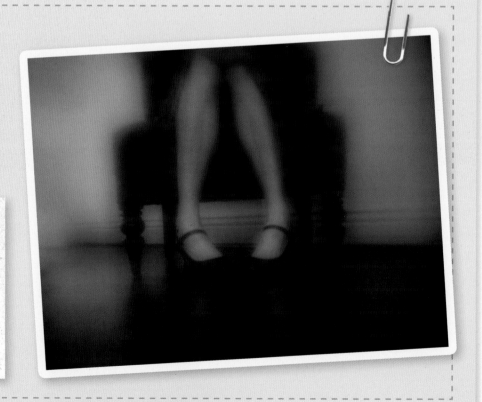

CAPTURING TRADITIONS

Routines don't necessarily have to be something you do every day, or even every week. Traditions, the more sacred and special routines that we participate in, might not have such a strict and regular time schedule, but they are still parts of our lives that mean something to us and our families.

They too can be a strong and unbroken fiber in our family tapestry. Year after year we partake in the ritual of something we hold dear. Whether it's based in our ethnicity, steeped in our beliefs, or merely a way to create some regular family fun, the traditions we follow become important parts of our everyday story. It could be as simple as a recipe you cook together for a special occasion, or a place you visit each summer, but whatever it is, don't forget to document your yearly traditions. In the not-so-distant future you will be able to lay them all out next to each other and see an entire timeline of your life.

Photobooth Fun

Of all the photos I have of my family, perhaps my most cherished ones are the annual photobooth strips we take at our local county fair each summer. Silly and spontaneous, each strip holds its own unique charms. When considered separately they're lots of fun, but placed with the others from summers past, this collection becomes a priceless family treasure.

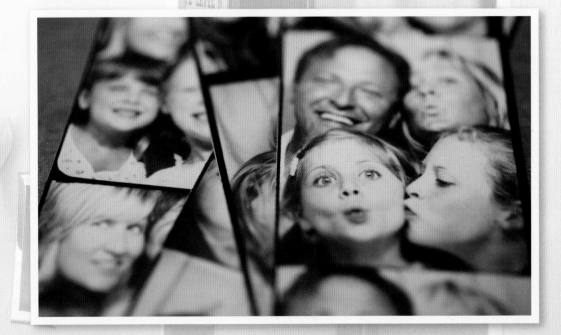

7
SPACES

THE MAJORITY OF LIFE AS WE KNOW IT HAPPENS WITHIN OUR OWN FOUR WALLS. EACH ROOM IN OUR HOME SERVES A PURPOSE. THE IRONY IS, IN THE AVERAGE COLLECTION OF FAMILY PHOTOGRAPHS THE TRACES OF HOME THAT TELL THE SACRED STORY OF FAMILY LIFE DON'T ALWAYS EXIST.

Is it that we don't see our normal daily routine as photo-worthy? Are we worried about the mess? Or the poor lighting? Or maybe we primarily save the camera for documenting milestones or vacations. Whatever the case may be, the truth is, our everyday life is completely and utterly photo-worthy! It's our life, after all, and there is great beauty in it. And the rooms within our home serve as the perfect backdrop for our photos, because they offer an authentic and integral context to our life stories.

As with many other elements of our imagery, shooting within our homes should be done with the intention of integrating our subject matter with our background. Where or how we capture any given moment at home doesn't have to feel like happenstance. By keeping our surroundings in mind as we shoot, we can bring more meaning and purpose to our family photographs.

If you can take the leap to consider home as an ideal stage for picture-taking, then you won't need to look far for the props that populate your images. Everyday elements are all around: the mirror on the wall, what's on the kitchen counter, the stacks on the bookshelf, or what's hanging on the coatrack. I believe that much of what we include in the frame of each image can symbolize the pieces and parts of our stories that might well be forgotten if not preserved in a photograph.

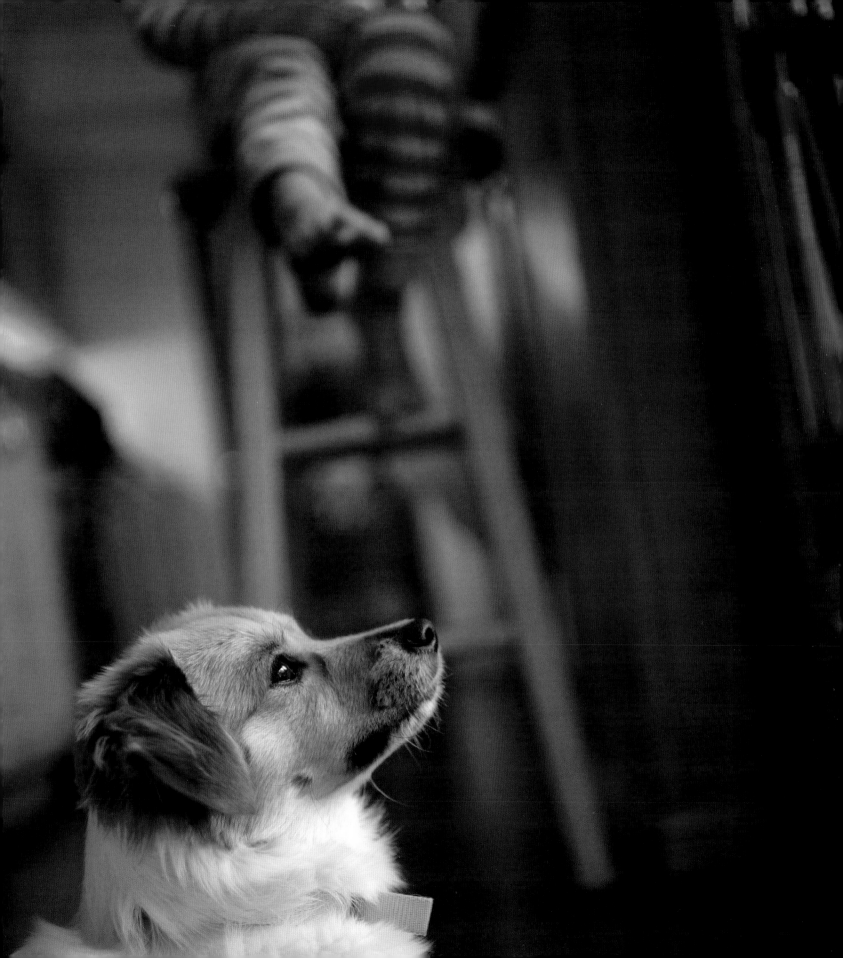

LIVING ROOMS

They don't call it the living room for nothing. The same goes for the family room. As you capture the everyday moments of your life, don't neglect the rooms where it all happens. Or the rooms where it's not supposed to happen, but it does anyway.

The color of the walls, the pictures that hang there, the bookshelves, and all the toys in the toy bins (and out of them) are all important traces of your life. Wherever life happens to be laid out in your home, those are the corners that beg to be illuminated.

Blog Entry

Lazy Hazy Daze

❧

Words and image
Meredith Winn
Shutter Sisters
www.shuttersisters.com

Wall-to-wall carpeting invites lounging. I had forgotten this about him. Legos spread underfoot, he marks his territory in this new space. I am marking my territory too, with photos tacked to walls and Buddhas placed methodically. I can't blame him for spreading out, and so I learn to step gingerly while in bare feet.

We moved 1800 miles to be here. It's new and it's summer and life turns upside down fairly quickly. So we unpack and disassemble life as we knew it and walk boldly into something new and somewhat surprising. It is the blending of the old and new lives that are creasing together like a to-do list that's been shoved deep into a pocket.

These are the final days of summer. And this year, this is how we are spending our time. It might not have been how I pictured it, but in this picture I see the truth of our reality and it's perfect just how it is. For this photo, I stood on a chair and shot straight down at him. The early morning sun cast a light on the bottom left frame and my iPhone lit up his face while he studied a new strategy on a favorite game. What I wanted to remember was the mess, the smallness of him, the dark edges, the comfort of that old bear we use now as a floor pillow.

Life is not always what you pictured, but it's always exactly as it's supposed to be.

KITCHEN

For many years I fought the truth I had been told for years—that the kitchen was the hub of the family.

Since I had dreaded using my own kitchen for most of my adult life, I was disheartened and disappointed when I began a family, feeling that somehow I was missing something. And yet over the years I have realized that the kitchen does hold a kind of magic that can't be found in any other room of the house. I see it in almost every photo I capture there. I don't consider myself a foodie, and I'm not a huge fan of cooking, and still there is a certain way that family gets nurtured via the kitchen that is almost intangible. Food is tangible, don't get me wrong, but there's something more to it than that. I wish I could put it into words. Instead, I just shoot. And of all crazy things, a lot of amazing stuff happens in and around the kitchen that doesn't always have much to do with food. Go figure.

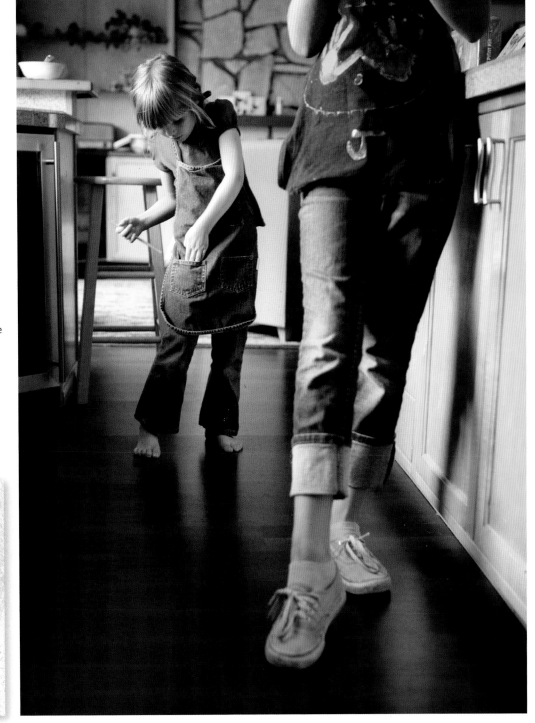

Depending on what your photographic intentions are, consider using elements around your subject to create visual interest. In this case, I used a detail of my oldest daughter and the kitchen counters to flank each side of my youngest, which features her in the space and the context of the moment.

Blog Entry

The Bright Side of Domesticities

Words and image
Tracey Clark
www.traceyclark.com

My youngest daughter has stated loud and clear that she needs my attention these days. Not only does it show in her behavior and attitude—she actually told me straight out. This is one of the upsides of having children old enough to communicate articulately what they want (and need) from me. But it's challenging too—there's no getting out of being a better parent when you're called on it. Gulp.

Finding engaging and enriching ways to bond with my girls can be tough. I get into a routine and I forget to think outside the box, to get away from the monotony that can be the norm. I know myself all too well and I recognize that I am often distracted. And I also find myself saying no to my children a lot. No to activities they want to get involved in, to excursions and adventures, to getting dirty, to big plans. I have recently been reminded that just because an idea sounds like too much work for me, or because I don't always enjoy the same things the kids enjoy, I shouldn't always say no to their requests. In fact, saying yes feels good! And we all benefit from it.

So with this picture, I am sharing a little glimpse into yes.

Yes, you can cook (even though I am not a big fan), because it doesn't have to be about me—I know, what an epiphany. It can be about ways my girls can have fun, be creative, use their imaginations, make their own choices (even if they actually do want to cook), find their strengths, and explore the world. All in the name of embracing the yes, and perhaps even a new routine.

FURNITURE

There may be no better prop for our everyday photographs than the furniture in our home. As for our children—who, let's face it, can act much like climbing monkeys—furniture becomes an extension of who they are physically.

Their bodies mesh and meld with the couch cushions, they sink into easy chairs, lean feet up on the coffee table, and sprawl out all over the floor, building forts with dining room chairs, sheets, and pillows. As our kids crawl, climb, and cuddle up, they are using our furniture for all of it.

Whether our kids are the most comfortable when they are draped across the arms of an overstuffed chair or curled up on a single cushion, there is no better time to capture them being them than on the very furniture that brings out the best in them.

Furniture can offer added visual interest to your shots as well. Fabrics, textures, and colors can all work well to create interesting images of daily life. Use these everyday prompts to your advantage. Angles, curves, and lines should be put into play as you frame your child, or a detail of your child in the shot.

When our children lounge around at home, they are in their truest state, and totally and utterly themselves. Whether they are engrossed in a good book or a video game, you've got a fantastic opportunity to capture a moment of them being them in the space they call home.

Patterns (Far Left)
Upholstery, fabric, and textiles can all be used as elements of interest in your photos. In this case, the combination of color, floral and striped patterns, and bare feet all work together to bring a certain whimsy to this image.

Furniture Frame (Left)
This photo was captured a few moments after the one next to it, when my daughter slipped into her favorite rocking chair. I used the chair itself to frame her. Considering she sat in that chair every day for years, incorporating it in our family photos will help serve as a reminder of that time in our lives.

FURNITURE

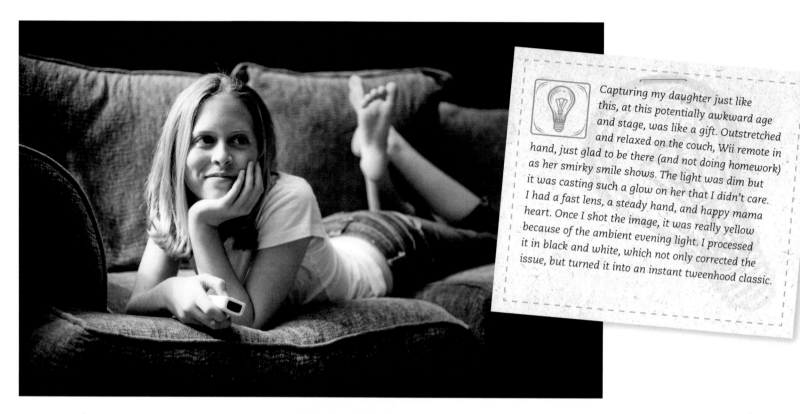

Capturing my daughter just like this, at this potentially awkward age and stage, was like a gift. Outstretched and relaxed on the couch, Wii remote in hand, just glad to be there (and not doing homework) as her smirky smile shows. The light was dim but it was casting such a glow on her that I didn't care. I had a fast lens, a steady hand, and happy mama heart. Once I shot the image, it was really yellow because of the ambient evening light. I processed it in black and white, which not only corrected the issue, but turned it into an instant tweenhood classic.

Although shooting pictures of your baby in the crib can be challenging (the height and the obstruction of all those bars), you can actually turn those seemingly negative things into positives. The strong and repetitive lines of the crib can help create a compelling composition and work to the overall advantage of your image to tell a story of context. You can shoot to capture what's between the bars, or shoot to get the bars at an interesting angle. Repetition and angles of the crib itself create a visually compelling composition (it's a commonly used compositional trick). Just look how it can lead your eye right to the cherubic subject matter at hand.

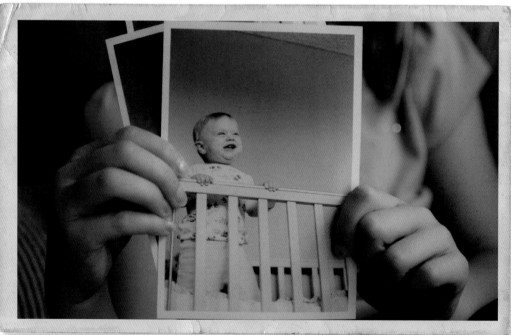

ARCHITECTURAL ELEMENTS

We may not love every single nook and cranny of our homes. Some corners might be magnets for clutter, while others might lack personality or style. But these are the areas in which we do our living. This is where our stories play out.

Look beyond the accumulated dust and the dirt of daily life and consider the elements of your own home that mean something to you. The hardwood floors, the front door, your reading nook, your old but charming windows—all these will add texture and visual interest to your images, while also bringing to life your story and where you live it each and every day. Using a door frame to frame your subject, for instance, will improve the composition of the shot and also give it the authenticity of your real life.

Our backdrops might not always be shiny and new. It's good to remember that even the worn out and dated architecture of our home can add visual interest. If there are things you're really not willing to reveal in your images, of course, you are free to crop or Photoshop them out. That's part of the beauty of using your camera. You have all the control over what you include from frame to frame. So whether or not you choose to show the ring around the bathtub is up to you. Just remember these moments are fleeting, and you'll never regret the photos you took of your child splashing around that dirty old bathtub!

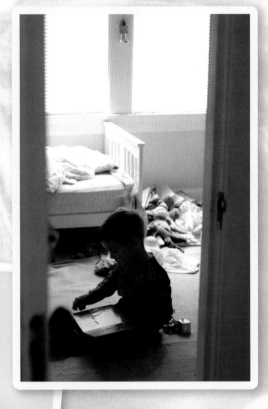

If you'd rather not edit out the grease and grime of life, consider softening it up. You can shoot out-of-focus images on purpose for a unique and artistic effect. Once you give yourself permission to shoot through a more impressionistic lens, you'll have a ball with it. Plus, no more soap scum on the tub! This shot was taken with a Lensbaby, which is a fun selective focus lens that yields awesomely artistic results. It's an inspiring muse if you're ever looking for one!

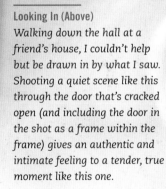

Looking In (Above)

Walking down the hall at a friend's house, I couldn't help but be drawn in by what I saw. Shooting a quiet scene like this through the door that's cracked open (and including the door in the shot as a frame within the frame) gives an authentic and intimate feeling to a tender, true moment like this one.

WINDOW LIGHT

When shooting daily life indoors, the windows in your home will become cherished creative allies. Through each window comes glorious natural light. That light is what will help you create the everyday photographic magic.

With regard to light, I have gotten to know every single window (and sliding glass door and sky light) in my house and how (and when) I can use it to best illuminate my kids, my dogs, and, of course, my coffee mug. That's part of the beauty of the "same old thing." You can study it, learn it, and depend on it. Over the years, I have become guided by light; what I see, where I go, and how I shoot is influenced by it.

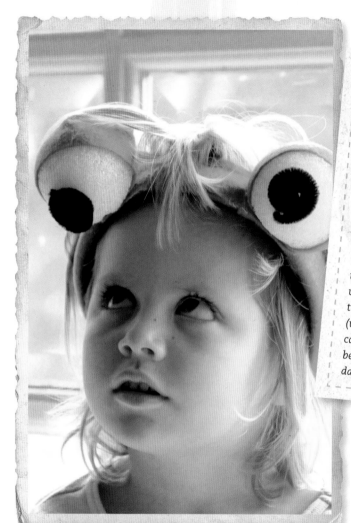

 Pull back the curtains and take some time to observe how light plays into your daily life. Notice which windows offer the most natural light, and at which time of day, and put this knowledge to good use. Move the kids' table toward the sliding glass door, scoot the board game closer to the window, open the front door to get the light to flood in— whatever it takes to find light that illuminates your children (watch for those coveted catchlights I talked about before) as they play out their day at home.

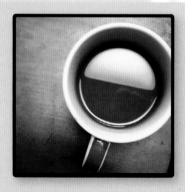

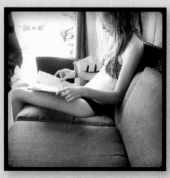

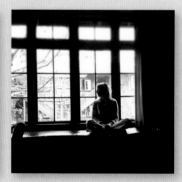

ELEVATE THE EVERYDAY

A Story of Motherhood

Coming Home

Words and image
Tracey Clark
www.traceyclark.com

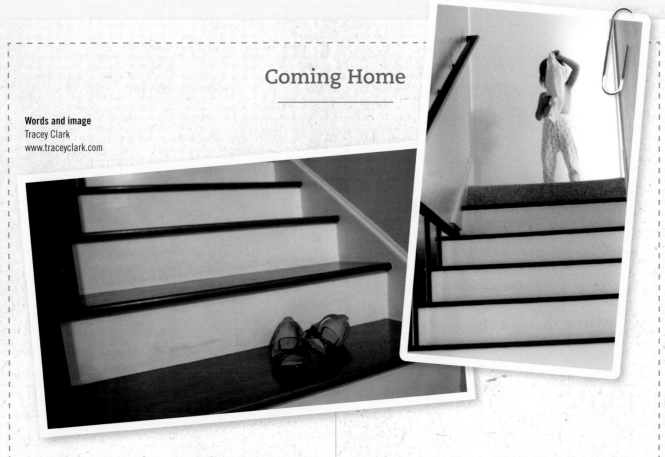

Recently my daughter attended her first Homecoming dance. Beforehand, the two of us plotted and planned how the evening would go, including when she would get picked up and where I would take the pictures. She surprised me when she asked if we could take photos in the entryway of our house, with our stairs as a backdrop. So many of our family moments had been captured there, she reminded me, and she had always loved the way they looked.

Although I had spent the last eight years using those stairs as a setting for a number of occasions—my daughters as babies climbing to the top, the annual father-daughter Girl Scout dances, the dogs lounging in the glow of the skylight—I hadn't thought of this location as an important part of our documentation. But my daughter's request reminded me of how the bones of our house have been a big part of the memory-making that happens here. It's not at all what comes to mind first when I think of our family photo library, but that doesn't make it any less important. Instead, it actually makes me appreciate and want to include the small vignettes of our home that much more.

Did we shoot the photos of Homecoming in front of the stairs? No. I was too nervous and excited and out of my right mind to do anything that deliberate that evening. Instead, I just shot everything the kids did, wherever they happened to do it. Such is the way it goes when you're trying to document a moment without posing or disrupting the main players (and you're the mother who is also trying to keep her cool). Believe me when I tell you that I was more nervous than my daughter was. If you're a parent of a teenager, my guess is you can totally relate.

Whether we are in this particular house forever or not does not matter; it will always be my daughter's childhood home. I know now that the photographs I have taken here throughout the years will serve as the visual stair steps that will always lead them back to their childhood memories.

Blog Entry

A Family Grows in Brooklyn

Words and image
Catherine Connors
Her Bad Mother
www.herbadmother.com

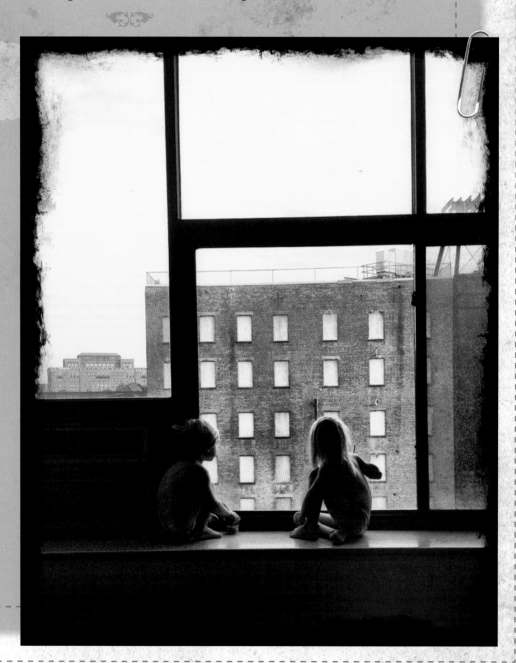

This is the story for this week, the only story, the only story that matters: they're here. Finally they're home. *We're* home, together.

This is the first day—the first days—of the rest of our lives.

PERSONAL SPACE

When it comes to sacred and telling photographs of your children, no room could be better than their bedrooms. Everything about your child is revealed within these spaces. Toys, books, games, themes, stuffed animals: every detail tells the story. Incorporating all the texture and color that bedrooms have to offer can add so much depth to your photographs and reveal things about your children at that moment that you will want to remember.

Approach documenting your child's space from their perspective. How does it all look from their eyes, literally? Lay in their beds with them and look around. What do you see? What is important to them?

Your Story

It's easy to talk about where everyone else spends their time. What about you? Where do you start your day, take time out for you, or feel most at home? Where are you able to truly be yourself? You can shoot simple vignettes of the parts of your home that are most meaningful to you. Or perhaps you can challenge yourself to tell a story of you that reveals something about who you are, what you do, and how you see yourself within your own four walls.

Alone Time (Left)
For most mothers, the bathroom is one of the only places you might find some alone time. For new moms in particular, the bathroom can be a sanctuary. That's why I was compelled to capture a moment like this.

If you can shoot with the eyes of a child, your images will help conjure up memories for them as they grow up and out of the décor of their space now. It's only a matter of time. You can also hand them the camera and let them do it! It's a fun way to get their true perspective on things. Then, print out their images and display them. Nothing would make them (or you) more proud.

8
PLACES

ALTHOUGH MUCH OF OUR LIVING
IS DONE AT HOME, THERE ARE A
NUMBER OF PLACES WE VENTURE
OUT TO ON A REGULAR BASIS.

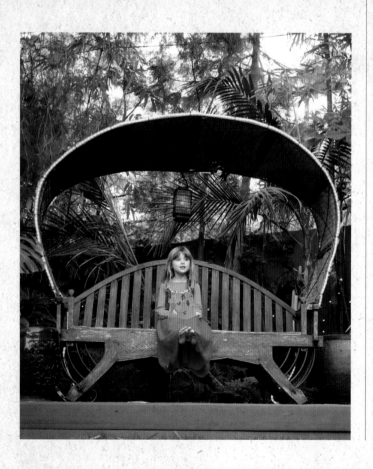

In the early days, staying in and nesting is common, but slowly we begin to stick our neck out and bring baby along too. We start to look forward to—and often depend on—regular outings, activities (both with and without baby), visits to see friends and family, and travel (for work and play). And eventually, that same baby you're toting all over town begins her slow and steady retreat toward other places—without you—to spend more and more time away.

Although many of the places we visit regularly fit into our daily routines as either trips of necessity, or simple pleasure, there are also the places we go (on special occasions, for instance) seeking newness and adventure. No matter where you go or why you choose to go there, every part of this journey begs to be documented. From your usual haunts (school, the corner coffee shop, the local park) to the one-stop wonders (theme parks, special events, different cities, states, and countries), keep your camera in tow so you can document how life is lived outside your home. It's a grand adventure, no matter how near or far you may roam.

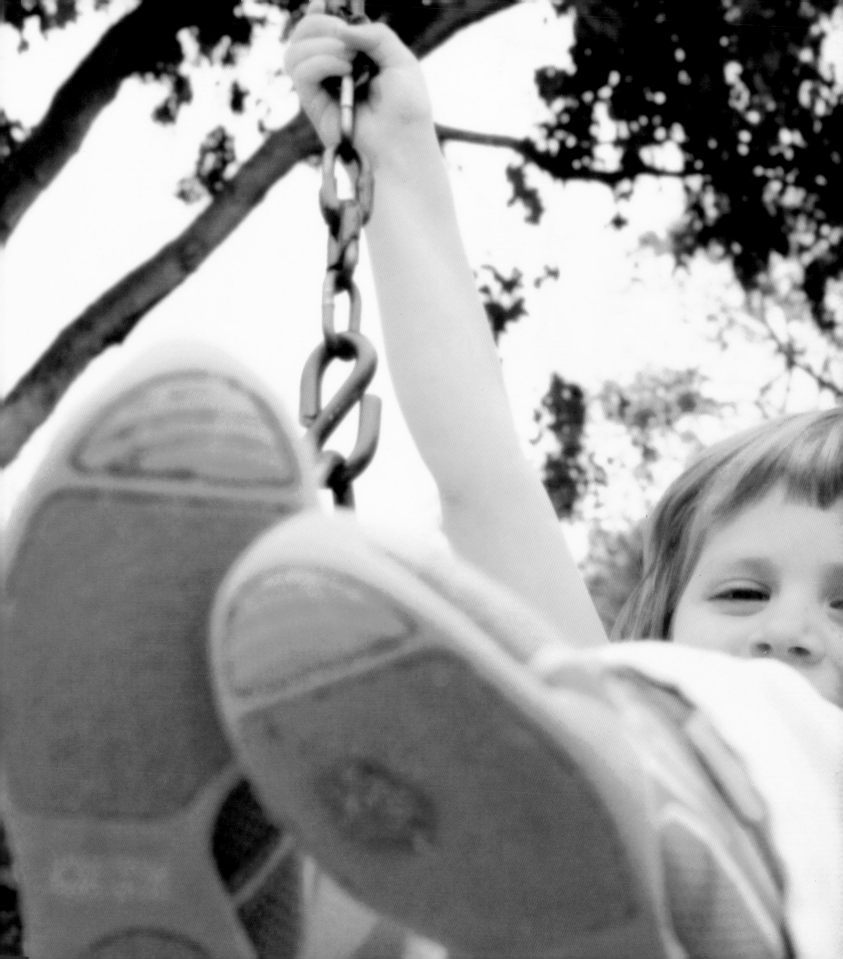

AROUND TOWN

Although every family has its different rituals and routines, many of us find that the same old thing is a comfort.

The same supermarket, mall, doctor's office, or restaurant—but for as much time as we spend frequenting these places, we very rarely think to document them. Our daily rounds might seem as mundane as it gets (and they can be), but just like the ordinary moments of home, there's an enchantment to be found when you seek it out.

These places are part of daily life—in a sense, they are our homes away from home. Although we probably don't want to pull up a chair and get cozy at the grocery store, we still feel comfortable there—it's just a different kind of comfort. We know what to expect, how long it's going to take, and how much it's going to cost. Have you ever considered documenting it? Maybe not. But don't rule it out. It is a part of our life story as mothers to growing (and hungry) kids. This is only one place among many that you can consider including in your collection of photographs.

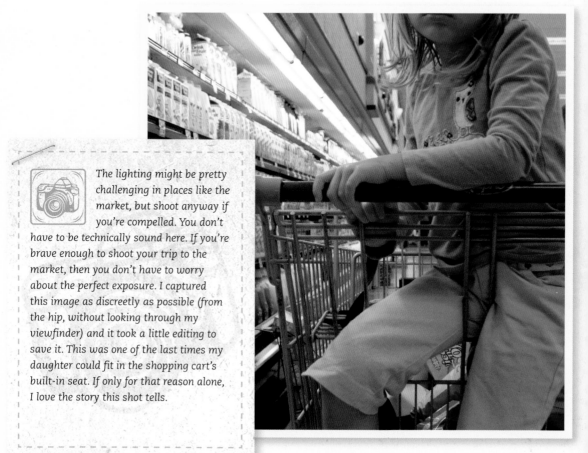

The lighting might be pretty challenging in places like the market, but shoot anyway if you're compelled. You don't have to be technically sound here. If you're brave enough to shoot your trip to the market, then you don't have to worry about the perfect exposure. I captured this image as discreetly as possible (from the hip, without looking through my viewfinder) and it took a little editing to save it. This was one of the last times my daughter could fit in the shopping cart's built-in seat. If only for that reason alone, I love the story this shot tells.

ELEVATE THE EVERYDAY

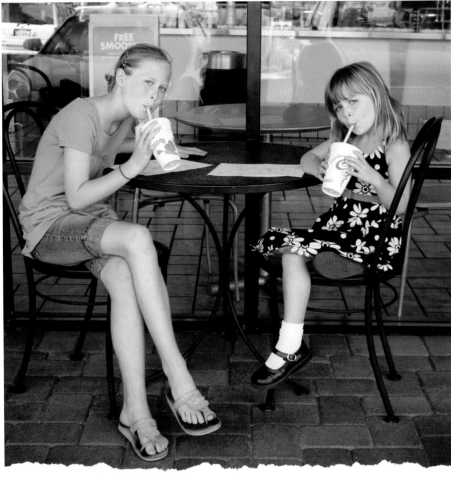

Although the daily routine is part of the story, the activities we participate in for fun and entertainment and the places we go to spend time together are usually much more photographically captivating than our normal comings and goings. From the movie theater to the zoo to the bowling alley to the beach, each local spot has a charm all its own. Capturing how you experience these outings is what will help bring them to life again when you're browsing your photo catalog.

Our mode of transportation is another aspect of daily life that often goes overlooked. We spend a lot of our time in transit. Another good reason to keep your camera with you (thank goodness for mobile phones)! There really is nothing cuter than a sleeping baby, and quite often children do a lot of napping in moving vehicles. Whether your mode of transportation is a car, the subway, your bike, or your own two feet, remember that as you get from point A to point B, there are all kinds of photo-worthy stories happening.

Family Favorites (Above)
I have craved smoothies since I was pregnant, and my daughters inherited the same passion. Everything about this kind of photograph is expressive. Fun colors, interesting and relevant props (the cups and straws), willing participants (smoothies=happy kids), and open shade on a warm summer day.

The moments that can be captured through our car's rear-view mirror are priceless. Using a frame (like the rear-view mirror) within a frame (our image) is a creative way to capture your small subjects. Just be sure you're at a complete stop when you shoot. Safety first.

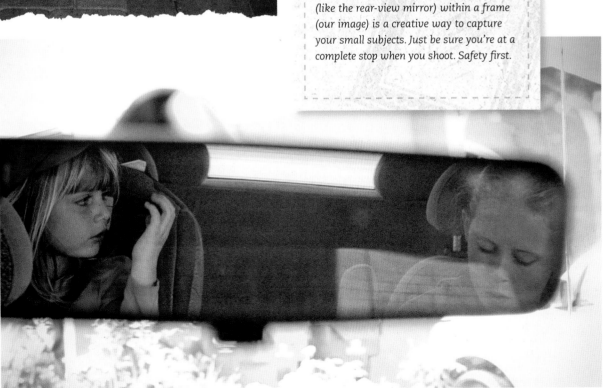

THE GREAT OUTDOORS

There is nothing like a little fresh air to give us a fresh perspective. We're not the only ones who are inspired by getting outside.

There's something about the earth and sky that calms even the most savage of beasts. When my youngest daughter was a baby, the only thing that soothed her restless newborn heart was the evening sky. All we had to do was lay her flat and face-up in the stroller, and tranquility reigned.

For me, the outdoors at its finest means long shadows of late afternoon followed by fiery sunsets. Children laughing, bubbles blowing, bare shoulders and bare feet, dizzy with space. There's just something that frees us up and makes room for breathing deep and exhaling deeper.

However, consider the flip side of all that glowy potential: dirt-covered ankles, skinned knees, snarly windblown hair, filthy shreds of clothing (if any at all). The latter is what many of our outside days look like around here. But that's the beauty of capturing your everyday life in its entirety. It's authentic. And because that's exactly what we're going for (because I promise you, that is what you will want to remember in years to come) we can shoot our scenario as it is, no apologies. No need for a wardrobe change. Or a brush.

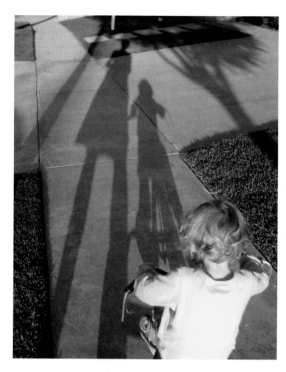

Late Afternoon (Right)

I had a surplus of images of my daughter on her bike, and wanted to somehow incorporate me being there with her. Including my shadow was a perfect way to do it.

I do preach the message of shooting life as it is, but I also can't fight my artistic tendencies to want colors to coordinate and to want a moment frozen in time to feel less dated and more timeless. Enter the beauty of the monochromatic photograph. Process a color image to create a black-and-white one using the saturation slide in your editing software. Dial the color all the way out using the slide and you've got a monochromatic photo. And then with a simple tweak of the contrast slide, you can slightly beef up the darks and the lights to make your black-and-white shot pop.

Blog Entry

Stories of Summer

Words and image
Tracey Clark
www.traceyclark.com

I've recently realized I have a perfectly documented photographic timeline of my family using just my images from the beach. From tiny, sandy feet and wispy, wind-swept hair to every pattern and cut of swimsuit to an infinite amount of seaside treasures found and captured in pictures, my children's lives can be traced back to the beginning from our collection of seaside photographs.

As my daughters have grown and changed, so have my photos. New moments appear and different perspectives catch the attention of my lens now. I sometimes lament the fact that their toes aren't nearly as cute and chubby anymore and it's no longer appropriate to shoot pictures of little buns peeking from bikini bottoms. Nonetheless, I embrace and enjoy discovering ways to capture who they are becoming.

I have to keep my distance a little more now and perhaps be a tad stealthier as I shoot (which means it's probably about time I invest in a new telephoto lens), but I'm up for the challenge if it means capturing images like this one and keeping this beautiful story of imagery flourishing. Plus, it's just one way to hold onto the fleeting moments of motherhood just a little while longer, which for me, is reason enough.

A Story of Motherhood

Migration

Words and image
Sheri Reed
Today is Pretty
www.todayispretty.com

While staring out the front window into a bleak February morning, birds entered my life.

My five-year-old suddenly set down his toys and wholeheartedly gasped, "Beautiful!" and I looked up to see a window full of birds. Dozens of robins dropped, like fiery orange comets, into the stripped winter trees next door. My boys—my oldest newly five and my youngest a few months past his first birthday—and I ran, window to window, hands and noses pressed to the glass to take in the magic. On this day, the migration of many things was made loud and clear. Birds . . . yes, birds, I thought, grabbing my camera, so unexpectedly inspired. I began to look up for the everyday beauty of their passing show.

A few years after my first son was born, I ran into an old friend who was deeply immersed in the early weeks of new motherhood. Mostly she shared the profound goodness: smallness, amazement, and beauty, all which cause a mother's heart to come undone. In fact, it wasn't until we were saying goodbye that, heart and eyes overflowing, she told me that parenthood was so much harder than she ever imagined. She looked in my eyes and asked, "Were you scared?" "Yes," I answered. "To death." What I did not say was that, several years in, I was still scared. Scared I'd never survive toddlerhood, scared I could never be enough, and maybe more than anything, scared I would never be able to fill the growing void that feeling like "just a mother" left inside me.

Once the robins cracked something open in me, I began to take my boys on "drive-by nature-gazing trips" along the driving route of a nearby wildlife preserve. A few visits quickly became several trips a week with frantic dashes to catch that "golden hour" before sunset. Those days out there, chasing bird glimpses along the dusty roads, saved me—from boredom, from loneliness, from feeling stuck, from the debilitating heaviness of creative stagnation, and ultimately from forgetting who I was. Boys tucked in car seats, the natural world passing us by, I began to feel like myself, most certainly a new self, but my own true self nonetheless.

The boys counted soaring hawks and learned to spot bright white egrets and curve-billed ibis while I studied the pulsing wings of the great blue heron with my camera. Black phoebes snapped up insects in midair, and the rat-a-tat-tat of an acorn woodpecker made us listen oh so closely. We discovered cliff swallow nests made of packed mud, baby swallow faces peeking out each muddy cave window. Have you ever watched a barn owl sweep out into the grainy light of dusk, big, bright moon face and long, white wings opening up like a ray of sunlight?

I was alone out there one summer evening, and I watched a flock of easily half a million red-winged blackbirds, grackles, and starlings explode into the sky. Camera in hand, I leaned back breathless against the hood of my car and those swooping, wheeling birds dove, as if by electromagnetic force, right into that gaping hole in me. Click, click, click. That hole left by the intense love, distraction, and hard work of the first selfless years of motherhood began to close. Click, click, click. Capturing the fitful, unpredictable beauty of those birds' wildness in photos was both breath-holding and heart-thumping, and once I discovered it, I gave unrelenting chase to the feeling.

The next winter, my oldest, just weeks shy of turning six, and I started across the open field that ended in the great horned owl's favorite perching tree. We had been watching his silhouette rise up against the darkening evening sky for weeks, and we hoped to catch him sleeping. However, a cacophony of geese distracted our trek, and we ended up following their call. What we came upon was a never-ending sea of chatty migrating snow geese, gathering *en masse* in the muddy wetlands. As we moved in, the nearest flock fled all at once, in a single thunderous motion that shook the ground we stood upon and rattled our guts within. This change in me would not be shaken.

I once attended a lecture with author John Irving, in which he said, "We don't so much get to choose our subjects as our obsessions choose us." I can't stop shooting the same photos of birds taking flight over and over. I know I can't. Not now. Not yet. It's the only way I have found to express the poetry I feel inside. On my best days, I stand alone out there, feet anchored in a green marshy meadow full of tall reeds and pussy willows beneath a dark spinning vortex of blackbirds, camera to my eye—it is here that I am able to capture the endless and glorious act of being me.

Your Story

What draws you out of house and home and into the wild blue? For me, focusing my lens on nature has been transformative. I find that it helps me get grounded and centered and almost always gives me a new way of looking at the world. Taking time to slow down, reflect on, and take in all that Mother Nature has to offer is a healthy way to spend some time. Whether you take advantage of the outdoors regularly or need to be coaxed into it, I encourage you to picture yourself outside. Take your camera and shoot what you see. Include yourself if you're so inclined.

Whatever the Weather
Puddles at your feet act as reflective pools and can bring a whole new perspective to the world around you.

SCHOOL DAYS

Our school-aged children spend much of their lives in school. There is much joy in this. And there is much heartache.

For as much as we potentially savor our time alone, we can also miss our constant companions. Regardless, it's all a part of life, and traveling through school, grade level by grade level, is an important rite of passage for many families.

Oftentimes, much of the school experience feels too routine to document. But book bags, binders, school uniforms: these are the props of our kids' daily lives. Capturing snippets of your child's life as a perpetual student can and should be added to your visual narrative.

Each school year I volunteer to spend time in my kids' classrooms. Some years are heavier with volunteerism than others. But I will be the first to admit that it's my passion for shooting photos of school-day activities that drives my altruism. I figure if I can get into the classroom long enough to lend a hand, get a peek into my daughter's second home for that year, and document it, everyone wins. I can't recall ever seeing a single photo of myself at school, save for in yearbooks.

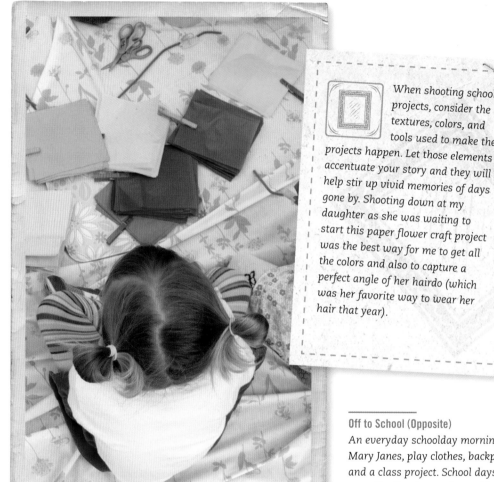

When shooting school projects, consider the textures, colors, and tools used to make the projects happen. Let those elements accentuate your story and they will help stir up vivid memories of days gone by. Shooting down at my daughter as she was waiting to start this paper flower craft project was the best way for me to get all the colors and also to capture a perfect angle of her hairdo (which was her favorite way to wear her hair that year).

Off to School (Opposite)
An everyday schoolday morning: Mary Janes, play clothes, backpacks, and a class project. School days seem fleeting, but an image like this freezes time forever.

ELEVATE THE EVERYDAY

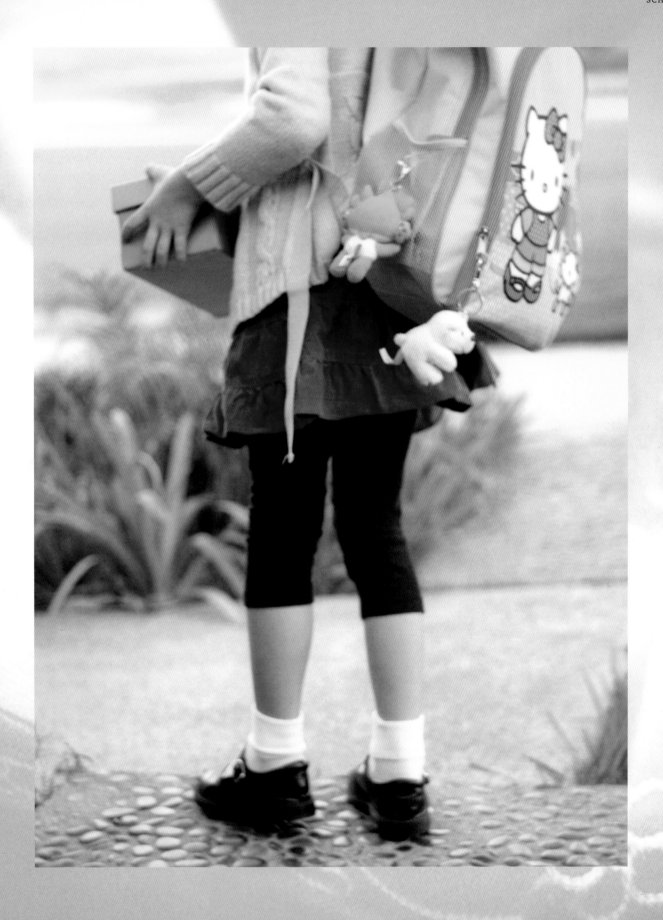

DESTINATIONS

Of all the things we look forward to, getting away from it all is a big one. The lengths we take to get to the places we want to go for rest and relaxation or for adventure (or both) know no bounds. However, making it happen as a parent can be no picnic.

Packing up and leaving for any duration of time is an investment of money, time, and energy. It takes so much just to get out of the house, it's a wonder we ever leave! Road trip antics, missing flights, lost luggage, bickering, and tantrums—we've all been there. It's not all that entertaining at the time, but being able to look back at photos of these exploits actually enhances the experience. Life is a balance of both ease and struggle and this is quite true when it comes to family getaways.

We are always snapping photos when we are seeing the sights. Landmarks, locations, the special stuff. But being on a trip can be special enough just as it is, no point of interest required.

Making Memories (Right)

A simple burger becomes a work of art when it's delivered by room service, and water is much more refreshing when sipped from a fancy glass at a restaurant. It's these bits and pieces that tell the real story of what life is like on vacation when you're a child.

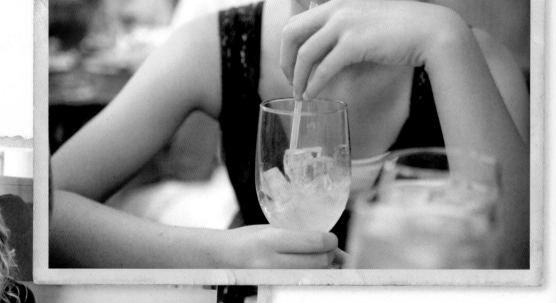

Special Access (Left)

I love this shot of my daughter relaxing in the Admirals Club lounge before our flight, knowing that this hour spent will forever be etched in my kids' minds as one of the coolest days ever. Getting special privileges doesn't get lost on them! The only reason we were given access was because we had missed our flight out the day before. Who knew that it was the most fun thing that could have happened to us? My daughters love the pictures from this day. It's proof of their brief yet memorable status as VIPs.

Your Story

The places we go with children in tow are one thing. The places we choose to go alone or with our partner or friends is a whole other story. Documenting your time away is as important as documenting your family vacations—because as moms, it's not every day we get to get away. Whether you travel for work or play, focus on what makes your trip(s) memorable. What do you enjoy? What do you savor? Or what could you do without? It's fine to love travel and it's also fine to dread it. Every scenario is unique, just as every mom is unique. Your mission is to document the time you are out on your own adventure (with a grown-up travel partner or not).

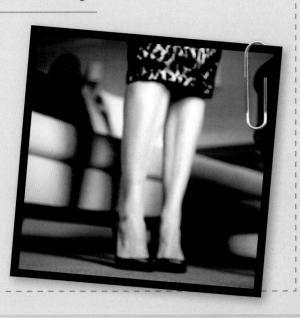

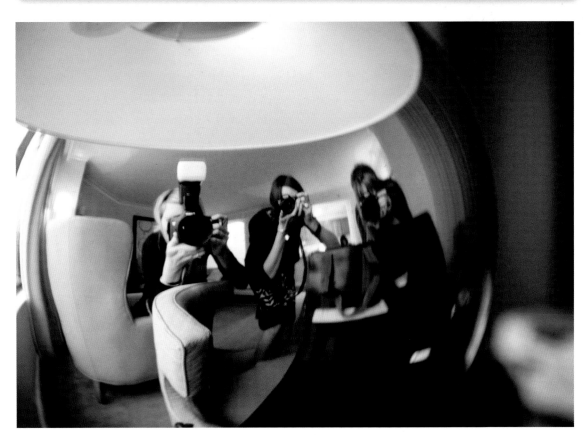

ELEVATE THE EVERYDAY

Creative Retreat (Left)
You know you're taking full advantage of being away when you order hamburgers through room service and find a million vignettes to shoot before you've even left your hotel room. Imagine having food delivered on a silver platter and having free time to play with your camera without a little voice asking to go to the hotel pool at 7:00 a.m. The friends I was with on this little work/play getaway were as snap-happy as I was, and totally inspired by something as basic as a table lamp. Glad I wasn't alone.

9
CONNECTIONS

THERE IS NOTHING MORE ESSENTIAL TO LIFE THAN HUMAN CONNECTION. FROM OUR EARLIEST DAYS WE BEGIN CONNECTING—TO LIFE, TO LOVE, TO SOURCE.

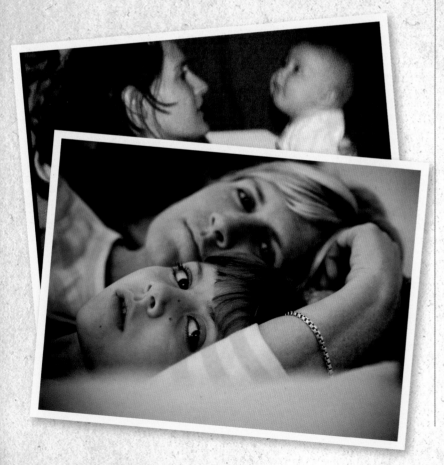

We immediately seek out connections through sound and sight, touch and feel. Day by day, we make our way by connecting with those who are a part of our lives. And as we grow up, these relationships shape us, sustain us, and carry us along our life's path.

From mother, father, sister, and brother to extended family, caregivers, close friends, and even pets, it is through our connections we thrive. The bond that we as mothers share with our children is unique—equal parts lovingly tender and fiercely loyal. It is complex, amazing, and is as important as any other connection could ever be. But we also cherish the connections our children have with people outside of us. We get as much joy in witnessing others love our kids and watching our kids love them back as we do in participating in our own relationships. Our kids are an extension of ourselves, so when we see them share bonds of love and friendship, we feel satisfied. Motherhood is funny that way. We simply want our kids to thrive. From the obvious to the more subtle, each connection is something to celebrate, honor, and document.

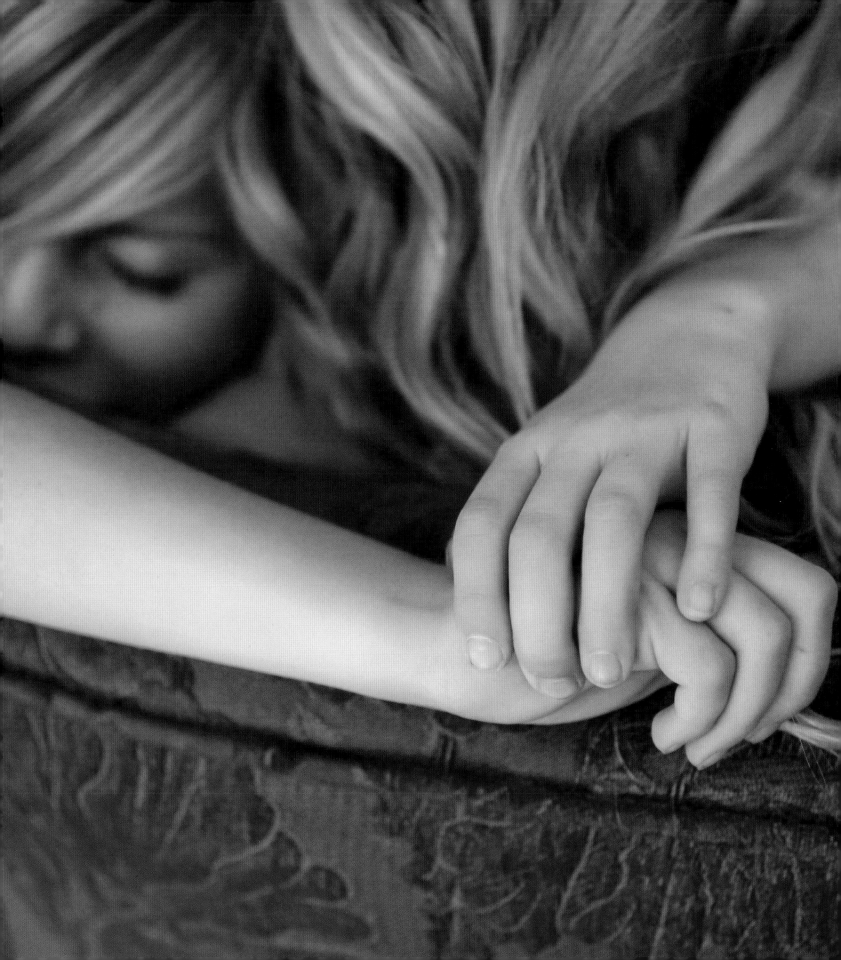

MOTHER & CHILD

Of all ironies, the number of photographs taken of a mother and her children together makes up a very small fraction of the photos taken over the course of a lifetime. This is partially because moms are often the sole family historian and are forever behind the camera, rarely in front of it. And even when we get the chance to be in the photo, we shy away.

I cannot tell you how many excuses I have heard, in my years as a portrait photographer, of why moms don't want to be in photos with their children. My simple response is this: you will never regret the photos you have of you with your children. And if that doesn't resonate, then think of it this way: every photo of you with your children will be a precious and priceless gift for them in the future. Whatever it takes to get you in front of the camera more often, I'm going to throw out there, because there is no more valuable photograph in any collection than a mother with her child. Not a single one.

A self-timer is a mother's greatest ally in documenting motherhood and memories. If you don't know how to use your self-timer, stop what you are doing right now and figure it out. I'll wait. It should only take about two minutes. And if you let it be fun, I promise it will be, and the more fun you have, the more your kids will love it.

STEP ONE: find a steady surface to set your camera on.

STEP TWO: focus on the spot where you'll end up being when the shutter clicks by pushing your shutter button halfway down.

STEP THREE: push the shutter button the rest of the way down (this triggers the timer).

STEP FOUR: rush to where your focus was set.

STEP FIVE: smile, laugh, and enjoy a little exercise and some photo fun with your kids.

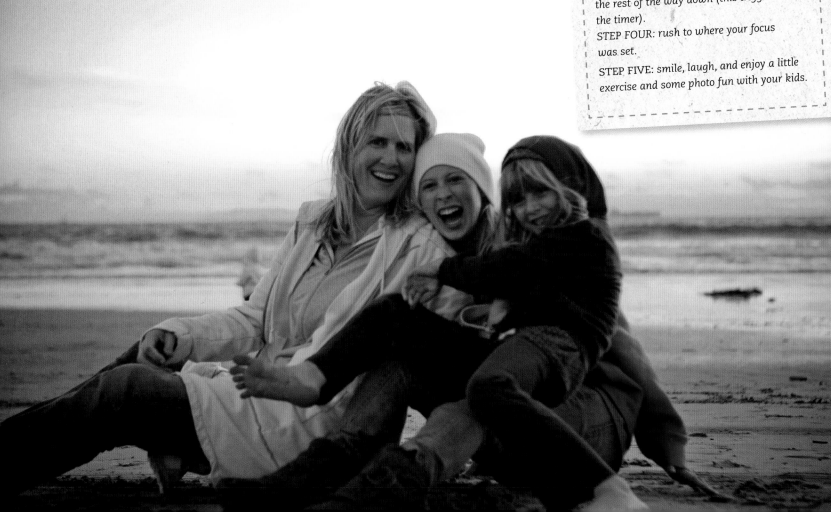

A FAMILY AFFAIR

If you can focus on something that sheds a light on those intricacies, your images will be worth a thousand words.

The photographs you will most treasure will be those where gestures of affection are present. When you are looking to capture the authentic relationship between people, seek out the visible connections, the body language, and the physical gestures between family members. When you distill those unspoken symbols of connection, you've captured something beyond a picture—you've created a family treasure.

Family ties are strong and the threads that connect family are what hold us together. As our children grow up, the special relationships they establish with family, whether immediate or extended, are unique, holding their own nuances and complexities.

Connections can reveal themselves in all kind of ways. And often the best way to find them is to be an observer. A moment of engagement like this between my daughter and her daddy was captured to look more like a dream than real life, with the glow of the late afternoon sun. Allowing for so much negative space around them was a deliberate compositional choice that enhances the emotion of the image.

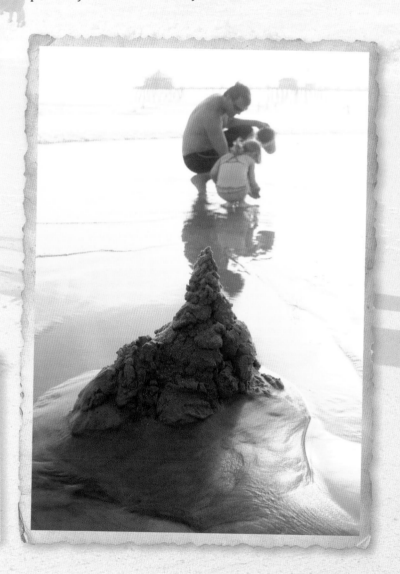

SISTERS & BROTHERS

There is no bond quite like the bond of siblings. Being one of three sisters, I know that to be a fact. But looking from the outside in relationships that complex may feel elusive. It doesn't have to be that way with our own kids if we take a documentary approach to observing and distilling the things that happen all around us.

That is to say, consider yourself a fly on the wall, and let your children reveal their sisterly or brotherly relationships to you. Be ready to capture what you see. As mothers, we get a daily inside look into the bond they share. Although we'll never understand it all, what we are continually privileged to witness can inspire some of the most special of all the family photographs, and the ones that will melt your heart.

 Your kids don't even have to be in the photo to have it tell a story. A shot like this one of a simple note from the little sister to the big sister shares a look into the fear she is experiencing as her teenage sister starts pulling away. These words sting like salty tears because I know exactly how she feels.

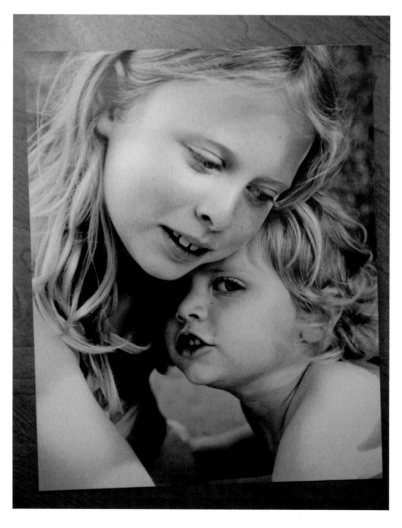

I never want you to leave me ever. I think we are great sisters.

Summer Sisters (Left)

I remember this moment like it was yesterday. A late August afternoon, mere days before my oldest started fourth grade. It would be hard for the baby to watch her sister leave each morning. It would be hard for me too. As they sat on the sidewalk, the hose gently flooded it with sun-warmed water. They tenderly held each other close, singing, and as they leaned together (with no prompting from me), all I had to do was click the shutter. The magic was already being made. I knew when I shot this it would be a favorite. I could just feel it. When that's the case, and you capture an image that you know will forever be a classic, consider processing it as a black-and-white image. There is nothing more simply, wonderfully, perfectly classic than that.

Blog Entries

June's Homecoming

Words and image
Gabrielle Blair
Design Mom
www.designmom.com

Have I told you about Flora June's homecoming? It was joyous. I think it was my favorite part of her birth.

June was born a little after 9:00 p.m. on a Friday night. Ben Blair and I woke up Saturday morning, feeling good and ready to get home, so we checked out of the hospital right away, about twelve hours after the birth. When we arrived home the house was peaceful and welcoming. Full of pretty spring light, with a kid-made welcome banner in the window. The five older siblings were playing at our dear friends' home, and the house was still clean and shiny thanks to a housekeeper's visit the day before. We settled baby June, unpacked the hospital bags, and took a very content nap.

An hour later the kids arrived home and it was like Christmas morning—all smiles and discovery. The siblings couldn't get enough of their new sister. Everyone took lots of turns holding her. Voices would start quiet and hushed, taking in this new little creature, and then get loud and boisterous because it was just so exciting.

I wish I could bottle the happy that was in the room that day. It was very clear to me that June will be as loved and adored as any human being ever has been.

Siblings

Words and image
Xanthe Berkeley
Shutter Sisters
www.shuttersisters.com

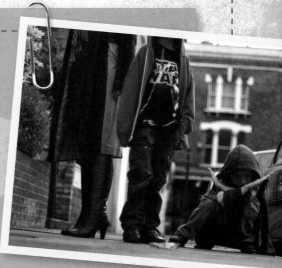

Three years ago, on my imaginary Christmas list, I only had one wish: that my two sons would be nicer to each other.

Back then, every day was a struggle, with constant fighting and very little goodness between my two- and five-year-old. I just wished for a bit more tenderness, companionship, and fun between the boys, to make the bickering bearable.

Since then, I've observed and photographed sibling relationships among adults and children, both friends and family, and witnessed a fascinating collection of positives and negatives, all with a unique bond. So I now realize that I already had my wish: they may not show their love for each other all the time, but it is there. I get real comfort remembering that.

This Christmas I'll watch my boys fuss, fight, and make each other laugh, like only they know how.

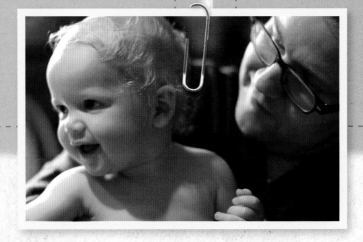

FRIENDS

In the early days we make our children's friends for them, and they usually consist of neighbors, our friends' kids, and family.

We encourage relationships and connections and watch them grow and bloom. Capturing these relationships from the start, you can actually see the progression happen as the kids begin to interact on their own and find their own space with friends.

When school days begin, you realize that your kids are not only capable of making friends, they find other kids they click with, just like we do. Being an observer as your child forges his or her own relationships can be entertaining, gratifying, and sometimes heartbreaking. Navigating friendships at even the youngest ages help us pave the way for future relationships. It's all a part of living rich, meaningful lives.

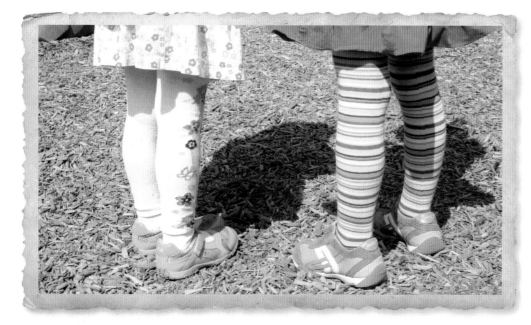

 Every friendship we forge along the way has its own unique charms. When you capture your kids and their friends, consider including something that speaks of their specific bond. Even something as whimsical as matching tights can shed light on the sweet nuances of connection.

Your Story

Making new friends and keeping the old are both a part of our motherhood journey. Time with our friends is valuable "me" time, and we can never build in enough of it! Enjoying your gatherings, get-togethers, and connections is essential to your overall well-being. Have fun documenting time with girlfriends. Celebrate your love of friendship through your lens.

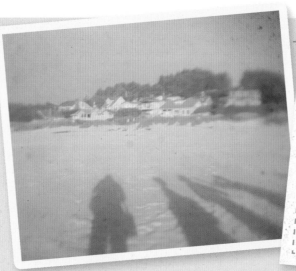

 For the last few years, I have met up with a group of friends for an annual creative retreat. The time we spend together nourishes and sustains me for many months to follow. In this shot, I focused on our shadows on the sandy beach. It is on this sand we meet each year, which makes a simple photo like this that much more meaningful. Playing with our cameras to get shots like these is integrated into our time together, which makes documenting it so easy and enjoyable.

PETS

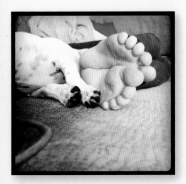

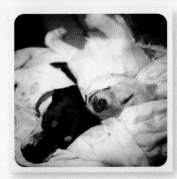

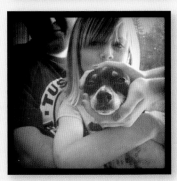

To have a pet is to know true unconditional love. Pets are companions, cohorts, playmates, and partners. They snuggle and sniff, purr and knead, and wiggle their way into our hearts, and we are never the same.

Whether we welcome pets into our lives as we raise our children, or if our pets came first and had to get used to the new members of the family, they stand by us, loving us and the children we share with them.

The complexity of the companionship of pets isn't easily understood until you experience it. Our pets are part of our family, and the love our kids have for our pets and the loyalty our pets give in return is photo-worthy from every angle.

Humor is a big part of being a pet owner. For as endearing as pets can be, they can be equally curious, playful, and zany, and when you mix that with childhood you can get hilarious results. Shooting the most absurd moments can help you tell great stories! And getting down on their level (both children's and pets') doesn't hurt either.

In the Moment (Below)
Shooting photos of pets can be even more challenging than children! The object (like in this shot) is to capture the moment without worrying about a pose. Pets don't always cooperate when asked to perform—plus, the more unposed a shot with your pet is, the more real it is.

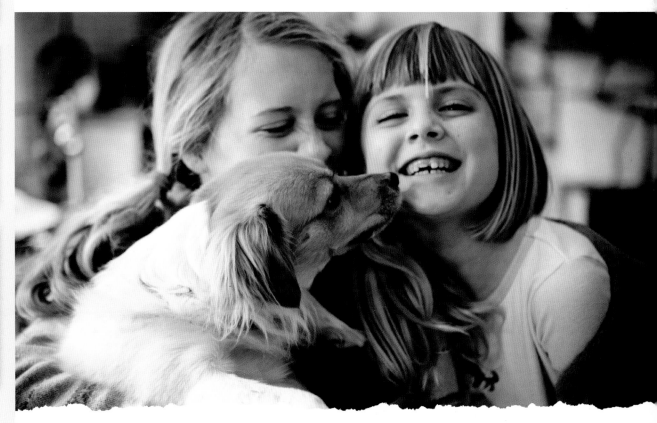

ELEVATE THE EVERYDAY

FULL CIRCLE

Discussing connections, family ties, and other nuances of various relationships wouldn't be complete without going back to the beginning—to our mothers.

How we were raised and the connection we shared with our own mothers (or fathers, or other main caregiver) plays a huge part in who we are as mothers. Whether we raise our kids in alignment with or in reaction to how we were raised (or maybe a little of both), our history has a place in our present story.

A Story of Motherhood

A Sense of Self

Words and image
Meredith Winn
the~spirit~of~the~river
www.meredithwinn.wordpress.com

When my mother took a bubble bath, she'd balance her white wine on the edge of the tub. I'd hang out with her in the bathroom, never wanting to leave her side. She'd talk casually to me and sip her wine as the ice clinked against the glass. I was not intruding on her time—I was silent and invisible. I had learned to be that way. I was simply the energy that flowed through the room, only wanting to be near that endless supply of mother love. Water would rise and fall over her breasts with each breath and laugh. This is what I learned by watching. This is what it means to be a mother.

I carry her with me now as I mother my son.

This middle place is not mid-life. It is merely space in time, a mathematical equation of birth-life-death. We spin in orbit here—spin out beyond ourselves, past freedom and invincible youth, but not yet to a place of rest. This place is the flurry and chaos, the fluttering of heartbeats like a hundred bird wings. One hand on a child and one hand on a parent, we are the balance, the weight centered on the rope in this tug of war where we hope not to forget our sense of self.

Collecting Memories (Left)
Knowing how much I value these images of my mother and me, I am motivated to create similar pictures of myself with my children. I know that each photograph captured will serve as a testimony to our time together; living, laughing, and loving.

Hope and everyday magic completes this circle. Our mothers instill in us this strength; we carry it silently and feed it to our own children. Drops of love melt like snowflakes on tongues. We draw upon this sweet elixir in times of weakness.

This is the beauty that surrounds us when we face challenges. This is the power of truth and the remembering of love. The emotions and memories of life and love are stored in my fat cells, in the creases of my stretch marks. They tell me the story of who I am.

Mother. Woman. Artist.

Yes, life is messy. Life is weird and mysterious and, surprisingly, most often not what we expected. How we handle it, how we view it, how we shift in our seats to change our perspective all plays a part in our experience. Looking for the light shifts the energy a bit, leaving empty hands free to create again. Leaving empty hearts ready to be filled. There is beauty in the decay. Find your truth by using your heart and mind and art. I say this out loud so I never forget.

Part of me needs to visually define my sense of self and how it changes as life moves forward. There is no easier nor harder way to do this than through self-portraiture. (And so I take photos.) My camera documents the space between here and there, joy and sorrow, and all the days between.

I take photos of the air around us, the magic that lingers there and the tenderness that rises after trying to find the right words. He has questions about my mom's illness. Of course, there are never enough answers to face the concept that is shattering his six-year-old world: mothers die. He sees past my explanations, past my tears and wobbly voice. He sees straight into me just as the lens of my Nikon peers unblinking, unflinching at the truth of who I am.

I focus the lens on myself to see what he sees in me. Catching a sideways glimpse of this mother I am, even if just for a moment, is helpful on hard days. When life is heavy like fog and the weight of it is bigger than life and death and sadness and truth. Photography teaches me to see, to be gentle with myself on this mothering path, and to hold myself with quiet regard for what I am right now, and for what I hope to become.

One thing I know is that sometimes things break. Yes, and even so, mothers raise their boys single-handedly and gray hairs sprout and crows' feet land and bad moods rise and love exists and life moves on. I now understand that there is endless strength in this.

When you preserve graceful beauty through photography, you also preserve fierce savage strength. Photography helps me look deep to find my roots. Then I look deeper to find the mud from where I grow. My story of self lives in that rich earth.

We (you and me) are women, mothers, and artists. We are like colored glass bottles gathering light on windowsills, reflecting and refracting beauty and pain, with chips and blemishes, age and history, all in one mighty collection. Through art, images, and shared truths, we give each other the weight of our words, our daily stories of struggle. This is what it means to be human. These relationships push and pull like taffy, stretched so thin that you just can't believe there's any more slack, when suddenly it folds upon itself and wraps around you with sticky arms of love.

10
AFFECTIONS

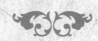

FROM THE STORIES I HAVE BEEN TOLD OF MY OWN CHILDHOOD, I NEVER REALLY HAD "A FAVORITE." NO BLANKET (LIKE MY SISTER), NO THUMB (LIKE MY OTHER SISTER), NO FAVORITE STUFFED TOY (LIKE MY DAUGHTER).

And yet, being a mother now, I know that even beyond "the one and only," there are fleeting affections that span the weeks, months, and even years of childhood.

I can recall my favorite red and white party dress. I remember my Snoopy phase. I still crave my favorite hot cereal, made only as my grandmother could. Musing on these memories takes me back to what feels like a lifetime ago, but the nostalgic presence of these affections are still with me, even after all these years.

I realize now that our phases and favorites are what brought us comfort and joy as children. Even more, they made us feel secure and taken care of. Who knows why children choose the things they do. Sometimes what they choose makes no sense, and sometimes, the levels to which they take their affections make us cringe. Stories of stinky, tattered threads of blankies that aren't allowed to be washed, or the wearing of rainboots around the clock, or mac and cheese for every meal resonate with most mothers—we have all been there.

We want to capture the sweet stuff in our photography. It's endearing to see our kids in their happy place with their most favorite things in the world (especially when those things are cute), but we also can't forget the more mundane pieces and parts that make up our daily lives. The things we swear we can't wait until our kids outgrow . . . until they outgrow them. Until we forget. The crayon stubs, the sparkly scuffed red shoes, the awkward brontosaurus, the naked Barbies.

As you document your daily life, remember the objects of affection. The ones you love, and the ones that only your children could love. Take note of pastimes and phases and stages that are making up your daily life right now. Allow yourself to capture the essence of what your children might be into at the present moment, even if you're sure it won't make a good picture, or you're more sure you'll never forget this time. Your images will help you see the more endearing and even photo-worthy side of nearly everything. It's part of the gift of photography. Eventually, these images will bring back a bittersweet recollection of days past.

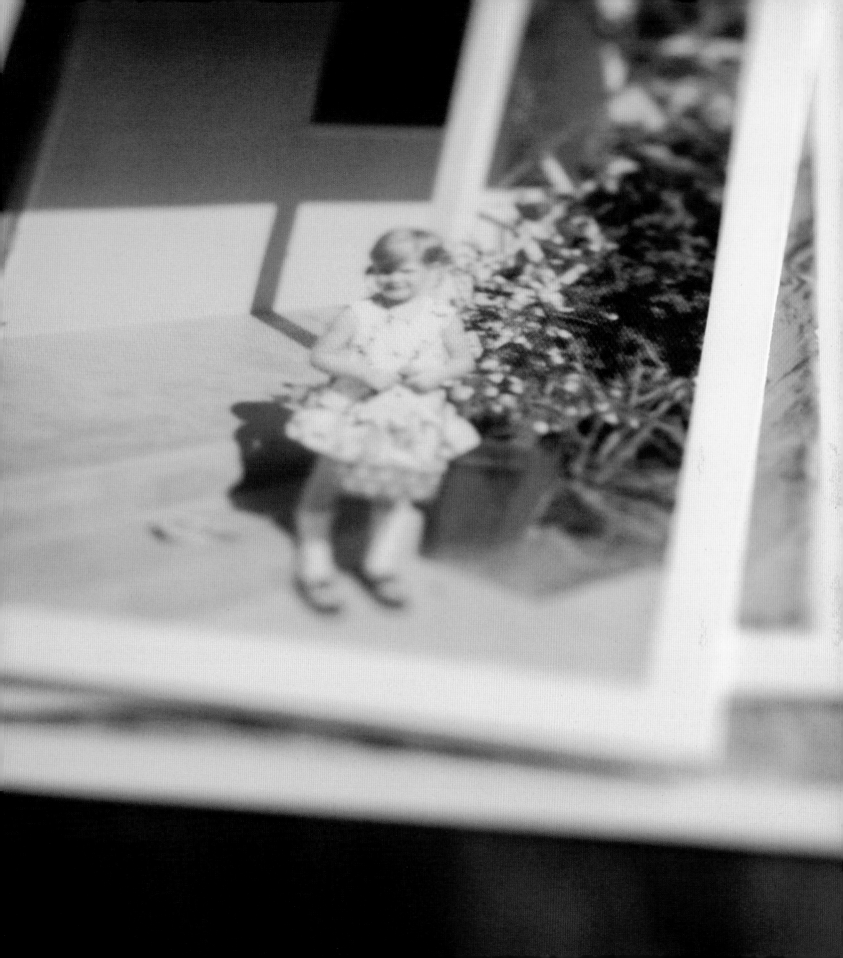

APPAREL & ACCESSORIES

How our kids dress and how they choose to accessorize can reveal a lot about them.

Even from a young age, children seem to gravitate to certain types of clothes or accessories. It can be humorous, endearing, and often annoying, but these are the things they grow out of (quite literally, when clothes are concerned), so the moments pass far more quickly than you might think.

When capturing what your child loves, let the accoutrement help you decide how to best feature it. If it's a tiny earring, a close-up of the detail will work. If it's an entire costume that your child wears long after Halloween, including it in the everyday context of your life may tell the story best.

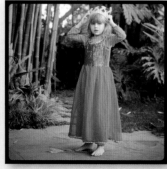

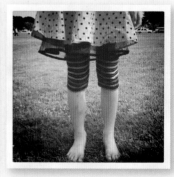

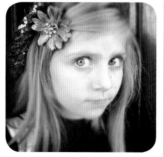

ELEVATE THE EVERYDAY

Blog Entry

The Striped PJs

Words and image
Ali Edwards
www.aliedwards.com

The other day I was folding Simon's pajamas and I was thinking about how much he loves them.

One pair of stripes. Two pairs. Three pairs. Four pairs. Oh yes, there's more.

They've seen holidays and everydays and vacations and airplanes and so many movies and breakfasts, and maybe even a few dinners.

Some pairs are just about ready to be retired and a couple new ones have been added to the rotation.

He loves to put them on in the evening and will wear them as long as possible on the weekends.

Only the long-sleeved and long pants sets—no short sleeves and shorts for him.

Sometimes I wonder if he'll want to keep wearing these into adulthood. Lucky for him they actually make them in adult sizes.

Here's to loving something in your own life as much as Simon loves his PJs.

PLAYTIME

No matter how many toys and games are stuffing your closets, our kids almost always have just a few of these they gravitate toward. Their affections toward particular activities begin young. And as they grow, they learn to engage more and more.

With each stage of development comes a new favorite toy or activity. Day after day, our children pull out the same toy bin, line up the same barnyard animals, build with the same Legos. As you observe (and often join in), consider all of the creative ways you can capture the moment of engagement. These are the images that will later evoke responses from the family like, "Oh, I remember when I used to . . ." or "I used to love . . ." and will continue to live on as reminders of our kids' childhood.

As your children grow and begin to turn their attentions beyond your four walls, the documentation can slow, or sometimes cease altogether. Although we are often totally immersed in our children's activities, we don't always think to make a record of these interests and how they influence our daily lives. Honoring where our children are focusing their attention can also be a way of supporting them on their journey. Coaching your child's soccer team, for example, can take up time; we're busy living these interests, not necessarily observing or even enjoying them.

But remember too that you are forever the documentarian. Ask yourself, "What is it about this activity or obsession that is so appealing to my child?" Seek out elements that could be used as visual symbols. This approach helps keep your photographic perspective fresh. By seeking out the love of the game (so to speak), you will be more inclined to want to capture the magic of this time of your lives.

It can be easy to photographically overlook the favorites of our older children. Skateboards aren't nearly as endearing as stuffed bears, but the inclinations of our kids as they transition into tweens and then teens can offer windows onto what they might enjoy for their entire adult life. Supporting these interests not only keeps you connected to your child—you could be fostering something that may remain relevant in the future and that future will be here before you know it! You may wish they would spend less time playing video games and more time doing other things, but one day you'll long to open her bedroom door to find her flopped on her bed, engrossed in play.

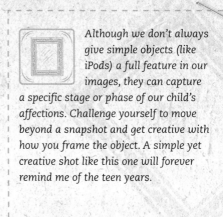

Although we don't always give simple objects (like iPods) a full feature in our images, they can capture a specific stage or phase of our child's affections. Challenge yourself to move beyond a snapshot and get creative with how you frame the object. A simple yet creative shot like this one will forever remind me of the teen years.

Fun and Games (Right)

Having a nearly six years' age difference between my daughters has always meant struggling to balance two totally different life stages. I remember when my oldest went through a Yahtzee phase. Although my youngest was far too young to understand it (let alone add up dice or write her numbers), she would never miss a game of Yahtzee. She would take her turn, rolling the dice three times. And she would hold her pencil with tiny fingers, marking small, meticulous circles in the boxes of her scorecard. She was as content (if not more) than she would have been if keeping score. Seeing a photograph like this in my collection melts my heart. Sometimes a mere object or game itself can communicate far better than a more obvious shot.

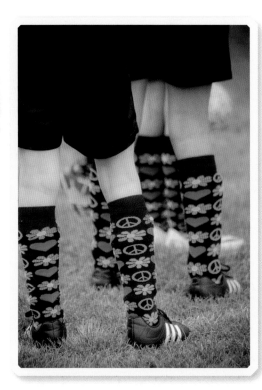

Sports photos from one season to the next can all blur together. Try focusing on telling elements from each season to set each year's photos apart. Something like these bright and colorful socks will always stand as our reminder of playing soccer in the off-season.

Your Story

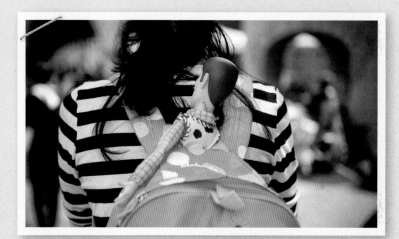

Where do you fit into your child's favorite? Are you happily making pancakes every day, handwashing a pink tutu, or keeping a keen twenty-four-hour watch on a cherished toy?

As mothers we are often asked to put ourselves last. Rarely are we asked what we want, what we like. Instead, we read books our kids want to hear (over and over again), we listen to music they want played and replayed, we taxi them from one activity to the next (with little complaining). Without a doubt, the affections of our children alter how we live our lives in one way or another, so the object of your visual storytelling is to express how your life revolves around these things.

This story doesn't end with your children and their flights of fancy. Capturing yourself as you are involved can not only round out a visual story, but can also help you to pull in traces of yourself as you follow and encourage your child's every passion (or whim). You are saying to your children that what is important to them is important to you. I value it because you do. It's a message and a feeling we all want our kids to carry.

WHAT'S REAL

Although some of our children's affections can change like the tides, it's just not always the case. I couldn't write a chapter about affections and not talk about the one and only "lovey." Just like with any of the other favorites, there is no telling what draws babies to the special something that ends up being the one single thing they would never, could never live without.

But no matter how it happens, one day you realize that your child has established a relationship to something that has nothing to do with you. A bond has been established—or perhaps a dependency or even an obsession—that defies all reason, and there is not much else to do but document it in photographs. If this "lovey" is in fact something with a face, then it—from my own experience with a small bunny named Guy—becomes not only a preoccupation, but a part of the family. Any mother who has a child with a favorite thing knows exactly what I mean. And there is nothing I wouldn't do to make sure that Guy is safe and sound day in and day out. Such is the life of a parent with a lovey in the family.

When your child has a favorite—like a blanket, for instance—chances are he or she rarely puts it down. Depending on how you look at it, a blanket might be one of the easiest favorites to photograph. To capture the truest story of your child and their favorite, the shots that will be most cherished are those moments caught in context. How your child holds the blanket, how she snuggles with it, or smells it, how she rubs it or twists it around her finger. Whatever the case, work to gather a collection of images caught in everyday life, the kind that will remind you of how your child's days were spent with her object of affection. Contrary to how it might seem, our kids will slowly loosen their grip on these objects of affection.

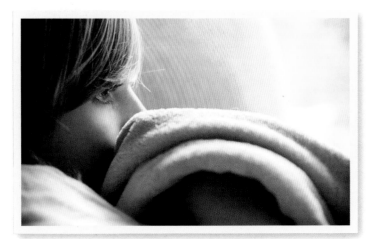

Comfort (Far Left)

Nothing can comfort my daughter like her blanket. In this shot, I kept it as simple as possible. Beautiful light, my daughter's partial (and utterly relaxed) profile, and the simple, soft folds of her favorite blanket.

Personality Plus (Left)

Because this rabbit is indeed a part of our family, taking photos of him now and again is part of the routine. I try to capture a little expression, gesture, or personality that brings him to life.

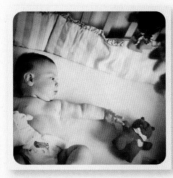

ELEVATE THE EVERYDAY

Remember the story of *The Velveteen Rabbit?* Then you know that through the years, your child's lovey will change as much as your child will. Your child will grow and change, while their lovies will change in a different way due to wear and tear. With each touch, hold, carry, toss, drag, sniff, tug, and hug, your child's prized possession will lose its shape, its stature, its color. Just as with *The Velveteen Rabbit*, love will certainly rip seams, discolor fabric, and remove fur (as well as eyes, ears, arms, or legs sometimes). This is when things get real. Consider documenting the process of how love works on your child's favorites. After years of affection, you'll hardly remember what that lovey looked like before the love.

Bunny Love (Right)

Because snuggling with lovies usually induces calm and comfort, your job is pretty easy. Sleep is always a good time to capture a telling moment of your child. My daughter used to suck on the arm of her favorite bunny. I have a photo library full of images of her and Guy, especially the ones of her in her daily routine, with this rabbit hanging from her mouth. The photos are more hilarious than anything else now, but this image of her napping with Guy stands as an all-time favorite. I took this photo only a few weeks before we had to draw the line and help wean her from sucking her bunny. It's these stories behind the shots that often make our images even more meaningful.

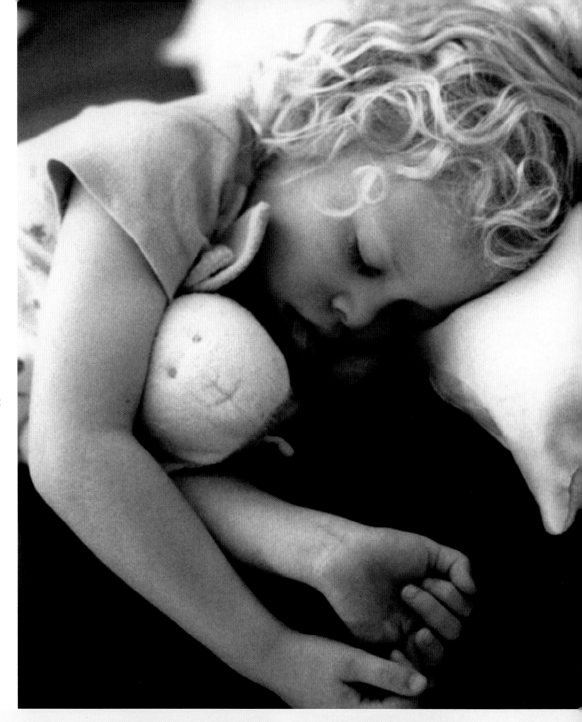

WHAT'S REAL

The dark side of some favorites might not be what you care to bring to light, but when you do, you've shared a story of reality. And reality can be ugly. In this case, these ratty old threads are heaven for one child, but not necessarily for his mom. And yet a photo of this authentic detail can be endearing if you learn to embrace the dirty laundry. To get up impossibly close to an object (or a person), you'll need a lens that allows you that option. Macro lenses are creative and useful tools for just this scenario.

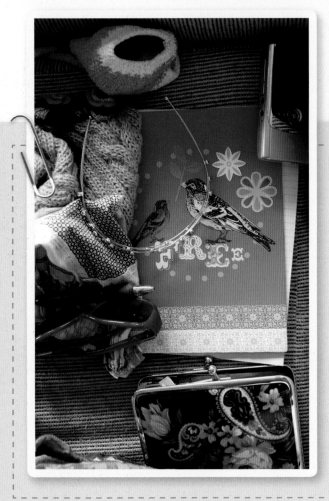

Your Story

Amidst the everyday of motherhood, we can't lose sight of ourselves. In this light, I encourage you to keep in mind all of your own affections. And I give you permission that they don't have to be associated with the things your children like! Focusing on our favorite things can bring us joy and help us to remember who we are (besides merely "Mom"). What can you do to document the things you love in a way that brings you joy?

Our own affections can lie within hobbies, books, recipes, outings, accessories, and more. No doubt some of yours will change over time, but keeping a running record of your favorites can be a fun and creative way to use your photography while continuing to tell the story of you as a mother and a person.

Old Soles (Above)

I wore these shoes almost every day for three straight years. I'd still be wearing them if I didn't get gum on them somehow and if my family didn't give me such a hard time about me wearing them for so long. Three straight years is a long time to do anything, let alone wear the same shoes. With a love and commitment like that, I had ample time to document my feet with the shoes on them.

Blog Entry

Perspective

Words and image
Andrea Corrona Jenkins
Hula Seventy
www.hulaseventy.blogspot.com

When things get to be too much, I ride. I get on my bike and I ride and ride. When my head is a mess and the house is a mess and the kids are a mess and supper is not magically appearing as I was hoping maybe it would, I head for the garage. This is where my favorite bike waits patiently for me. If I can, I ride during the magic hour when the long legs of daylight stretch out before me and the tops of the houses glow. I pedal as fast as I can. I coast, pedal, and repeat. My old bike rattles and creaks like an old carnival ride; this makes me love her about a hundred times more than I already do.

I ride past manicured yards and unruly ones, past papery poppies and complicated irises, past my favorite aqua-colored house and the convenience store on the corner. I collect the scents of the neighborhood as I go. Grilled beef from the Vietnamese restaurant down the street, laundry drying in a basement, grass wet from sprinklers, hints of honeysuckle. Discarded items sit in jumbles at the end of each driveway in anticipation of trash day. A broken shovel, a tangle of white tubing, a seatless tricycle, a metal shoe rack that has obviously been replaced by a shinier, more promising shoe rack. They know they are headed for the dump, but remain oddly hopeful. Past trash and recycling bins I ride, past a Little League game in full swish and the school playground, onto familiar and unfamiliar streets. I am always changing my route. I never take the same way twice.

It's been exactly one year since I bought this bike. Best eighty dollars I ever did spend. Because when I ride, things fall away. When I ride, it feels a little like flying. And when I get home, dinner still has to be made, messes still have to be cleaned up, deadlines still wait, but I am a thousand pounds lighter and my mind is quiet. And that's definitely worth eighty dollars. Plus all the rest of the money in the world. And then some.

11

MILESTONES

TRAVELING THE PATH OF MOTHERHOOD
MEANS ANTICIPATING, APPROACHING,
AND ARRIVING AT A GREAT NUMBER
OF MILESTONES ALONG THE WAY.

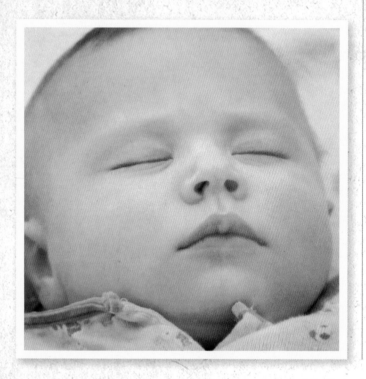

Most of the milestones our children experience are "firsts": first steps, first haircut, first day of kindergarten, first sleep-away camp. Even still, the word first implies that there are likely more to follow. Although some milestones may be celebrated only once (the first haircut, for example), others will be celebrated regularly. For example, the first birthday—although a very big first, it is followed year after year by similar pomp and circumstance. Whichever the case, these are only some of the events that kick off the momentum of life full of the big stuff. The special occasions, the celebrations, the benchmarks of our children's journey.

This chapter is dedicated to the quintessential and momentous highlights of life. Although so much of the everyday consists of the little things, these big things are the milestones we often recognize universally and use to gauge our way. They remind us to honor and celebrate not only our children, but also ourselves.

FIRSTS

No matter where you are on your motherhood journey, there are firsts to celebrate. You don't need to have a baby in the house. Baby's firsts are delightful and magical, it's true, but so are all the countless others that happen along the way.

Remember that just because there isn't a book to fill out for older kids (like our beloved baby books), you shouldn't stop documenting the many milestones of every age. From the first day of kindergarten to the first day of college and everything in between, these occasions are big, for our kids and for us.

You Are Special (Above Right)
We celebrate more than just birthdays with our coveted Waechtersbach Red Plate. Any and every milestone in our family calls for something special being served up for the honoree. In this case, it was the first day of high school. A single candle represented this momentous first.

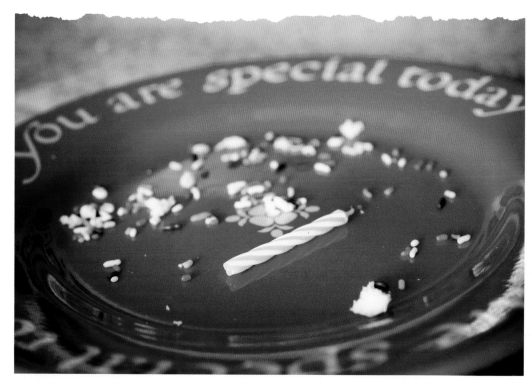

When focusing on something big (and obvious) as losing a first tooth, consider taking a more candid approach. When we prompt our kids to show off their brand new smile, they will—usually with a big cheesy grin. That works fine sometimes, but try waiting just a few moments longer for a more relaxed smile that will likely be more "them." This shot of my daughter was taken on Thanksgiving, the morning after she lost her first front tooth. She had a lot to be thankful for, (and her expression and new smile) proved it.

TRANSITIONS

Although some milestones happen on one particular date (the first day of school, for example), many of life's highlights occur more as transitions from one way of being into another—like potty training or sleeping through the night.

Your child might vacillate back and forth for a while between two states, until one day the transition is complete and it's taken you (and your child) from one place to the next new adventure. These kinds of events can be duly documented by capturing the process and progress of our kids and ourselves during this stage of transition.

Life is a Process (Above Right)
Being potty trained is a milestone, but potty training is also a process. Capture the diapers, the small toilet, the big one, and of course the big-kid underwear to tell a complete story of how your child got from there to here.

Mobility is one of the common themes of growing up. Each milestone—sitting up unsupported, crawling, standing, walking—seems to lead to just another step toward independence. Consider documenting the joyful yet bittersweet moments of our children's (quite literally) moving on. From crawl to walk to ride to drive, this mobility—each step of the way—is made to be commemorated by your lens. With a simple, unexpected crop like this, a shot of your baby crawling can visually symbolize how quickly they move and how fast they grow up.

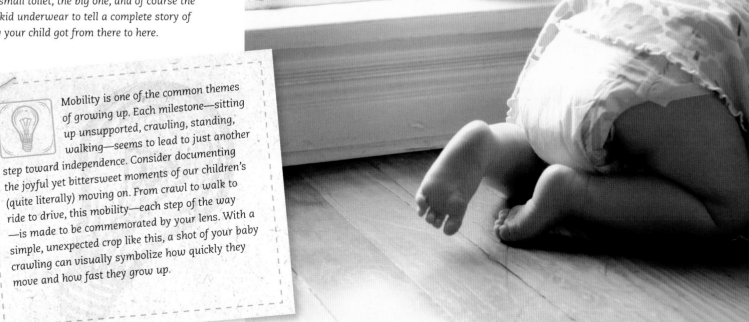

BIRTHDAYS

Each year we celebrate birthdays, and every one brings something new: one chapter closes, and a new chapter opens.

Candles, cake, the birthday song, and festivities of one kind or another are symbols of celebration that help us ritualize this very important milestone. The props may stay the same (give or take chocolate cake or vanilla), but the honoree changes a bit with each passing year. There's something about tradition, doing it the way it's always been done, that gives us and our kids that comfort of ritual. Birthdays might include similar bits and pieces year after year, but that's just the way we like it.

Indecisive (Above Right)
We bake our own cakes each year, but usually decide on only one flavor. This was taken when my youngest just couldn't decide which she liked best.

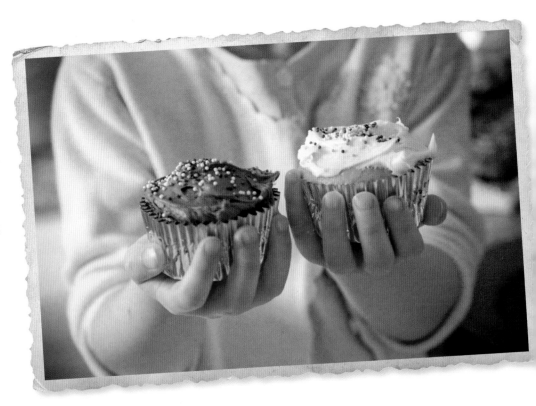

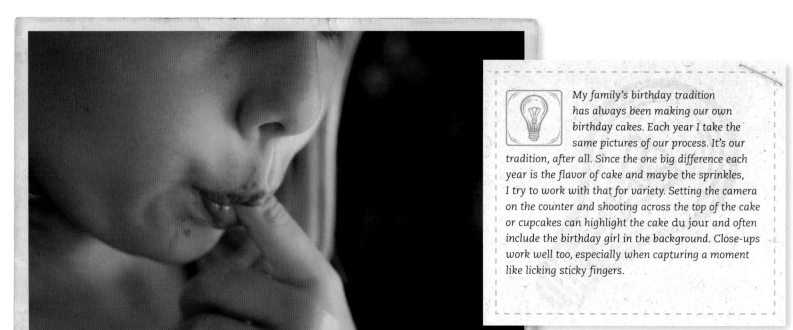

My family's birthday tradition has always been making our own birthday cakes. Each year I take the same pictures of our process. It's our tradition, after all. Since the one big difference each year is the flavor of cake and maybe the sprinkles, I try to work with that for variety. Setting the camera on the counter and shooting across the top of the cake or cupcakes can highlight the cake du jour and often include the birthday girl in the background. Close-ups work well too, especially when capturing a moment like licking sticky fingers.

 My daughter's feelings were perfectly captured here, right through the net of a birthday bounce house. The original color version was distracting, but as soon as I removed the color, the emotion came through. I had no idea if I'd be able to effectively shoot through the net, but I went for it anyway. To my delight, in black and white, the netting actually enhances the shot through the repetition of lines and the context it gives. And the frame of the window framing my subject makes it even more effective.

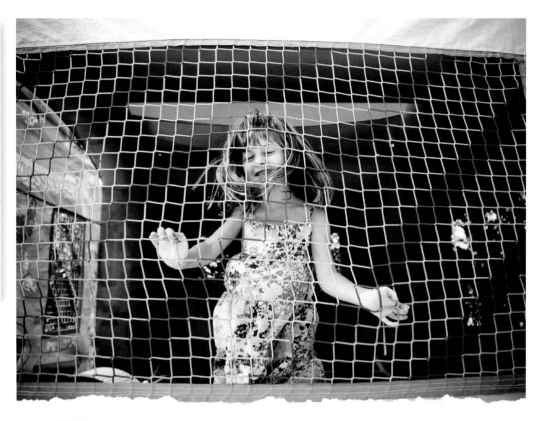

The mark of another year can be captured in a more subtle way by focusing on the emotions of the event. Joy, elation, hesitation, exhaustion, satisfaction, or whatever it might be. Whether your child hasn't napped and is on a sugar overload, or you've frosted one too many cupcakes, everything that goes into a birthday (both energy and emotion) takes it out of a mom. Seeing a glimpse of that through your lens just adds to the story. Amidst it all, allowing yourself some time of reflection during this very special, very sacred time of year—the marker of your motherhood—can open up an entirely unique perspective.

Your Story

My mother gave me this bracelet for my daughter's first birthday. It was a trying year, and being given a gift that recognized and honored that first-year milestone meant so much to me. It's the kind of memory that evokes a feeling I want to hold onto. The feeling that with each of my daughters' birthdays, I too am growing, changing, and evolving as I raise them.

Remember that reflecting on milestones from your perspective as a mother might be a completely different experience to your child's as he or she passes milestones. The push and pull of emotion that often arises with each big step can blindside you when you're not expecting it. Keep in mind that all of these feelings (both in celebration and in heartbreak) are natural. If you can take a look through your lens with all these complex and contrasting feelings, the story you can tell is one that often means the most.

CULMINATIONS

For as much as the big events feel like new beginnings, many are actually endings as well. Graduations come to mind, for as much as they mark a whole new chapter, they equally mark the end of another. Sometimes focusing on the end of something and photographing that can be far more powerful and evocative than the celebration of the start.

For me, the night before my daughters' birthdays often evokes as much emotion as their actual birthdays do. After all, saying good-bye to the past year is a part of welcoming the future one. The endings, along with the letting go, are aspects of motherhood that remain constant. Every day, every year, through the big moments and the small, it's a bittersweet experience of fleeting moments.

Guest of Honor (Right)
Ever since my daughters were very young I would get them involved in preparing for their own celebrations. Including them in even the simplest of tasks brought them (and me) joy and helped all of us mark the celebration of the milestone at hand. When looking through a celebratory lens, everything is photo-worthy.

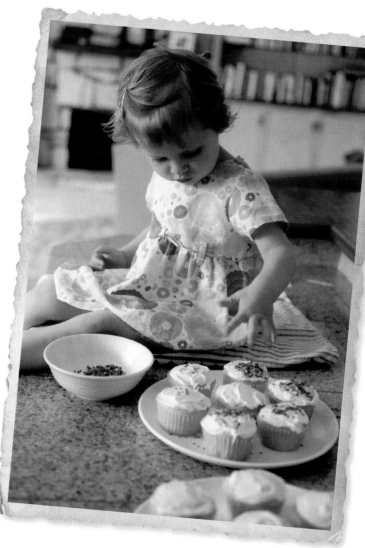

ELEVATE THE EVERYDAY

Blog Entry

Thirteen Years

Words and image
Tracey Clark
www.traceyclark.com

Today, my firstborn baby is celebrating a milestone birthday. She is turning thirteen. Last night, amidst the normal routine of piano practice, homework, dinner, and more homework, I was compelled to capture her last evening of twelve. I know she has been waiting for this day forever (being the youngest in her class gives her good reason to be eager) and yet I could also sense her hesitation. She is beginning a new chapter as a teenager now, and with that comes all the stuff that we've always heard about teenagers (which isn't all that complimentary, in case you hadn't noticed). I think with her newfound status, change will be inevitable, and so comes fear. For both of us.

What will this mean? What is different now? I guess the answer is simple. Nothing and everything.

This morning we all awoke to sleepy yet excited exclamations and birthday wishes. I said to my youngest daughter, "We have a teenager in the house now," and before I could even finish my thought, the birthday girl chimed in from the other room with an urgency in her voice, "I'm still the same person!"

I get it. The fear of uncertainty. The mixed emotions about the great unknown. The joy. The anticipation. The worry. The celebration. And so it goes, on and on into forever.

Like with most milestones, this one is bittersweet. I feel that familiar push and pull of motherhood that constantly asks us to love and let go. Love and let go. Love and let go. Although it's a daily experience, we are so busy living, we don't always notice it. That is, until they take their first steps, start kindergarten, turn thirteen . . .

It is such a honor and a privilege to be given this gift and yet, with each tug of letting go, our hearts break a little bit. Even when you've felt it before and know it's coming, it still hurts.

I sit here at my laptop, eyes wet from crying mama milestone tears. I look back at birthdays past, at photos and stories and memories from my baby's birth up until now and every minute in between, and I can't stop crying. Thirteen years of loving and letting go streaming down my face like some kind of salty holy water, soothing my heart, cracks and all.

This is motherhood. This is life. And I wouldn't trade it for anything.

HOLIDAYS

If your family is anything like mine, the year is plotted and planned out around annual holidays. Between family, friends, and school activities, our lives circle around the calendar of holidays.

Each year is a little different from the next, although some traditions, holiday rituals, and routines remain constant. For me, capturing each holiday and what it means from year to year has been a creative way to express the life of our family.

More often than not, people choose to document these momentous occasions through posed shots, pretty faces, and new outfits. But, don't overlook the genuineness of the holidays. Yes, they can be overwhelming (and, quite frankly, overrated), but they can also bring magic and a sense of wonder and a chance to see the world through new eyes—your child's eyes. If we can take this approach as we document holidays, we can make the images that will tell the stories of what holidays are really about. And focusing on joy and beauty is one way to celebrate through a lens of gratitude.

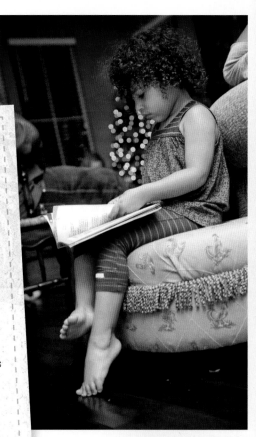

 It can be a challenge to shoot with a flash indoors and still get the ambiance and enchantment of the moment. Although your camera's flash can be inconsistent and difficult to get down to a science, you can try the tissue-paper trick discussed previously to give you softer and more even light. If you have an external flash (one you bought separately that you mount on your camera), you have a little more flexibility. "Bouncing" your flash off of the ceiling or a nearby wall softens the light from the flash, giving you a soft, natural result. It's as simple as pointing your flash away from your subject and toward a nearby surface (light-colored walls are ideal).

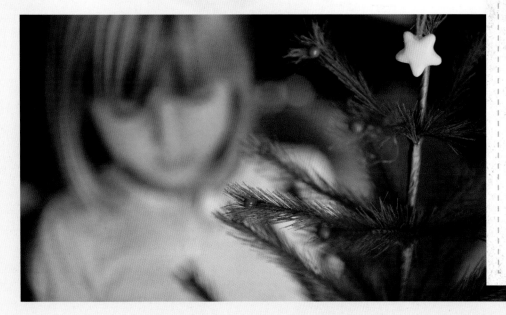

 Consider taking a documentary approach to your holiday photographs. When you become the observer (and not the prompting photographer) you can capture the kinds of moments that will make your mama heart skip a beat. When your kids are consumed by an activity (such as collecting Easter eggs or decorating a Christmas tree) you can capture natural and earnest expressions of what the season, and your child, is all about.

Allowing your children to enjoy their own process (whatever it may be), you can afford yourself some time to get creative with your angle and composition as you shoot them "in their own world." Don't be afraid to get up close, or get down on their level (shots from the floor are my favorites). When you relax and let your children be themselves, you let photographic miracles happen.

SPECIAL EVENTS

Momentous occasions come in all shapes and sizes. Sometimes an event like a grandparents' golden anniversary or a family wedding can be the mark of something special for our children. If you've ever had one of your children act as a flower girl or ring bearer, you know exactly what I mean.

Capturing the story of an event should include both the portraits of the key players as well as the details of what made the event memorable. Beyond the traditional group shots, observe the elements of the occasion that stand out to you: the colors, the flowers, and other iconic symbols of the event. These detailed shots, like how big your son's mini-tux was on him, will work together with the portraits to create a visual record that will be as unforgettable as the event itself.

All Dressed Up (Below)

One unique thing about special occasions is the wardrobe. Sometimes these are the only occasions when we really get dressed up. That means something different for everybody, but don't forget to capture the costume of the occasion to tell a special story.

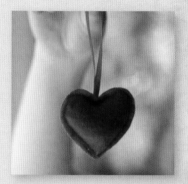

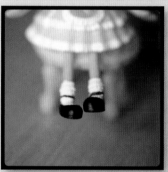

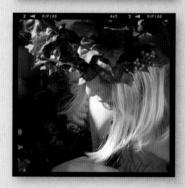

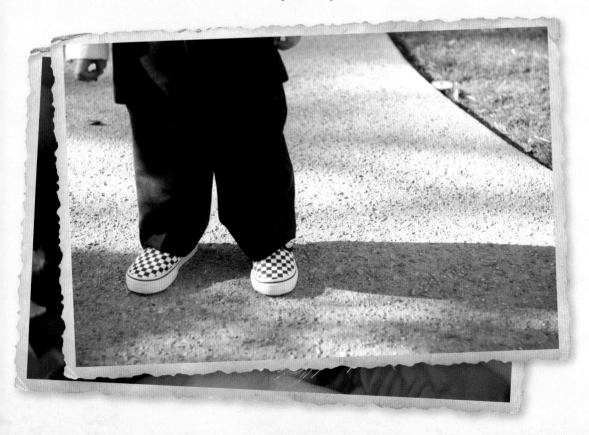

ELEVATE THE EVERYDAY

THE INEVITABLE

Being the mother of a teenager gives me a different perspective than the one I had when my children were much younger. In the baby ~~daze~~ days, you couldn't have convinced me that the time would pass this quickly. Nor would I have believed that documenting my teen would be nearly as fun and rewarding as documenting my baby or toddler. It would have been inconceivable to me.

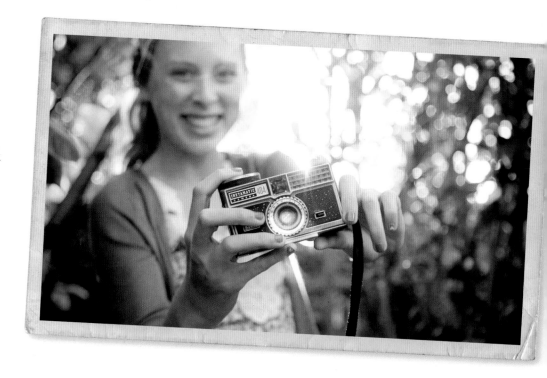

But fast forward to today, and with the start of high school, everything feels new. We are in a world of "firsts" with my daughter that rivals the pace of her first year of life. First football game, first homecoming dance, first tryouts for musical theater. It's exciting and exhilarating and totally terrifying. Why? Because I know what comes next. These firsts lead to the next ones, the ones that lure her away from me. Driver's license. College applications. Moving out. If there is ever a time I know that the next few years will move at warp speed, it's now. And I don't want to miss a single minute with my trusty camera by my side as another way to focus on what's important, to really see the magic of these days, and to capture them in a way that will not let me forget. Ever.

A Thousand Words (Above)

Now more than ever I realize that every photo that captures the heart and soul of my children was worth taking. It makes me so happy that my daughter now enjoys the photos I've taken of her throughout her life. It might just be the greatest gift of all.

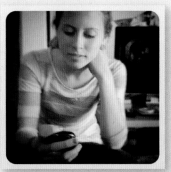

ELEVATE THE EVERYDAY

A Story of Motherhood

A Letter to My Son

Words and image
Stacy Julian
www.stacyjulian.com

My firstborn son left this summer to attend a university out of state. I cleaned and packed up his bedroom and his childhood. I put all the mementos, trophies, trinkets, and notes in a big Rubbermaid bin, and then I put the lid on.

I knew this was coming.

I knew I would be sad.

I did not expect the extremity of my sadness or the empty heartbreaking feeling that lingered at my very core.

I find solace in words, which often take the form of a letter. This letter to my son has helped me heal. Perhaps my words will encourage another woman in my age and stage to explore the balm of self-expression.

Dear Clark,

As I boxed up the remnants of eighteen years and a million moments, I giggled at the memory of your winning the "diaper dash" on an unplanned stop to the supermarket. Other moms coaxed their toddlers to the finish line while you, sans any prodding, knew precisely what to do and walked out with your Little Tikes prize in tow. I smiled as I remembered you pointing out the car window exclaiming, "capidal bealding! capidal bealding!" when we drove over Capitol Hill to visit your resident daddy during his hospital shifts. I swelled with pride when in my mind's eye I stood at the chain link fence, watching the first grade mile run—and watching you lead the pack! I readily cringed when I remembered the phone call from the Mount Spokane ski resort. "Is this Mrs. Julian? Your son and a tree were involved in a collision . . ." I will not forget with what resolute determination I drove up winding, snow-packed mountain roads to your rescue. And yes, anger still wells up inside of me when I remember the night you stayed out well past the witching hour while I paced and prayed, and then paced and prayed some more.

Wasn't it just yesterday when I followed you to the kindergarten crosswalk and watched you run full-bore up the steps and through the door? It had to be last Friday night that you were awarded the gilded bowling pin for first place in the 1950s dance contest at your middle school? I'm certain it was a mere moment ago that we watched you stride confidently across the arena platform to receive your high school diploma, and yet, as I sit here reflecting, it feels like forever that you've been gone.

What is it about time that causes endless hours of piano practice to evaporate into nothing? Where did Cub Scouts and homework and the soccer carpool go? Suddenly gone are the days that I can fix you breakfast, and gone are the nights that I can open your bedroom door and whisper, "Goodnight . . . I love you."

Why does something you've planned for and saved for and anticipated and rejoiced in have to feel so sad? I know that keeping you here would be holding you back. You are exactly where you need to be, and every day I'm grateful for the people, places, and things you're experiencing. I just wish someone could tell me when my heart will stop hurting. Part of me wishes someone had warned me of the imminent danger to my soul. Another part of me knows that no one could have adequately prepared me it. I know that this journey through separation is something each mother deserves to walk in her own individual way, so I too will bite my tongue and withhold the warning voice. Along this path I have learned a deeper understanding of the Biblical wisdom of Luke 2:19, "But Mary kept all these things and pondered them in her heart."

I will set an extra place at the dinner table for as long as it takes. I will sit with the pictures and the scrapbooks and watch the mishmash of video clips to hear your voice. I will play your music. I will make your food, and I will take the lid off your freshly stowed childhood whenever I need to.

I know you're not gone forever, but I also know you're gone for good. Be brave, my son. You are ready.

Love, Mom

12
NEXT STEPS

THE EASE AND ACCESS OF DIGITAL
PHOTOGRAPHY HAS YIELDED THOUSANDS
UPON THOUSANDS OF PHOTOGRAPHIC
IMAGES AT OUR FINGERTIPS. AND THAT'S
OFTEN JUST IN OUR OWN PERSONAL FAMILY
LIBRARY. THIS IS PROOF THAT WE ARE
DOING A GREAT JOB AS FAMILY HISTORIANS
AND ARE IN FACT DOCUMENTING
OUR LIVES LIKE CRAZY. BUT WHAT
HAPPENS NEXT?

Once the photos have been taken and edited and filed away onto our computers (or cell phones, even), what do we do next? The answer, for many people, is nothing.

As family historian, it is not only our job to take the photos, it is also our job to share them. For as much as this next step of getting them off of your computer and into or onto something (anything) other than locked away on your hard drive feels daunting, my intention is to offer a few very simple solutions that will hopefully overwhelm you less and inspire you more. There are a few ways of making the most of your next steps. And just remember, anything that gives you and your family the opportunity to enjoy your photographic handiwork is a good thing.

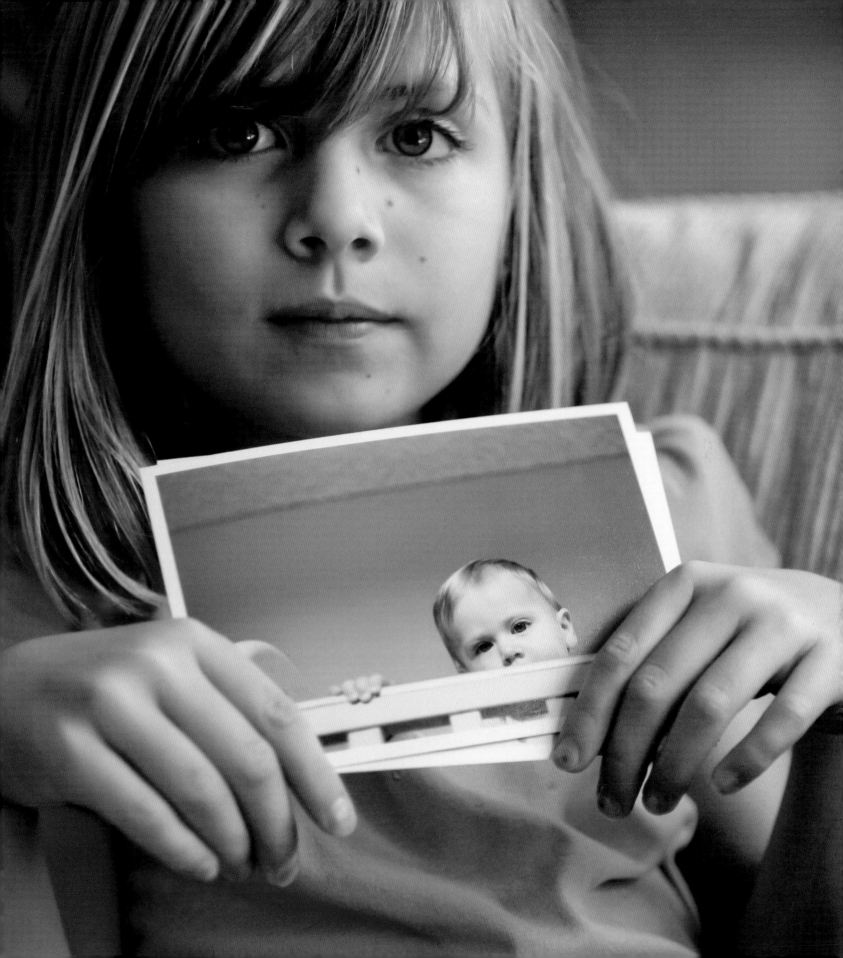

POST-PROCESSING

There are a million ways to use your images once you've taken them. But even before the printing or the album-making, there is post-processing. With digital photography, the post-processing (or the editing and enhancing of the digital files) is just an extension of the image creation, and a step to get you to the end result.

Because this book focuses on capturing your daily life (and not on post-processing your photos), I will only touch on the topic briefly. There are entire books on post-processing if you want to learn more and go deeper. I do appreciate, however, that very simple tips and tricks in photo editing can work wonders to improve your images. In this chapter, I will cover the most basic elements and the most helpful hints I can think of so that you can keep your post-processing work easy and fun.

Once you've captured your images, you will need to upload your images (which are digital files) into your computer. From there you will need some kind of editing software. The most basic options were likely loaded onto your computer when you got it, and more advanced programs are available for purchase. There are also numerous online editing solutions, many of which are free to use.

Once you begin to edit, there are several options and tools to consider. I generally refer to these tools as "slides": quite often, slide toggles are used to add or remove or increase or decrease certain effects. See the box below for more details.

GUIDE TO SIMPLE EDITS

Exposure: When your shot is too light or too dark, use the exposure slide to compensate. When you increase the exposure you are lightening it up, while decreasing the exposure will darken your image. More often than not, you'll be increasing the exposure to brighten up your underexposed shots.

Contrast: Contrast refers to the difference between the lights and the darks of your shot. This is the slide that can add a little more drama to your images. A little contrast can make a big difference and make a dull, flat image really pop.

Saturation: This term refers to the control of color. To increase saturation is to make your colors more vibrant, while decreasing saturation slowly lessens and removes color. To "desaturate" your image to the end of the control option would make your image monochromatic, or black and white.

Monochromatic (Black and White): Once you've desaturated your shot (making it black and white), you can then tweak it some more. Monochromatic images can be flat and muddy, a result of too much gray. For a little extra drama, use the contrast slide to bump up the blacks a bit (which will also whiten the whites at the same time). Your end result will have a variety and balance of blacks, grays, and whites.

Vignetting: Simply put, the vignette slide allows you to add a darker or lighter "frame" around your images. The darker option can be a very useful and effective tool for shots of your kids. With the slightly darker tone around the frame of your shot, your eye is led right to the subject within the image.

One-Click Edits: From the simplest of online editing solutions to the most complex and detailed photo editing software, there are usually very user-friendly ways to edit your image with just one click. Although they are convenient and easy, keep in mind that one-click doesn't mean foolproof. Even with these easy editing options, you are almost always able to use another tool of your choice to go back in and tweak to get your desired results.

Cropping: This tool can be invaluable when it comes to fine-tuning your photos. The cropping tool allows you to make minor crops or major ones, depending on your needs. Since it's not always easy to be paying attention to everything going on while you shoot, having the crop option to turn to when there are things in your frame that you want to crop out or parts of your shot you want to focus in on is invaluable.

DISPLAY

When you think about printing your photographs, framing probably comes to mind first. And as simple as it seems, it's probably the best way to display your work.

So get to it. Pick your shot. Decide what size you want it. Choose a frame. Hang it up (or put it on a shelf or mantel). The less deliberation you do, the better off you are—so follow your heart to pick the shot, trust your instinct while picking a size, go with your artistic vision when choosing the frame, and aim for great visibility when you hang it. Simple, isn't it?

This huge wall in our family room was bare for six years. Until, one day it wasn't. There's a long story (involving a film crew) behind why I hung the first few frames up, but it wasn't until one day when my husband just started hammering nails into the rest of the stretch of remaining wall that we finished the job. No plotting or planning or strategy involved—just hanging. The eclectic collection of frames and images reflects the many years that I gathered things up for the eventual family photo wall. Just doing it (rather than just thinking about doing it) has been the best gift I could have. I cannot tell you how much we enjoy this representation of our life. And to think, it was as simple as a hammer and nails.

DISPLAY

Tips and Ideas

Although framing photos isn't rocket science, sometimes we get creatively blocked and unable to make a decision on what photos to choose and how to display them. Consider these simple ideas to get you motivated.

↞ When matting your photographs for frames, consider using a "museum board" matte. These are double the thickness of a traditional photo matte, and make your work look amazing.

↞ Swap past images with new images. Although it's fun to display images from the past, it's nice to designate a few frames around the house as "update frames." That way you always have current shots of the family without over-cluttering every surface with photos.

↞ Consider cropping your shots into squares. Squares can give a traditionally cropped image a more artful feel.

↞ Look into alternative display options. Frames are awesome, but the possibilities are endless. Consider having a photo canvas made, look into the photo board mounting alternative, or even have your photos printed on glass. These alternatives also make great gifts for family and friends.

↞ Seek out inspiration. Photo display solutions are everywhere. Feel free to find an inspiration room or wall and copy it. From catalogs to design shows, inspiration is everywhere. It can take the pressure off when you have a model to work from.

↞ Consider a variety of types of images for display. When you offer a mix of portraits, full-body images, small details, and some images that aren't even of your children (maybe a landscape or a vignette of an everyday item), you tell a well-balanced story. Artsy shots are great alternatives to the more traditional shots. And then your photos are doing double duty as they work as both art and heirloom pieces.

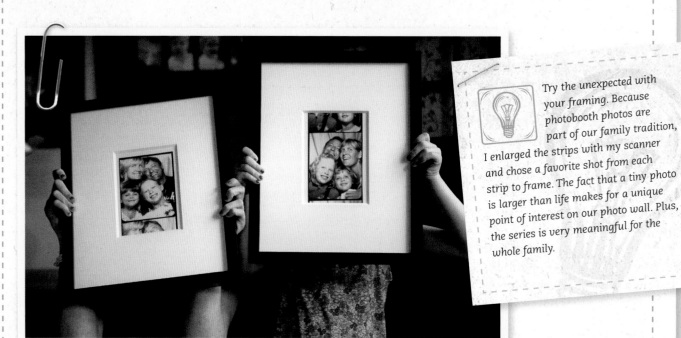

Try the unexpected with your framing. Because photobooth photos are part of our family tradition, I enlarged the strips with my scanner and chose a favorite shot from each strip to frame. The fact that a tiny photo is larger than life makes for a unique point of interest on our photo wall. Plus, the series is very meaningful for the whole family.

TRINKETS & TREASURES

Beyond traditional display options, ideas for creatively using your photos in other ways are growing by the minute—photos can be put on everything from coffee mugs to cufflinks to purses. The sky's the limit. I love finding new ways to integrate my daily-life photography into my daily comings and goings.

I'm a mug girl, so that's an obvious one. But there are commuter mugs too. There are also key chains and money clips, vases and jewelry boxes, magnets, mouse pads, coasters, calendars, and card decks. There are T-shirts, aprons, and blankets. Jewelry, hair clips, and makeup bags. Seriously. Almost anything you can think of is out there. Exploring your options and using your favorite photos on items like these can be fun and clever ways to enjoy your photos every day. Have fun with it!

Captured (Left)

When deciding what image to put on what product, try to get the two coordinated. Your choice of photo will sometimes dictate what kind of object you want it printed on. The more timeless the shot, the more likely you'll use the product that it's on for an extended period of time.

ELEVATE THE EVERYDAY

PRESERVING MEMORIES

Since photographs themselves are probably the most cherished of all keepsakes, it would make sense that we think about how to "keep" them. I've already mentioned how important it is to get our images off our computers and into our hands. Here's a simple list of things you might want to do with your photos.

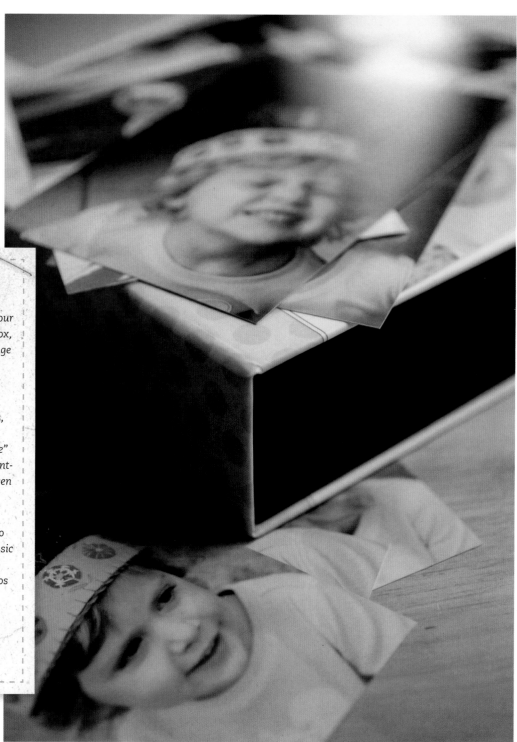

Here's a simple list of things you might want to do with your photos:

Photo Memory Boxes *not only display your photography on the outside of the box, they are made to be a simple (and gorgeous) storage solution for photographs, mementoes, and other keepsakes.*

Photo Binders *are also a great, flexible storage and display solution for photographs, paper mementos, awards, and certificates (or any other paper keepsakes our kids might bring home). "Photo safe" plastic sleeves are made for storing a lot of different-sized options. You can get decorative binders or even have your photo printed on one.*

Photo Journals *are instant keepsakes that become even more special when written in. Having a photo printed on the front elevates the journal from a basic blank book to something you (or your child) will really use. Although this isn't a keepsake for photos (besides the one on the front and maybe a few printed on the inside) it could be turned into one if you or your children wrote in it. Journal writing is a perfect complement to photography.*

THE PHOTO ALBUM

Nothing ever takes the place of classic family photo albums. The options have grown exponentially when it comes to what kinds, what sizes, what styles, and what methods you can use to get your images into books, but there is no better way for you and your family to enjoy your photos than to have them in some kind of album.

Cherished Memories (Below)
My daughters enjoy looking through our family albums and photo books as much as I do. To see them pore over the pictures makes it all worthwhile.

Traditional photo albums are becoming somewhat of a lost art, but they are actually very easy to keep up with if you simply start printing a few images from each group of photos you shoot. Or if you already have shoe boxes full of images in a closet. Don't think too much about this—just select a few shots and get them into an album. You will never regret having photos in albums, and your kids will love to look through them, now and in the future.

Photo binder albums with clear photo sleeves can be used to house a number of different sizes of prints. Personally, I have kept up with printing 8 × 10-inch images of each of my girls throughout the years to put into their own photo binders. I try to choose what I would consider a quintessential shot of them for that time period. Having a photo story in larger prints that spans their lives is a treasure.

Digitally printed photo books are taking the world by storm. With the ease of uploading and the simplicity of dragging and dropping your images into designed templates, and then getting them shipped to your door, bound and beautiful, there's no reason we shouldn't have libraries full of family photo books. They are affordable, convenient, and are ideal for getting photos back into our hands.

Scrapbooking is a way of life for many women, and it's an effective, engaging way to take the stories of your family to a whole new level. It can be done in the traditional way (cutting, pasting, crafting, creating, stamping, embellishing, etc.) or done digitally, or both. Either way, scrapbooks are prized possessions that honor the images, words, and stories of us.

CARDS & MORE

Holiday cards are no longer the only kind of card that you can use for your photos. Whether you make them yourself or use a digital printing service, the possibilities are endless as to what you can do with a photo (or two or three or more).

DIY photo projects can include anything you have a desire to make. Anytime you would normally use craft paper in a project, consider using a photo instead. Print on brochure paper made for photographs and use it in exchange for craft paper. It gives your projects a more personal touch. Let your creativity run wild and have fun with it. Creating things for yourself, your friends, and especially for your kids can be rewarding and heartwarming.

Celebrate Your Photography (Right)

The sky's the limit when it comes to using/sharing/displaying your photography so use your imagination! It can be as simple as printing your images on thick photo brochure paper and taking it from there. For example, this photo garland is an easy and unexpected way to showcase your everyday images in a whimsical and celebratory way.

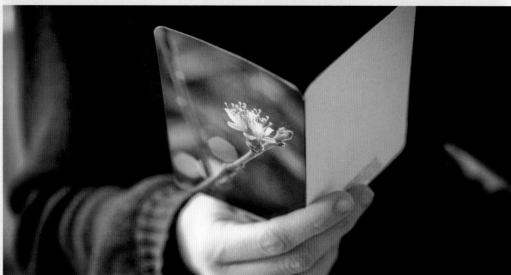

 Consider these additional card options:

Invitations to birthday parties or any other event celebrate the person of honor.

Thank-you notes are extra-special when they have photos on them.

Notecards give you a good chance to show off your more artful images and encourage you to keep the art of writing notes alive.

Gift tags are tiny (non-folded) versions of notecards and can take giftwrapping to a new level.

Photo place cards let your guests know, in a creative way, where their seats at the table are.

Calling cards are like business cards for families. With photos on them, they're a great way to enhance information exchange with people while you're out and about.

Create photo bookmarks for yourself or as an easy and highly personal gift to give alone or with a favorite book.

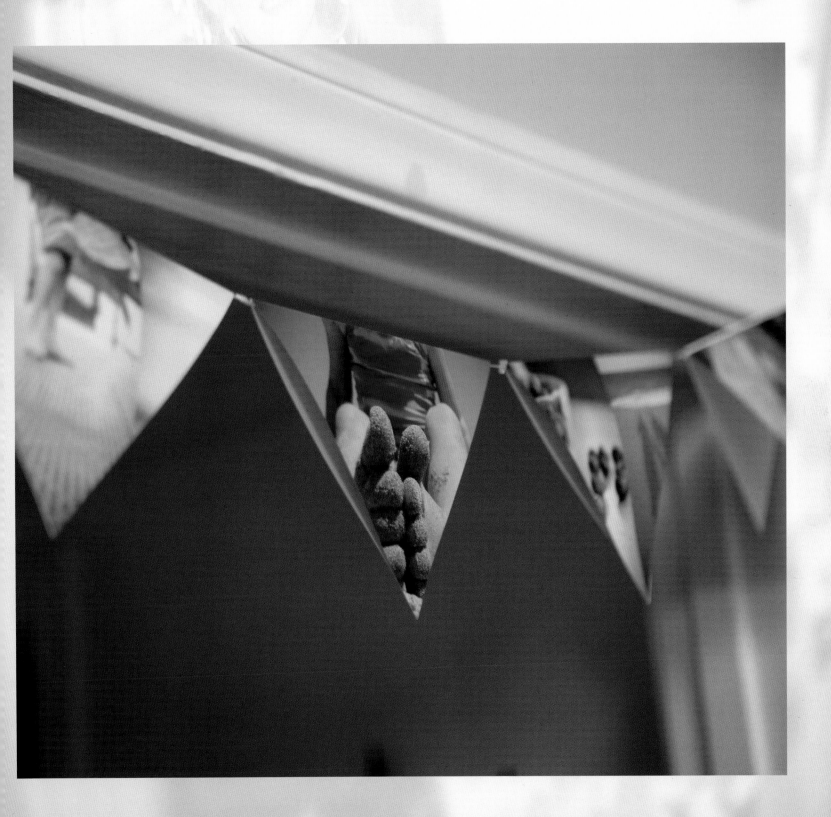

Blog Entry

Picture Comfort

Words and image
Tracey Clark
www.traceyclark.com

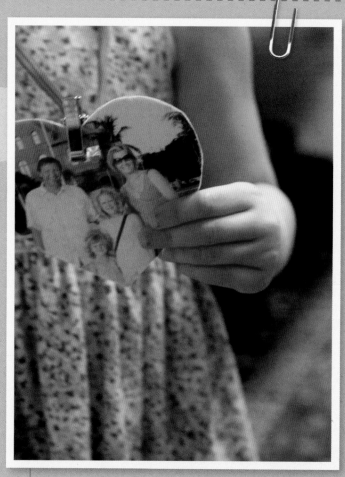

For a young child, going to daycare or preschool is a big step into the world of the unknown. And the early stages of this separation can be difficult for both parent and child. In my case, my daughter is still weepy when I drop her off at school, and it's been almost two months. Who knew? On particularly tough days she seeks solace in the "comfort necklace" I made for her. It's a simple heart-shaped piece of laminated cardstock that I decorated with a photo of our family on one side and a little love note on the other. It's designed for her to hang around her neck (I used a lanyard with a clip on the end to hang it from) when she wants to keep us close.

When my oldest daughter began her preschool career, I made a comfort necklace for her as well. She wore it every day for almost the entire year. She even wore it when babysitters came, or when she went on sleepovers with her grandparents. I loved that she could carry a piece of her father and me as she forged her own independence (even though the forging was sometimes reluctant). When she would get nervous, she'd reach for it, hold it, and gaze at it as a reminder that she was not alone and we were always with her in her heart.

I hadn't originally planned on making one for my youngest daughter. She acted as if she wouldn't miss us one bit when she started school. But a week before her first day of school, I began to feel the ache of impending separation and decided to make one for her anyway despite her super-confident attitude. As I tenderly cut out the paper heart and meticulously chose the photo and message for her necklace, I realized that I was making it more for me than for her. It felt good for me to give her something familiar, something that reminded her of us and said "You are loved."

It is true that my youngest hasn't attached herself to her necklace quite as desperately as her sister did, but she still knows it's tucked in her backpack, even when she doesn't choose to wear it. It's something very special and important to her. Knowing her sister had one (and still has it hanging on her bedpost) makes her cherish it more. And on occasion when I pick her up from school and she's got it draped around her neck, I know that a little piece of me was there for her when she needed it.

COMMUNITY

The more you immerse yourself into the world of documenting your daily life through photography, the more you will want to share it. Telling your personal story and expressing yourself through creativity is nourishing, fulfilling, and empowering. Finding like-minded women who are doing the same thing—pointing their lens toward their own lives—will not only keep you encouraged and enlightened, it can also help you grow and further develop your love of photography.

I encourage you to explore the many resources that are available to you. Whether it be through local opportunities (classes, workshops, professional organizations, photo walks, meetups, or social groups) or something you discover online (blogs, websites, forums, Flickr or Facebook groups, Instagram, e-classes, or workshops), connecting with other women and mothers can provide you with a whole new level of joy, creativity, and inspiration. From my personal experience, connecting to community can transform your life and provide limitless inspiration as you elevate the everyday.

Join Me

I invite you to join me at some of my online homes away from home:

Shutter Sisters, the community blog for all women passionate about photography.
www.shuttersisters.com

Big Picture Classes offers creative web-based classes and workshops with an emphasis on community.
www.bigpictureclasses.com

Paper Coterie provides exceptional, inspirational photo-based products.
www.papercoterie.com

And if you would like to follow along with the continuing story of *Elevate the Everyday* please visit my website at www.traceyclark.com.

CONTRIBUTORS

Tracey Clark

Blog: *Tracey Clark*
www.traceyclark.com

Tracey Clark has built a career on her belief in the beauty of everyday life. From books to blogs to classes and conferences, she preaches and teaches her inimitable perspective to women who are looking for ways to enjoy a more impassioned and creative way of being in the world. Tracey is the founder of the popular community photo blog *Shutter Sisters* and author of *Waiting for Baby*, *Baby of Mine*, and co-author of *Elevate the Everyday: A Shutter Sisters Guide to Shooting from the Heart*. She and her family live in a California coastal town where they spend their free time collecting treasures by the seaside and building sandcastles. Tracey shoots with whatever camera she's got with her and is mother to two impossibly amazing daughters.

Denise Lynette Andrade

Blog: *Boho Girl*
www.deniseandrade.com

Denise is the writer of the widely read blog *Boho Girl* where she has chronicled her journey of leaving the corporate world to start a creative career, as well as her path of fertility, adoption, motherhood, and the raw, honest layers of emotion that comes with it all. She is a photographer of artists and is currently creating a new life for her family in the far lands of the Pacific Northwest. Denise shoots through the lenses of her Canon 50D (aka her "Big Camera") and iPhone and is mother to a little wood nymph, Cedar Leonard Kroon.

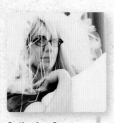

Catherine Connors

Blog: *Her Bad Mother*
www.herbadmother.com

Catherine is a mother, writer, and recovering academic who recently contributed to Canada's brain drain by relocating to New York City. She's the Director of Community and Social Good at www.babble.com, and a freelance writer who writes, sometimes, about surviving motherhood, sometimes about surviving womanhood, sometimes about trying to make the world a better place, and more often than not about her belief that bad is, really, the new good. Catherine shoots with her iPhone and is mother to Emilia and Jasper.

Xanthe Berkeley

Blog: *Xanthe Berkeley*
www.xantheberkeley.com

Taking photos has always been part of Xanthe's life as she adores capturing the beauty in everyday moments. She loves sitting around the campfire, wearing Chuck Taylors, growing beautiful things in the garden, and singing along to music with her boys. Xanthe shoots with a Canon and is mother to her two amazing boys.

Ali Edwards

Blog: *Ali Edwards*
www.aliedwards.com

Ali is an internationally recognized scrapbook blogger, author of four books, product designer, and instructor who conducts workshops around the country, internationally, and online. Her passion resides in that very special place where the stories and images of life intersect. She is well known for capturing everyday life with photos and words and creating scrapbooks from those moments that often pass by in an instant. Ali shoots with a Canon 5D and is mother to Simon and Anna.

Gabrielle Blair

Blog: *Design Mom*
www.designmom.com

Gabrielle Blair's site, *Design Mom*, was named a Website of the Year by *Time*, and recognized as a top parenting blog by *The Wall Street Journal*, *Martha Stewart*, *Real Simple*, and *Parents Magazine*. Gabrielle is also a founder of www.kirtsy.com, and *A*ltitude Design Summit. Before her social media career, Gabrielle was a graphic designer and art director in New York. Currently, Gabrielle's family is spending a year (or two!) abroad in the French countryside. Gabrielle shoots with her Canon 50D and is mother to Ralph, Maude, Olive, Oscar, Betty, and June.

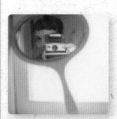

Andrea Coronna Jenkins

Blog: *Hula Seventy*
www.hulaseventy.blogspot.com

Andrea is one part photographer, one part writer, one part modern dancer, and one hundred parts mama. She writes the Covet column for *UPPERCASE* magazine and is convinced that life would stink without the following: Polaroid cameras, bicycles with baskets, old school photobooths, underground hip-hop, vintage everything, and lemon sugar anything. She shoots with pretty much any camera she can get her hands on (though she is partial to her Polaroid SX-70), and is mother to two of the coolest kids in the world.

Stacy Julian

Blog: *Stacy Julian*
www.stacyjulian.com
Stacy is a life enthusiast, a recognized leader in the scrapbooking industry, and the founder of online education at Big Picture Classes, where women all over the world gather to pursue a happier, healthier, and more creative lifestyle. She is also the author of several books, and is a passionate and sought-after speaker and trainer, presenting across the United States and abroad. Stacy loves to shoot with her Canon Rebel, and is the mother of four boys and one very adorable Korean princess.

Amy McMullen

Blog: *Amy McMullen*
www.amymcmullen.com
Amy makes portraits in her beloved hometown of Portland, Oregon, where she finds a little bit of pretty every single day. She has a penchant for vinyl records and vintage aprons, and is a blossoming foodie, a bit of a bookworm, and a small time adventurer. She shoots with her Canon, her iPhone, her oldest's plastic instant camera—whatever she can get her hands on—and is mother to two beautiful boys, inside and out.

Catherine Newman

Blog: *Ben and Birdy*
www.benandbirdy.blogspot.com
Catherine is the author of the award-winning memoir *Waiting for Birdy* and writes regularly for many different magazines, including *Disney Family Fun*, *O*, *Real Simple*, *Brain*, *Child*, and *Whole Living*. She writes about cooking and parenting on her blog. Catherine shoots with a Canon Rebel XSI, and is mother to Ben and Birdy.

Sheri Reed

Blog: *Today is Pretty*
www.todayispretty.com
Sheri lives in Northern California where she also works as a writer and editor, raises a family with her husband, and photographs birds and other pretty things. Sheri shoots with her Canon Rebel and is mother to Clyde and Leo.

Kelly Rae Roberts

Blog: *Taking Flight into Art, Love, and Life*
www.kellyraeroberts.com
Kelly Rae is an artist, author, and possibilitarian. She is the author of *Taking Flight: Inspiration + Techniques to Give Your Creative Spirit Wings*, a bestselling book that encompasses all aspects of what it means to live the creative life. Her artwork can be found in stores nationwide on a variety of products ranging from stationery products to home *décor*. Since becoming a mother, her heart has widened beyond measure and her inspiration has flown off the charts. She shoots with her Canon Compact Macro lens and is mother to a sweet baby boy named True.

Angie Warren

Blog: *Musings from Me: A Blog by Angie Warren*
www.angiewarren.com
A writer and artist at heart, Angie adores capturing the everyday moments of her family. Using whatever medium is close by, her aim is to document—for herself, her children, and those she loves. She is the founder of the website The Creative Mama, author of the e-book *Project Photography* (geared towards moms looking to get better images of their children), and the voice behind the highly-sought-after Fly Guide. Angie loves to shoot with a variety of film and digital and is mother to Danny, Luke, and Quinn.

Meredith Winn

Blog: *the~spirit~of~the~river*
www.meredithwinn.wordpress.com
Meredith is a freelance writer and photographer. She blends the beauty and chaos of the written word with artistic expression through photography as she focuses on the details of life that we all cherish the most. She is a contributing photographer for Getty Images and has had both her photography and writing published in a wide variety of publications. Meredith shoots with a Nikon and is mother to River.

Kristin Zechinnelli

Blog: *Maine Momma*
www.mainemomma.blogspot.com
Kristin is a photographer and artist living on the coast of Maine. She believes in the magic of the everyday and is always striving to capture that in her words and photos. Kristin loves to shoot her Nikon straight at the sun and is mama to three amazing souls.

INDEX

Acknowledgments

It is with much love and gratitude that I acknowledge:

Carey Jones, my editorial confidant and cherished friend, who continuously blesses me with her gifts of language and clarity. Adam Juniper, Natalia Price-Cabrera, Zara Larcombe, and Tara Gallagher at Ilex Photo, and the designer Jane Lanaway for graciously bringing this book to life. The folks at Focal Press for believing in it as well.

My father Robert New (who poignantly captured so many cherished images of my mother and me when I was young) and my photography father Michael Good.

The community of creative women that surround me with support, encouragement, and motivation. Shutter Sisters, Big Picture Classes, Paper Coterie, and of course, the Lovebombers.

The exceptional women and mommy friends in my life who have not only helped me be a better mother, but who have mothered me in so many ways.

My dear friends Myriam Joseph, Jen Lemen, Kristi Rosales, and Karen Cage. My sisters Becky Silke and Jessica Fuselier. My second mothers, Grandma Betty Arnold, Nancy New, and Charlotte Gittleman. My Mommy, my little Mommy, Shelley Hungerford, to whom I am forever and always grateful.

A Very Special Thanks To

My amazing husband, whom I love beyond words. Without him, and his endless love, support, and understanding, I wouldn't be the woman or the mother I am today.

Our two incredible daughters Julia and Iris, who have given me the greatest gift of all, their presence in my life. I can only hope they read this book as a tribute to our lives together and that they always know how deeply they are loved. I dedicate all of this to them.